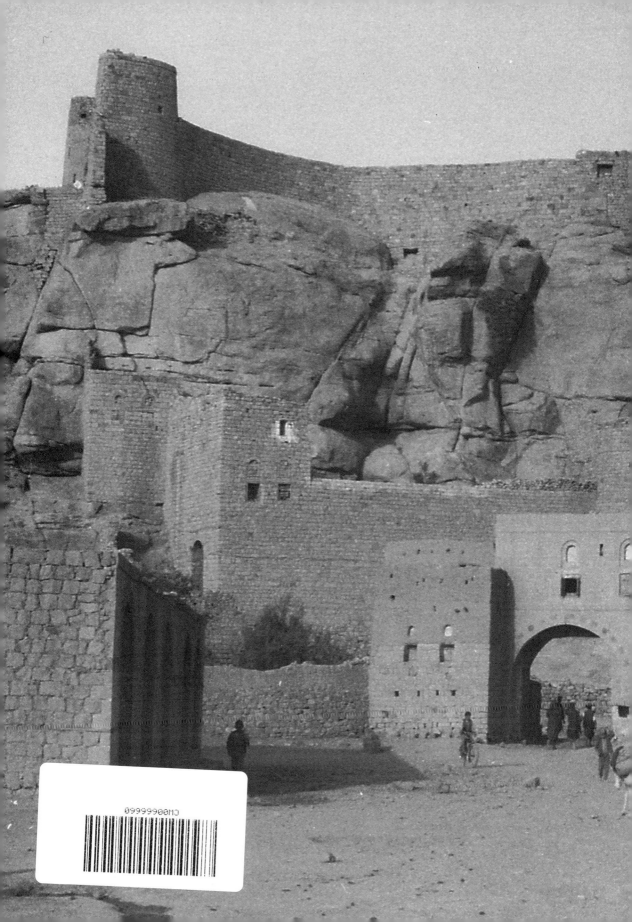

SEEN IN THE YEMEN

With happy memories

from Freya Stark

SEEN

IN THE

YEMEN

Travelling with Freya Stark and Others

by
HUGH LEACH

With a Foreword by
John Murray

Arabian Publishing

Typesetting and digital artwork by Jamie Crocker, Artista-Design, UK
Printed and bound by Toppan Leefung, China

Frontispiece Freya Stark in the Al-Haimah al-Dākhiliyyah, near Sanaʻa, 1977

End papers Interior of Radāʻ Citadel

PHOTOGRAPHS

The images from this book are available to purchase
as photographic prints from:

Arabian Album, 14 Cruden Street, London N1 8NH

Email: aralb@jashworth.demon.co.uk

اَلْرَفِيقُ قَبْلَ اَلطَّرِيقُ

Choose first your companion; thereafter your road.

This book is dedicated to

DAME FREYA STARK

An engaging travelling companion

And with special thanks to
two other well-travelled ladies

Cold voices whisper and say −
He is crazed with the spell of far Arabia,
They have stolen his wits away.

CONTENTS

LIST OF MAPS

ACKNOWLEDGEMENTS

THIS IS NOT solely my book, but a joint effort with all these splendid people hereby listed. First and foremost among them must come the indefatigable Susan Maria Farrington, MBE. She has deciphered page upon page of illegible script from this old Luddite who has yet to master any form of information technology, typed up countless drafts, and made many valuable suggestions. Thank you, Sue. Rosalind Wade-Haddon has cast her expert academic eye over the whole text and helped identify the precise location of certain pictures taken nearly forty years ago. The final photograph in this book was taken by her and is reproduced with her kind permission. It was fortunate she was resident in Sanaʻa during Freya's visits and was able to help entertain her.

Joy Ashworth helped with the initial scanning and selection from some 3,500 negatives and umpteen boxes of old prints. And it was she who encouraged the idea of resurrecting the project abandoned perforce over thirty years ago. This was followed by a stream of visitors who, over three months, looked through my own preferred choices of more than two hundred prints. Careful logging of their individual appraisal of each image's merits, or otherwise, gave me an objective view as to how the reading public might see them – a useful corrective, as this did not necessarily coincide with my own subjective judgement. Principal among those who helped in this exercise were Christopher Ind, Pia Cooper, Charlotte Alfred, Emily Blott, Charles Bird, Harriet Howard, Averil Hughes, Sue Kerry, Peter Card, Eliza Lady Conyngham, Nick Cook, Robert and Patricia Heelis, and Lt-Col. Matt Pearson.

Tina Rowe and Steve Roberts gave the public an initial glimpse of what was to come in their entertaining article carried in the *Western Daily Press* of 21 November 2009.

Ali Balable, who was born and lived his early life in Saʻdah, was invaluable in giving exact identifications of the various photographs of that city. Anderson Bakewell and Francine Stone helped similarly with some of the Tihāmah prints, as did Tim Mackintosh-Smith with those of Sanaʻa. Adel Aulaqi gave me advice on Arab proverbs and calligraphy. Meriel Buxton helped open a useful door, which resulted in Barnaby Rogerson pointing me in the right direction. Sonia Kidson did some initial editing of my first draft. And Alasdair Macleod, Head of Enterprise and Resources at the Royal Geographical Society, and his colleague Jamie Owen in the Picture Library, kindly helped identify early photographers in the Yemen.

On the technical front, sincere thanks go to Jeno Richter and his two assistants Fabrizia Ferrara and Kelly German at Snappy Snaps in Victoria Street, London. The use of their sophisticated equipment was invaluable in making extra file copies of selected prints. I am likewise grateful to Ram Bhukhureea and his assistants at Apollo Photocopiers, Bellenden Road, Peckham Rye. I must have made more than a thousand photocopies as we worked our way through the various drafts, as well as photocopies of the prints themselves.

Finally, but by no means least, I thank William Facey, my publisher, for giving me the confidence that despite my own shortcomings the book would pass through a safe pair of editorial hands. And, of course without Freya, our trusty Leicas and the generosity and hospitality of our various hosts in the Yemen, the project would never have seen the light of day.

Hugh Leach
2011

FOREWORD

I CAN WELL REMEMBER when I first took down from my shelves and opened a copy of Freya Stark's *Seen in the Hadhramaut*. I was immediately drawn in to this strange world, so mysterious and so alien. What enchanted me were Freya's extraordinary photographs, reproduced in photogravure on a light brown/sandy paper. Freya's eye for people, for the lie of the land, for architecture and, above all, for detail, was truly remarkable. In particular, her portraits of Yemenis have so much life that they make you feel you have met them. Being a woman fearless she could often take photographs where no men were allowed. She and her little Leica (which is in our family collection) travelled everywhere together.

Freya never photographed in colour, and on looking through *Seen in the Hadhramaut* you will see why. Colour can distract the eye, especially in a country like Yemen where the colours may be dramatic, but the light and shade are even more intense and count for more. In black and white, imagery gains a different aesthetic and becomes so much more effective.

In her introduction to *Seen in the Hadhramaut*, published in 1938, Freya describes it as a world that had been by-passed by history, its inland cities continuing their remote, invisible life while the Indian Ocean was filled with the noise of war. This is certainly the impression conveyed by her pictures – that there had been little change since biblical times and the days of the incense routes.

When in the 1970s I heard from my father Jock Murray, Freya's publisher, that Freya and Hugh Leach were to meet in our publishing offices at 50 Albemarle Street to discuss a volume on North Yemen as a companion to *Seen in the Hadhramaut*, it came as marvellous news. Sadly,

for various reasons, that project never came off, as Hugh Leach recounts in his introduction, but I am delighted that Hugh kept the idea alive and has now produced this book of his own evocative photographs, taken with his own Leica. He has rightly followed Freya's example and kept to black and white. This book will be a delight for all those fascinated by the Yemen.

John R. Murray
2011

PROLOGUE

And when the queen of Sheba heard of the fame of Solomon ...
she came to prove him with hard questions. And she came to
Jerusalem with a very great train, with camels that bare spices, and
very much gold, and precious stones: and when she was come to
Solomon, she communed with him of all that was in her heart ...
And king Solomon gave unto the queen of Sheba all her desire,
whatsoever she asked So she turned and went to her own
country, she and her servants.

THE BIBLE (Authorized King James Version),
1 Kings 10: 1–2, 13

The hoopoe ... said [to Solomon] *... "I have come to thee from*
Sabā' with tidings true. I found there a woman ruling over them
...and she has a magnificent throne. I found her and her people
worshipping the sun besides Allah." ... Now when (the embassy)
came to Solomon, he said: ... "That which Allah has given me
is better than that which he has given you!" ... And he diverted
her from the worship of others besides Allah She said: "O
my Lord! I have indeed wronged my soul: I do (now) submit (in
Islam), with Solomon, to the Lord of the Worlds."

THE HOLY QUR'ĀN, Surah 27: 22–24, 36, 43–44

"AND WHAT is the use of a book," thought Alice, "without pictures or
conversations?"★ Dear and gentle reader, as well as good stories there
are plenty of pictures and conversations in these pages. Please do not
discard this volume after a first cursory glance, never to be re-opened
once buried beneath others cast aside onto your coffee table. It is
designed to fit neatly onto your bookshelves, to be taken down when
the day is done, the glass filled, the pipe lit and slippers fetched, and

★ Opening lines of *Alice in Wonderland* by Lewis Carroll.

1

carried thence to bed where, before the light is extinguished, one can disappear into a pre-oil Arabia where *contentement passe rychesse*.★ Digestion of knowledge can be left until morning.

I have been motivated to produce this book, using as my guide the immortal Alice, by another that I came across some forty-five years ago. After a two-year tour serving in the old British Western Aden Protectorate, during which I took the opportunity to make a short tour of Hadhramaut, I was captivated by Freya Stark's *Seen in the Hadhramaut*, published by John Murray in 1938 – a book strikingly unlike those unwieldy coffee-table tomes with their garish coloured photographs arranged busily across the pages, all too often with the spine-gutter slicing someone's face in two. This one, with its borderless photogravure images on mushroom-coloured paper and minimal text on the facing page, not only breathed but, on being opened, spoke.

Why is it that colour photographs fail to evoke the same aesthetic responses as those in gently toned black and white? Maybe it is because our imagination is stifled, stolen or supplanted when the eye is offered images brighter and glossier than reality. Those black-and-white images in Freya Stark's book, or Wilfred Thesiger's prodigious photographs, or those of the Central Asian traveller Ella Maillart – all of whom used 1930s "screw-thread" Leica cameras – conjure up a far more evocative image of distant lands than any modern colour print. Few today appear to possess the artistic eye of those early travellers. Maybe the ease and promiscuity of modern automatic cameras, now simplified further by digitization, saps the discipline required to compose in those classic "golden thirds".

★ An anonymous sentiment, dated 1626, expressed on an old stone cemented into the wall of a house in the port of Enkhuizen, Friesland, northern Holland. The inscription reads: "Contentement passe rychesse. Anno 1627" – possibly a local reaction to the riches amassed by merchants of the Dutch East India Company, in the way similar feelings are expressed today about bankers and the super-rich.

So much for my general motivation; the impetus for this particular book was an idea that occurred to both Freya and myself after our joint travels in the Yemen in the 1970s, to which we shall return shortly: Why not replicate her 1938 book with a selection of photos that we had both taken on our journeys together, augmented by some I had taken on my own? We should entitle it simply, and matchingly, *Seen in the Yemen*. Before that, somewhat with tongue in cheek, I had suggested she might do one last book on her own, entitled *An Autumn in Himyar*.

When Freya and I were both in London at the tail-end of 1977, we approached John (Jock) Murray, who had published her other books. How well I remember those cosy visits to Albemarle Street. He was keen on the idea though worried about the expense of producing it by the same photogravure technique again. Enquiries suggested that only one firm still did this and that was in Germany. We experimented in other methods, such as duotone. Leica in Wetzlar, Germany, were approached for help as we were determined upon dedicating the book to "Two Middle-aged Ladies", our respective 1930s Leica cameras. But in the end time ran out on us; I was posted to the Sudan for four years and Freya returned to her home in Asolo. So John Murray felt, reluctantly, that the project would have to be abandoned. Freya commenced one of her letters to me: "A sad note this morning from the House of Murray."

Some years later, after Freya's death in 1993 at the age of one hundred, Malise Ruthven, one of her godsons, asked if he could have her negatives from our 1970s Yemen journeys, which I had yet to send to her archival collection at St Antony's College, Oxford. Malise was engaged in producing a four-volume series of Freya's photographs, chosen from negatives housed in the Middle East Archive there, depicting her travels in Persia, Iraq and Kuwait, the Levant and South Arabia. These were published by Garnet Publishing in the autumn of 1995.

After so-called retirement, I was engaged in further travel adventures

in Central Asia and other writing projects when I was approached by Joy Ashworth, who runs an online photographic library, *Arabian Album*. Would I be interested in allowing my own large collection of Middle East photographs to be accessible to her library? I wondered whether this might be a last chance to resurrect the *Seen in the Yemen* project, using my own photographs but dedicating the book to Freya. After much soul and negative searching, and having approached William Facey of Arabian Publishing to actually produce it, the present publication is the result.

With the book's genesis thus accounted for, let us retrace our steps to the autumn of 1975 when I first met Freya Stark, at her home in Asolo, northern Italy. Accompanied by my friend Theodora Mugnaini, I was driving home on completion of a happy four-year posting to Cairo, in an ancient front-wheel-drive Citroen car know universally as *traction avant*, which I had found there. On board ship from Alexandria to Venice, we had discussed the idea of springing a surprise visit on Freya. Neither of us had met her previously, except in her books. Theodora, like Freya, had spent part of the war serving in Egypt, so here was a common introductory bond. Discovering Freya's house, we simply knocked on the door.

During a long afternoon and evening I found we shared many interests in common, among them a deep affection for the Arab world, the poetry of Matthew Arnold, and 1930s screw-thread Leica cameras. We agreed that black and white was the true photographic art form. Before we left I mentioned that my next posting was to Sana'a, in the Yemen. Spotting the thoughtful gleam that came to her eye, I knew instinctively that it heralded some sort of joint future. I concluded my diary entry that night: "It was such a delight meeting you Freya; I loved your home, your library and all your eighty-two years. I sense you are enjoying life's 'Indian summer' whilst I, exactly half your age, am in the midst of my real one. I do so hope we shall meet again."

The following March, recently arrived in Sana'a and scarcely settled in, I received a telegram announcing succinctly: "Arriving Wednesday, Freya." She did, at 6.30 in the morning. I had been forewarned she could prove a demanding companion who might dictate a travelling agenda. The reality proved the reverse. She was companionable, considerate, grateful and, at the advanced age of eighty-three, happy to be led rather than to lead.

Freya's only previous visit to north Yemen had been in 1940. At the time she was in Aden employed by the Ministry of Information. She had persuaded her immediate superior, Stewart Perowne (whom she later married), and the governor, Sir Bernard Reilly, to send her to Sana'a so that she could counter Italian propaganda. Fearing that Italy would soon join the war on the side of Germany, and with the large Italian presence not only across the Red Sea in Ethiopia and Somalia but also in Yemen, chiefly in the form of medical missions, Britain was concerned about the latter's continuing neutrality. Should Yemen too declare for Germany there was a danger the Red Sea could be closed to Allied shipping. Freya's seven-week visit to Yemen is covered, mostly through a series of letters sent to Perowne, in Chapter Three of her book, *Dust in the Lion's Paw* (John Murray, 1961). One of Freya's reasons for wanting to revisit now was to relive those experiences and see the old city again. During her stay she gave me a more personal and graphic description of that venture.

The journey up from Aden in 1940 had been made in a lorry and taken six days. She was accompanied by a driver, a cook – "He was Stewart's own and he was rather annoyed at losing him" – and a soldier escort. The most important item of luggage was a cinema projector and a number of films. The first night's stop was at the frontier post of Kirsh, followed by a night in Ta'izz and another in Mukhā. There she stayed in a *burj* (tower), courtesy of the garrison commander. A singular experience

that night will be related later when we see a picture of her dwelling. Next morning she continued along the Tihāmah, through Zabīd, Bait al-Faqīh and on to Hudaidah. She stopped there for two nights before continuing to Sana'a up "Twitchell's Road",⋆ on which there was an involuntary night's stop when the lorry broke down. On her arrival in Sana'a, a Turkish General of Artillery was turned out of his house to give her a room. Freya's memory suggested it was that of Qaim Makam Mahmoud Bey, somewhere near the Burj al-Nūbah.

Freya had brought with her four main films, and some minor ones, to show on her projector. The idea was to counter Fascist propaganda that Britain was on the point of defeat. Since at that period of the war there were no films to demonstrate this not to be the case, the four that Freya had brought with her were: Army manoeuvres at Aldershot; Navy manoeuvres near Malta; RAF life at Cranwell; and Everyday life in Edinburgh. The latter proved the most popular. Some of the shorter films were in fact of the First World War, but Freya felt confident her audience would not detect this. The films were shown in the harems of various notables in the city. She was befriended especially by the wife of Raghib Bey, the Foreign Minister, and was eventually allowed to show the films in the very rooms of Imām Yahyā's wife. Some of Yahyā's sons used to come and watch them although she never met the Imām himself; he had vowed never to meet a European woman. However, she knew he sometimes watched through a curtain. She discovered this by once drawing it back a little pretending she'd lost her way, and saw him peeping through a slit.

The Italians were very difficult and tried to foul up her activities. The two foremost were Dr Rossi, Head of the Medical Mission – "little

⋆ Karl S. Twitchell was an American engineer working in Saudi Arabia. He improved the Hudaidah–Sana'a road by strengthening bridges and culverts. The road was metalled only in the 1960s by the Chinese.

brute" – and Dr Favetti, a merchant – "a pleasant enough fellow but we were on opposite sides". His son had been taken prisoner in Ethiopia. There was also a Dane, who was very much in favour with the Imām "for whom he'd invented a special cannon". He was on Freya's side and against the Italians. She never met Imām Yahyā's son and successor, Ahmad, who was living in Ta'izz.

Freya's mission may have had more effect than was appreciated at the time. In early 1943 the Imām interned some Italians and closed two pro-Axis radio stations. In the event Italy really gained little from its flirtation with the Yemen and, realizing this, concentrated its attention on Ethiopia.

Most of her letters were, as mentioned, to Stewart Perowne, to whom she was not married at the time – "just good friends". He had given her £100 in expenses for the whole expedition. She was also provided with secret ink and various code words to secure their communications. Though she used both, the people at the other end in Aden had forgotten about the ink and lost the key to the codewords! At the end of the two months she returned to Aden by ship from Hudaidah. She had taken several rolls of film with her precious Leica whilst in Yemen, but the captain of the ship, obeying security regulations, made her throw them all overboard. They would have made valuable archival material, especially those of the old city walls and main gates of Sana'a, which were "always locked at night". In 1976, on the first evening of her return visit, we walked the streets of the old city by moonlight, and in the following days located some of the houses where she had stayed and shown her films those thirty-six years previously.

On the second day I took her, at his request, to see the Minister of Information, Yahyā Al-Arishi – not an easy man and, at twenty-nine, very much a young Republican. In an hour and a half's interview, all in Arabic, she was back at her 1940s work. He wanted to grill her for Sana'a Radio about her earlier "colonial mission". Despite his attempt to floor

her, he was soon charmed into submission. He ended by giving her a book about "the Revolution and all that has followed" and hoped that as a result of her visit she would now write something for him in similar vein.

We unearthed an old Turkish bandmaster, Musigar Turmash Muhammad Effendi, then aged seventy-five, who, amazingly, remembered Freya from her 1940 visit. They talked happily in Turkish. Born in Istanbul, he had come to Yemen with his father when he was nine, during the last years of the Ottoman occupation. He was still active teaching music to Yemeni military bands. (Six years earlier, in 1970, when I had accompanied our ambassador from Jeddah to a palace ceremony in Sana'a to mark the restoration of British–Yemeni relations, Turmash had taught the Yemeni band to play the British national anthem. He had no sheet music but recorded it a few nights previously from the BBC World Service. I still have the recording of it that I asked the ambassador's wife to make from a small machine I secreted in her handbag. It is recognizable.) Turmash thought that the house in which Freya had first stayed on arrival in Sana'a was "almost certainly that of Mahmoud Bey, who had returned to Yemen in 1337 AH" (AD 1918 – interesting that, as an old Ottoman Turk, he had instinctively used the Muslim Hijri calendar, as he would have done back in Turkey). As that was the year the Ottomans finally withdrew, Mahmoud, presumably, like Turmash himself, had come to Yemen at the close of their occupation and stayed on, as so many did. He added: "Or it might have been the house of Qaim Makam Ismā'īl Bey, who followed Mahmoud as Director of Artillery and was subsequently beheaded for being involved in the coup that toppled the Imām Yahyā." Turmash spoke as if these events had occurred the previous month!

Freya's days in Sana'a were packed with tea parties given by the local women, and visits to highland villages around Sana'a often accompanied

by the British ambassador, Bill Carden. Travelling conditions may have improved over the years but there were still plenty of unmade roads to jolt the bones of an eighty-three-year-old. I recall her sitting contentedly by the roadside for five hours on our way to Ta'izz, engaging passers-by in Arabic as we struggled to fix the gearbox of the Land Rover which, unlike her, had succumbed to the rough treatment. When we finally continued our journey after dark, she curled up on the back seat like a ten-year-old.

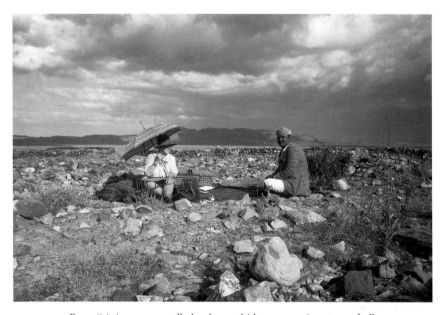

Freya "sitting contentedly by the roadside … engaging passers by".

In Ta'izz we stayed with John Wood who, as both an expert on Yemen's flora and an historian, held his own with Freya over the dinner table. During our three-day stay, we were entertained by local notables who had heard of this inveterate traveller. We enjoyed a picnic lunch, composed of a sheep grilled on hot stones, arranged by a Hadhrami

shaikh, Abdullah Al-Himyar, who had been brought up on stories of Freya's journeyings in his home country. Also present was the nephew of her "Uncle of the Beni Himyar" (see Chapter XIV of *A Winter in Arabia* and the photo facing p. 284 in the 1940 first edition). The nephew, now an old man, was about fifteen when Freya made her visit in 1937, but remembered it well.

On return to Sana'a, Freya was moved to write a five-line postcard to Stewart Perowne, with whom she had been out of contact for some time and who was then living on the island of Gozo, Malta: "So strange to be here after all these years. It is just as beautiful as ever and I must send you greetings." Although now separated, they were never formally divorced. I could not help noticing that she had spelt his surname, her own, incorrectly – perhaps a reflection on their unsatisfactory union. She finally departed for Cairo on a Russian Aeroflot flight delayed for three hours. An embassy stalwart haggled with the Russian crew to get her the best seat.

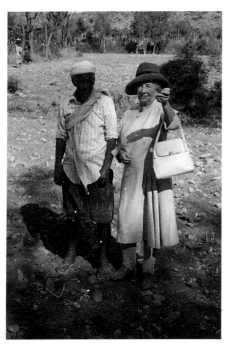

"Also present was the nephew of her 'Uncle of the Beni Himyar'."

On Freya's return to Italy, a letter arrived proclaiming that it had been "one of the best holidays ever, and if you could put up with this elderly companion once more I should love to return. I want to improve my Arabic and it will make me feel young again." Return she did for this elixir in early November

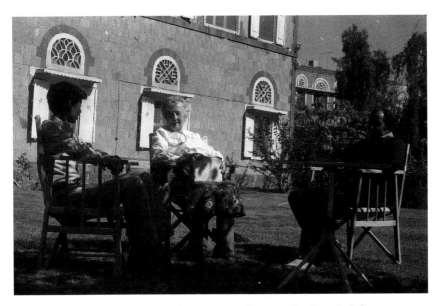

Freya sitting in my garden in Sana'a talking to a local youth (left)
and my driver Mubārak (right).

the same year, this time for a longer visit. The Arabic request was solved
by Clive Smith, the British Council representative. He found a blind boy,
Ahmad, who sat with her in my garden for two hours each morning.
Clive's wife Ann was also active in introducing Freya to ladies in the city
and looking after her when I was busy in the embassy, and Rosalind
Wade (now Wade-Haddon), an adviser to the Sana'a Museum, would
help me entertain her at dinner. I remember how Freya would emerge
for dinner after I had sounded the dinner call on my bugle (traditions
die hard), dressed as though dining at the Presidency, her white cotton
head-bonnet carefully adjusted to cover a scalp disfigurement, the result
of an accident in her youth. Inevitably such a distinguished visitor
attracted similar guests around that table. One of the more memorable
was Sir William Luce, visiting Sana'a in a retirement role after a lifetime's
work in the Sudan and Arabia. The two had not met previously but now,

11

fulfilling their joint ambition to do so, they exchanged stories to which Rosalind and I listened in silent awe and wonderment.

There were more day trips to the highland villages in the Al-Haimah al-Dākhiliyyah district around Sana'a. Wherever we went, as on her previous visit, Freya actively engaged the local people in conversation and took pictures with her beloved Leica. We made a week-long safari first to Hajjah, a provincial capital in the highlands north-west of Sana'a, and then down to the Tihāmah. We were accompanied by John Shipman, who had served previously as a Political Officer in Hadhramaut during the British period. With their exchange of reminiscences about that country, he proved an ideal companion for Freya. We made our way up through Bājil, where there was ample evidence of its fame as a livestock market, camping the night at Al-Zuhrah in the Tihāmah foothills, and going thence on up through the attractive village of Suq al-Mu'arras and

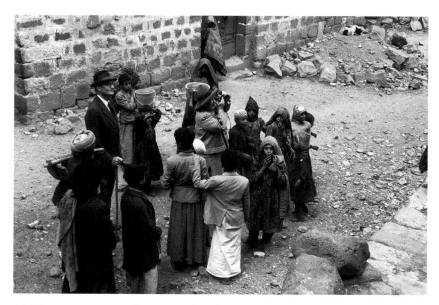

"Wherever we went ... Freya was active taking pictures." Freya at Shibām, near Sana'a.
The British ambassador, Bill Carden, looks on.

12

on to Hajjah, its citadel gazing down imperiously on the town below. Unfortunately, my negative strip of this part of the tour was ruined by one of England's leading photographers. Henceforth I determined to develop my own as Freya had done during her Hadhramaut travels, aware that excessive heat can spoil undeveloped film. However, my diary recollection of Hajjah states simply that whilst its setting is dramatic, the town itself is "square and heavy". Descending, we spent another night camping in the foothills where we bought, hastily grilled, and gnawed our way through a *tais* (a young goat). It was more than Freya's teeth could comfortably manage.

Returning southwards along the Tihāmah we made our base at Al-Jarrāhi in the house and courtyard of our faithful driver, Mubārak. Freya, like many Arabian travellers, felt more relaxed in the company of the lowland and desert Arab than among his more intriguing mountain

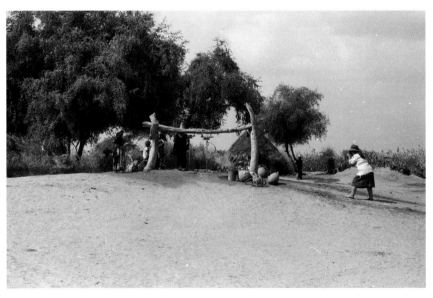

"… in the Tihāmah foothills." Freya captures a well-head scene at Zaidiyyah.

"... marrying off his thirteen-year old daughter."

cousins. She was in her element sleeping under the stars on the flat roofs of mud-brick Tihāmah houses and disappearing into the women's quarters, from where sounds of hilarity would emerge.

Our days in Al-Jarrāhi coincided felicitously with the 'Eid al-Adha, during which Mubārak was marrying off his thirteen-year-old daughter. We lived, in privileged conditions, among some fifty unveiled women who had gathered for the event. We made another brief visit to Ta'izz and thence went on to Mukhā. Here Freya was besieged by nostalgia and pointed out the *burj* where she had stayed those thirty-five years previously. Zabīd, that wonderful old university town, one of Freya's favourites, as it is mine, merited a full day.

And so, reluctantly, back to Sana'a. Throughout all these vicissitudes Freya proved to be a thoroughly invigorating companion, bringing alive her

14

previous adventures. She asked only once for an extra day's rest, which she spent lying under a *ghāf* tree whilst recovering from a stomach upset cured quickly by her proven method of eating plain, stodgy rice.

The month over, Freya, accompanied by John Shipman, left on a flight bound for Damascus. I felt a gap, but it was filled not long after by two letters. The first was sent from Damascus:

> All those lovely days, none of your hundreds of guests can have enjoyed themselves more, or brought away a more magic kaleidoscope of pictures to browse over at leisure. The browsing flocks in Tihamah round our camps, the beauty of Zabid with its great mosque and emptying houses; Mukha past and present and Ta'izz future, and most of all the feast and wedding and the warm, charming welcome at Mubarak's. And all the stars wandering above our uplifted sleeping through the nights.

And, a week later, after her return to Asolo:

> It all seems like a beautiful dream, those weeks in Arabia; they grow and grow as I think about them and have a strange living quality as if I could go back again and again and find them living as ever. My little white goat, the beauty of the stars (hours of night spent looking up at them), the nice kind women and the little bride, and you and John and Mubarak all so thoughtful for this aged traveller. I came away very much touched and happy and prepared to go on as long as time allows to see and be a burden to my friends …"

Before we say goodbye to Freya I am tempted, for the sake of posterity, to record some of her thoughts, observations and reminiscences

that she relayed during the many long evenings we spent together. My justification for detaining the reader in this way is that I feel the book is as much hers as mine.

In an early discourse Freya made it clear that she had had enough of war; she had lived through two. She now saw a Britain "risen like Phoenix from the ashes, leading a pacifist Europe. Guerrilla warfare should be our only defence." She was also concerned about the role of America as principal world leader, wondering whether it possessed the right moral credentials. She concluded this brief homily with an involuntary smile: "We all have to move a little to the left as we get older."

One night I showed Freya a film in Arabic that I had been given many years previously in Jordan by the then Minister of Information, Ma'ān Abu Nuwār, and put together by his team. Appropriately, to show it I had to use an old-fashioned film projector of the sort Freya had used on her 1940 visit. Entitled *The Arab Revolt*, it contained archival footage of the Hijaz campaign, including shots of the Hashemite Amirs Faisal and Abdullah, as well as T. E. Lawrence. Freya was visibly moved; she had known Abdullah quite well, after he became King of Jordan. At its close she made one of her profound remarks: "The main virtue of that film lies in its imperfections; a strength the Arabs have if only they knew how to use it." This led to a discussion on two types of humanity: "Those that worship efficiency for its own sake, and those that muddle through savouring, for they have the time, life on the way. The latter are so often the more efficient; the former, for certain, will cause our destruction." Discussing Lawrence, Freya remarked that she had known Farīda el Akle, who had taught him Arabic in Jubail, Lebanon. Farīda had told Freya that Lawrence had an inherent dislike of women, though she thought he liked her more than most. (I was secretly amused, for Freya herself clearly preferred the company of men.) Farīda had also commented that

Lawrence's Arabic "wasn't really very good". I retorted that this was unfair. Anyone who has been through that mill knows that one's school-learnt Arabic only blossoms when consummated in the field and when, perforce, there is no other means of communication. Lawrence had known Farīda el Akle before his immersion in the Arab Revolt (1916–18) that made him not only a celebrity but a more accomplished Arabist.

Freya's great hero was Field Marshal Wavell. She had known him whilst working with Lady Wavell in India at the close of the war. Defending her protagonist, she liked to comment: "Churchill was a big man; Wavell was a great man. There's a difference, hence the two could not get on." I teased her by querying why there was no Matthew Arnold in Wavell's *Other Men's Flowers*. Freya countered: "These were not necessarily his favourite poems but the ones he knew, mainly, by heart, and used to recite as he rode alone." We agreed poetic support was needed as one "rode alone". Reflecting on our joint ardour for so "riding alone in a wandering life", she mused: "Those Sanusi bedouin in Libya, who were rounded up by the Italians during the early stages of the war as being military suspects, died in hundreds in their camps. Why did they die? Simply from being cooped up, there was nothing medically wrong with them. We could do the same."

She confided much about her brief time with Stewart Perowne. It was not so much that he was homosexual; she could have lived with that had she known before the marriage, by which time she was fifty-four and he forty-six. It was his intellectual companionship that she sought. It was the not knowing, when most others did, that hurt.

Freya saw life both mentally and physically through the eye of an artist. What she said, be it in passing or considered, was measured. She once made a salient remark about the Arabic language. I recorded it from memory in my diary notes that night and quoted it back to her the next

morning: "The Arabic language in its richness is like a great organ playing with all its stops pulled out." She fixed me with the stern eye of a vexed English teacher at school. "No, I didn't say that; you've added that bit about the stops; take it out." And, of course, the analogy stands better without it. Her own letters, from a few of which we have quoted, were penned as if by brush; but there is no unnecessary touching up.

Perhaps not unusually for those who appear to the rest of us to have poured three lives into one, Freya used often to tell me how she still felt "unfulfilled". With that improbable farewell observation we must now, sadly, let her go. But we shall meet her again in Alice's demanded pictures. When I think back to those two visits, my most vivid memories are of her unfailing good humour, her unremitting equability, and her ability to make the most of every waking hour, even if "the most" meant no more than retiring on a rug under a *ghāf* tree, or on the roof of a Tihāmah house swaddled against a dust storm. She was uncomplaining of the hardships of travel and, when briefly ill, accepted it as part of the course of things, not to be countered but to be subject to time as the healer.

We met subsequently several times in London and continued a correspondence for many years. We last "met" on a rainy day in late September 1993 at her memorial service in St James's Church, Piccadilly, and at the subsequent gathering of her friends in the comfort of Albemarle Street. She was vividly present at both. When my memory dims it will be refreshed by some thirty of her letters. One of her last read: "A gloomy world, dear, but sunrises and sunsets and much loveliness inside it." I shall remember her as part of that loveliness, as will others who travelled similarly with her, or with the companionship of her words.

A valedictory reflection

A posting such as Yemen did indeed bring, in Freya's words, "your hundreds of guests". There were some well-known Arabian travellers among them, including, as well as Freya, Violet Dickson, the grand old lady of Kuwait, and Wilfred Thesiger. All explorers, not least Arabian ones, have a sensitivity about others trespassing on their patch. Wilfred had a special rancour reserved for women trespassing on his. But, as I teased him, both Freya and Violet were much kinder about him than he about them. Indeed Freya was fascinated to learn about his exploits. And with regard to Violet, Freya would only jest: "Did she do as well as me?"

All three have now been gathered to their maker so, reflecting on that well-known Arabic proverb quoted on the dedication page, "Choose first your companion, and then your road", I can say with feeling that if I am allowed to join those "up above", it will be Freya whom I will ask first to be my companion, before making my choice of a specific "ethereal road".

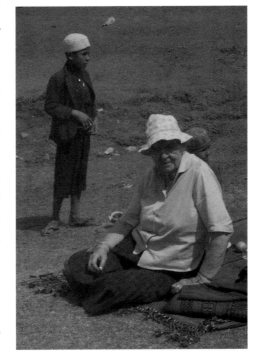

Dame Violet Dickson near Jiblah,
May 1976.

Wilfred Thesiger on the outskirts of Zabīd, January 1977.

YEMEN
A BRIEF SURVEY

AT THE END of her initial page-and-a-half foreword to *Seen in the Hadhramaut*, Freya wrote that Mr Murray had demanded more. She protested, commenting that no one would read a long introduction to a picture book. "Why should anyone? One might as well read a history of the Netherlands before enjoying a Dutch landscape." But Mr Murray was impervious to reason.

When Jock Murray was still intent on doing our joint book, Freya wrote to me that he had just sent her a copy of her previous, eventual, fifteen-page introduction. "It fills me with despair because it is so *long* and I am past writing anything so learned and complete. We must do this together; you can give me the facts and I will find the words. I hope it need not be quite so long." Alas, it is no longer a question of "together". But, on reflection, some introduction abridging Yemen's rich history, its religions and physical make-up really is necessary to bring the pictures alive.

Before we embark upon this task, dear reader, especially if you are of a pedantic disposition, please note that whilst I have tried in the Glossary and Index to follow an accepted standard in the rendering of Arabic words and names, there is only one true way to spell Arabic, and that is in its own script. Transcribing Arabic terms as correctly as one can into Latin script is dependent on choosing a standard transliteration system, augmented, when dealing with vernacular pronunciation, by the writer's individual ear for phonetic variations. However, I have kept the definite article as Al-, or al-, and have not, where pronunciation dictates, elided it to its partner as is done in spoken Arabic. In the text and captions I have indicated long vowels with a dash above the letter, but have omitted

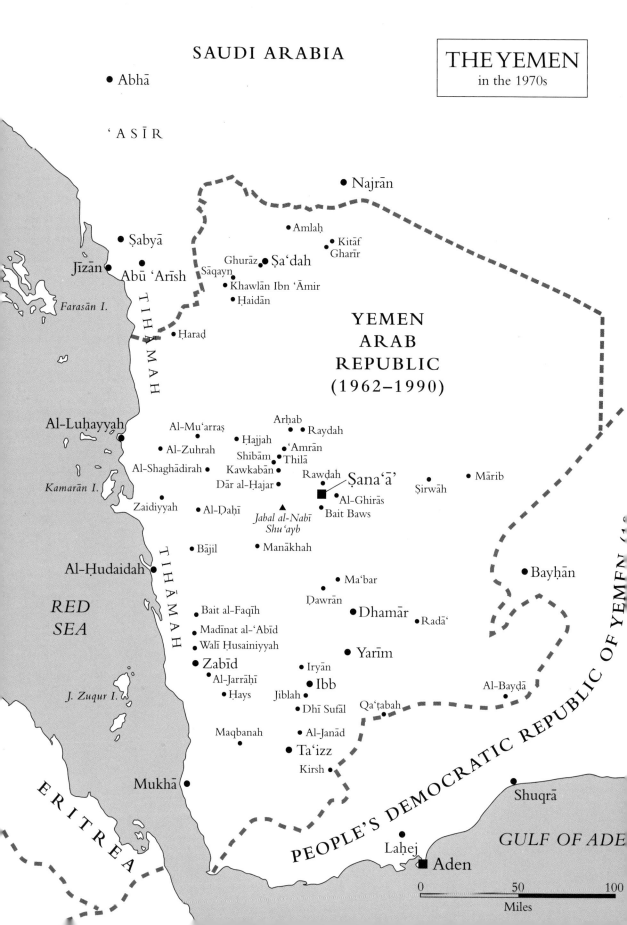

the diacritical dots that distinguish the emphatic consonants, though these have been retained in the Glossary and Index. As for dates and detail of ancient happenings, none of us was there. We rely upon the sources from which we each draw; hence differences. Of course we all make mistakes; final elimination is like removing the last grain of sugar spilled onto a thick pile carpet. Let us all be conscious of the parable of motes and beams.

Pre-Islamic history

There are various theories as to the origin of the name Yemen. According to the 19th-century Austrian orientalist, Eduard Glaser, it derives from Yamanat, the title by which a part of its land was known in the 2nd century BC. More popularly, it is held to stem from the Arabic word *yaman*, meaning happiness or prosperity: Yemenis say it is so called because when the sons of Qahtān settled there they found themselves prosperous. Others say that that the Arabic name derives from the Roman description of the country as *Arabia Felix*, so portrayed because of its wealth and astonishing green fertility contrasting with the deserts to the north and east. Another separate meaning of the Arabic *yaman* is "right hand side", an apt enough appellation if one is sailing northwards up the Red Sea towards the Muslim holy cities. Personally, I suspect Glaser to be nearer the truth. Whatever the case, few travellers familiar with the Arab world would deny Yemen's physical beauty. And its architecture can have few rivals save, perhaps, the ancient city of Fez in Morocco. Most of the country's physical aspects can be covered in the pictures; here we need dwell mainly on the non-visual.

Yemen is also known popularly as the land of Sheba (Sabā). This stems from the Biblical and Qur'ānic stories of a queen of that name (hence our introductory extracts) ruling a kingdom based on Mārib,

famous for its dam, and visiting Solomon in Jerusalem in the 10th century BC. (In the Qur'ān, Sūrah/Chapter 34 is entitled "Sabā", but the story of her visit to Solomon is carried in Sūrah 27, "The Ants"). To Yemenis she is known as Bilqīs, though not specifically so named in the Qur'ān, and many Yemeni girls are given that name. However, the Ethiopians across the Red Sea also claim her as their own.

Yemen's ruling elites, before and after the emergence of Islam, are a series of somewhat convoluted regimes. We shall do our best to act as guide through this maze. But as ever in such matters, there is no universal academic concordance, especially as to dating. This is constantly being modified and refined as a result of fresh archaeological and epigraphic evidence.

The roots of South Arabian culture are extraordinarily ancient. There is now archaeological evidence that the Yemeni traditions of settlement, irrigation and farming trace their origins as far back as the Early Bronze Age in the 3rd and 4th millennia BC, which puts the antiquity of ancient Yemeni society on a par with those better-known cradles of civilization, Mesopotamia and Egypt. By the late 2nd millennium BC, ancient Yemen's highly distinctive South Semitic writing system was emerging, perhaps as a result of contact with the Levant. However, we do not have any actual inscriptions from before the early 1st millennium BC, and so it is only from that time that we can start to construct a political history of the country. Essentially, the mountainous terrain hindered the unification of the country under a single power, and the surviving inscriptions show us that there were six principal overlapping pre-Islamic kingdoms, each centring on the cult of its particular deity, and on highly developed capital cities of fine stone architecture, with city walls, palaces, temples, markets, tombs and formal inscriptions.

The earliest such kingdom that we can identify in these sources is Saba, whose power expanded from the Sabaean capital, Mārib, east of

Sana'a, in the centuries after 1000 BC, and lasted from perhaps around 950 to 115 BC. The term Saba is sometimes used, incorrectly, to describe the entirety of south-west Arabia. It is identified with the Biblical Sheba and has historically been the best-known ancient Yemeni kingdom because of the legendary queen of that name. And whilst nothing has yet been found to indicate positively that there actually was a queen named Saba or Sheba, it is not impossible, as female rulers did appear in early Arabian history; we shall meet another later. However, according to the inscriptional evidence, its early rulers were male *mukarrib*s, or priest-kings, who were later replaced by more conventional kings, or *mulūk*. Their capital, Mārib, was famed for its great dam, described by mediaeval writers as one of the "Seven Wonders of the World". Archaeology shows that the dam, a marvel of structural engineering with elaborate sluices, was used to impound flash floods from the mountains to the west, and was indeed the mainstay of a vast agricultural system dependent on gravity-fed irrigation. The wealth of Saba was based also on the overland incense trade to the north that grew up from the early centuries BC, but Sabaean craftsmen made, and exported, gold and silver drinking vessels too. In the centuries before AD 600, Mārib faded as its fields rose with centuries of silt, and the waters from the great dam could no longer feed it − a creeping catastrophe symbolized in popular memory as the bursting of the dam, which had fallen into disrepair as its usefulness declined.

The desire to control the rich incense trade led to the Sabaean conquest and colonization of neighbouring polities, first Awsān to the south and Nashān to the north-west. Awsān's territory extended along the coast as far as the Bal al-Mandab, and there is a suggestion that it also controlled part of the East African coast. Little is known of Awsān, except that its possession was contested between Saba and another powerful neighbour, Qatabān.

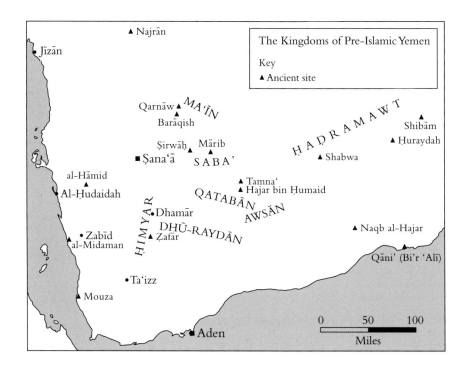

In the 4th century BC, Greek authors tell us of other kingdoms besides Saba: Ma'īn centred around the Wadi Jawf in the north-east, towards the modern Saudi border; Qatabān to the east, in modern Bayhān, with its ancient capital of Tamna'; and, farthest to the east, Hadhramaut, with its capital city of Shabwa. These ancient kingdoms were centred on wadis draining the highlands and plateaux into the inner desert later known as the Ramlat al-Sab'atain, and depended on massive irrigation works to sustain their peoples. The archaeology of Qatabān's settlements, as of Saba, suggests an origin before 1000 BC, and similar antiquity can be deduced for the origins of Shabwa. The Minaeans, of Ma'īn to the north, seem to have flourished between 500 and 100 BC, and were distinctive in that they seem to have concentrated not on political expansion but on commerce, controlling the routes north

through Arabia, establishing a trading colony at Al-'Ula in the northern Hijaz, and trading far and wide into Egypt, Syria, Mesopotamia and the Levant. They were supplanted by the Nabataeans of Petra and Madā'in Sālih during the 2nd century BC. By the 3rd century BC, Qatabān and Hadhramaut, previously allied with or subject to Saba, had become powerful enough to challenge Sabaean dominance. Later, the Qatabanian kingdom came to a sudden and violent end when its capital was attacked and sacked by the Hadhramis in about the 1st century AH.

The 1st century BC saw a shift in power away from the cities around the inland desert basin to the highlands, as it is from now that the kingdom of Himyar comes to dominate the others. Having first gained independence from Qatabān, from their capital at Zafār (the adjoining mountain is still known as Jabal Zafār), ten miles south-east of modern Yarīm, they set about absorbing both Qatabān and Saba. This realignment may have had something to do with a shift in the trade from the inland routes to the sea. The Himyarites lasted, despite a Sabaean revival and Ethiopian invasions, until the early 6th century AD. By tradition, Himyar was directly descended from Qahtān. Appropriately, the later Zaidi Imāms claimed direct descent from the last of the Himyarite princes. Most traces and artefacts found by archaeologists today are ascribed to the Himyarites. By AD 300, a Himyarite king, Shammar Yuhar'ish, had united the remaining extant kingdoms and took the title of King of Saba, Dhū Raydān (Raydān being the citadel of Zafār), Hadhramaut and Yamanat. These united territories would have approximated, less the north-west, to what constitutes the majority of modern Yemen.

There is little dispute among scholars that the name Hadhramaut is related to Hazarmaveth of the Bible (Genesis 10: 26; I Chronicles 1: 20). There Hazarmaveth is mentioned as a son of Joktan (considered the Yemeni Qahtān, though some dispute this), fifth in order from Shem, son of Noah. The followers of the Joktanite clan became known as

Stone depicting a bull's head, a common feature in Himyaritic sculpture, found on the ground at Sāri, near Baida.

Hazarmaveths, "Hadhramautis" as one might say today, though they are properly known as Hadhramis. A literal translation of the Arabic, *hadhr maut,* would be "presence of death", though that is probably coincidental. Whilst the overland trade was principally in the hands of the Minaeans and Qatabanians, Hadhramaut was one of the most important actual producers of frankincense and myrrh, other than Dhofar farther east. The kingdom's political origins go back to the early centuries BC, with its capital at Shabwa, where impressive ruins still stand. In the 3rd century AD it was finally conquered by the Himyarites.

We may digress briefly to query whether up to this point there had been any invasions of the country from outside Arabia itself. Whilst there was plenty of fighting between the various kingdoms as they sought to take over parts of their neighbours' territory, until the end of the 1st

century BC there is no recorded evidence of attempts to invade by foreign powers, least of all from Europe. Alexander the Great had nursed an ambition to invade the incense-producing lands of Arabia, but Arabs today jest that he just wanted to retire finally to the "Happy Land". His early death in 323 BC at the age of thirty-three, on his way back from his Asian conquests, forestalled the fulfilment of his dream. However, in 25 BC the Roman Emperor Augustus determined upon controlling the trade with the East and gaining the riches of south-west Arabia for Rome. Accordingly, in 24 BC he despatched an army under Aelius Gallus that landed at Leuke Kome, where stands the present-day Saudi Arabian coastal town of 'Aynūnah, north of Al-Muwaylih. The expedition was treacherously misled by its Nabataean guides before reaching Najrān, where they first encountered serious opposition. Their numbers had already been depleted by sickness. They continued south, capturing various cities, before laying siege to the city of "Marsiaba", probably Mārib. There, thwarted, they were forced to retreat. Even more men were lost to the harsh desert conditions during the long march back. On Gallus's eventual return to Rome with the remnants of his army, Augustus appointed him Governor of Egypt, where his career was recognized as being rather more successful than his Arabian adventure had been.

The gods of the South Arabian kingdoms were such as those of the sun and moon, as we saw from the Qur'ānic quotation at the start. But with the death of the Himyarite king, Shammar Yuhar'ish, in about AD 300, Yemen moved gradually into an epoch of rule by monotheistic regimes and intervention by outside forces, notably Christian Ethiopia and Sasanid Persia. In AD 356 the Emperor of Byzantium, Constantius, sent a mission to Yemen from Ethiopia under one Theophilus Indus as both ambassador and bishop. He founded churches in Aden, Zafār, Sana'a and Najrān. Whilst he is reputed to have been theologically an Arian,

Christianity in Yemen assumed a Syrian Monophysite character with large communities developing, especially in Najrān and on the island of Socotra. However, there is evidence that both places subsequently became Dyophysite Nestorian bishoprics.*

Judaism too spread on some scale in southern and western Arabia in the early centuries AD, though its adherents ascribe its origins to some centuries before. We shall deal with this important subject in greater length shortly. But of concern to us here is that in the third quarter of the 4th century AD the Himyarite elite itself abandoned the old gods and converted to Judaism, and introduced a mild form of monotheism as the state religion, as a means of uniting the country. In *ca.* AD 518 the Himyarite king, Yusuf As'ar, more commonly known in Arab tradition as Dhū Nuwās, "He of the Curls" (presumably a reference to his sidelocks, *zinnār*), declared war on the Ethiopians in Yemen and their Christian allies, and in AD 523 ordered the massacre of the entire Christian community in Najrān. The Christian king, or Negus, of Ethiopia, acting on orders from the Byzantine Emperor, invaded Yemen in revenge for the rebellion and massacre at Najrān and briefly took control of the country. The defeated Dhū Nuwās is reported to have ridden his horse into the sea in despair, never to be seen again. Thus perished the last of a long line of Himyarite kings. Yemen now fell under

* Arianism rejected the divine nature of Jesus and also the doctrine of the Trinity, and thus was closer to later Islamic doctrine about Jesus than were other Christian sects. Arianism was condemned as a heresy in AD 325 at the Council of Nicaea. Monophysites maintained that his divine and human natures were inseparably fused in the single person of Jesus. They rejected the orthodox doctrine determined at the Council of Chalcedon in AD 451 that within Jesus the divine and the human did coexist, but were so coherent that they could not be separated. Dyophysite or Nestorian Christianity maintained that in Jesus there were essentially two natures, one human and the other divine, and that they were separable into two persons; thus Mary could not be the Mother of God. Nestorianism was declared a heresy at the Councils of Ephesus and Chalcedon in AD 431 and 451. It continued to flourish in Syria, Iraq and Arabia. Its doctrine is somewhat closer to Islam than Monophysitism, and legend holds that the Prophet Muhammad learned about Christianity from a Nestorian monk from Syria named Bahīrāh.

the rule of the Ethiopians and their notable governor Abraha, an able despot who broke away from his masters and established his independence in Sana'a.

The early Muslim era

In around AD 570 the remaining Himyarites called upon the Sasanian Persians to expel the Ethiopians. The Persians in their turn introduced Zoroastrianism, though it never caught on widely. In AD 628 the Sasanian governor in Yemen, Badhan, was converted to Islam by emissaries from Medina. Yemeni tradition holds that the Prophet Muhammad, during his lifetime, sent his cousin and son-in-law, 'Ali, to Yemen. It was not long before the country became predominantly Muslim. In AD 657 'Ali, who had become the fourth Caliph, ordered that Yemen should be ruled by a single governor resident in Sana'a, an enactment that was implemented only periodically.

It is interesting to note that Muhammad eventually included the Zoroastrians as Ahl al-Kitab, "People of the Book", with the Muslims, Jews, Christians and Sabians (Mandaeans). His knowledge of their existence is most likely to have come from Yemen. It is also worth mentioning here that in 631, by which time the Christian community in Najrān had been restored, probably by Nestorians, they sent a delegation to the Prophet Muhammad in Medina, the year before he died. The Christian envoys were warmly welcomed and made use of his mosque to worship. However, in 635 the second Caliph, 'Umar, expelled the community from Arabia.

Under the Umayyads, who unilaterally moved the seat of the Caliphate from Medina to Damascus in 661, Yemen was ruled by governors sent from Syria. Similarly, when the Abbasids succeeded the century-long dynasty of the Umayyads, they ruled from Baghdad and

governors were sent to Yemen from there or Basra. Inevitably, the weakening of central Islamic power wrought by these changes brought about a concomitant confusion in the writ of Yemen's own rulers. Divisions began to occur around the country; we shall look only at the more significant ones. In about AD 820 the Abbasid Caliph, Al-Ma'mūn, sent a military commander, Muhammad Bin Ziyād, to quell a rebellion in the Tihāmah. He made his capital at Zabīd and founded the Ziyādid dynasty, which quickly imposed its sway over all Yemen, including Hadhramaut and Najrān, and shook off Abbasid suzerainty. Ziyādid power was broken in 994 by the egregious Isma'īli Qarmatians, whom we shall meet shortly.

Quite separately, in about 840, Ya'fur bin 'Abd al-Rahmān, who claimed direct descent from the Himyarite kings, overthrew the governor of Sana'a and ruled throughout the central highlands including Ta'izz. This Ya'furid dynasty was eventually recognized by the Abbasid Caliphate, but the Ya'furids shortly had to deal with a quite different newcomer from Basra, Yahyā bin Husain Al-Hādi, who became the founder of the Zaidi dynasty. And here we arrive at the line that was to last for the next one thousand years and more.

Essentially, two principal sects of Islam then evolved in Yemen which remain to this day. The first are known as Zaidis, who have ruled the country through their Imāms. The term "Imām" in Yemen refers to the ruler, rather than, as in Sunnism, a "religious dignitary"; the word means literally "in front", for example a prayer leader in a mosque. In mainstream Shī'ism it refers to the progenitorial line of Twelve Imāms, starting with Muhammad's son-in-law 'Ali, and ending with the twelfth who disappeared down a well in Samarrā north of Baghdad and went into *ghayba* (occultation) in about AD 870. Shī'is await his return to put the world to rights. The Zaidis are a breakaway sect from that line of Twelve Imāms. Zaid bin 'Ali, a younger brother of the fifth Imām, started

his own interpretation of Shī'a Islam in Basra. The sect is thus often known as "Fivers". As mentioned, one of his followers, Yahyā bin Husain, known as Al-Hādi, came to Sa'dah in the north of Yemen in 897 and promulgated this Zaidi exposition of Islam. They are considered the most moderate of the Shī'a (with the possible exception of today's Ismā'īli Aga Khanids), relying as they chiefly do on the earliest of the four Sunni *madhhab*s or schools of law, that of Abū Hanīfa (d. 767). Further, the Zaidis incorporate the teachings of the Mu'tazilites or rationalists, who accept, *inter alia*, that the Qur'ān was created for the age when it was revealed, as opposed to the orthodox dogma that it was uncreated and for all time. Perhaps even more pragmatically, the Zaidis place a liberal interpretation on the qualities required of their Imām. His being learned in religious matters and possessing physical prowess is considered more important than being in a strict line of succession. While primogeniture became the pattern for later dynasties, there is no direct line consequent on Al-Hādi.

Al-Hādi established an Imāmate for the Yemen which lasted until the final serving Zaidi Imām, Ahmad bin Yahyā, in 1962. Many Imāms during the previous years had been assassinated or overthrown. During all this time the Imāms have ruled variously from Sa'dah, Sana'a, Zabīd, Ta'izz and elsewhere, though Sana'a, with its central highland position, sits the most naturally as centre of government.

Most other Muslims in Yemen are Sunnis who follow the *madhhab* of Muhammad Idrīs Al-Shāfi'i (died 820). They are stricter adherents to the orthodox traditions of Islam. Known as Shāfi'is, they live mostly in the south and along the Tihāmah, where there are also a number of Sufi or mystical sub-sects.

Apart from the Zaidis, another breakaway faction from Twelver Shī'ism is the Ismā'īli sect. Struggling minorities are always of especial interest, and it is important to dwell on them for the moment as they

33

have played an important part in Yemen's history, and one especially interesting Ismā'īli sub-sect remains to this day. The Ismā'īlis are sometimes known as "Seveners", as the schism occurred after the death of the sixth Imām, Ja'far Al-Sādiq, in AD 765. In the straight Twelver line, Ja'far's successor was Mūsā Al-Kāzim, whilst others claimed it should have been his elder son, Ismā'īl. The main branch of Ismā'īl's descendants, which has continued to this day, are now known as Nizarite Aga Khanids, the present Imām, Karīm Aga Khan, being the forty-ninth in direct line from 'Ali, Muhammad's cousin and son-in-law. (They do not recognize Hasan, 'Ali's first son, as the second Imām, otherwise Karīm would be the fiftieth). But over the centuries there have, inevitably, been other divisions.

An early splinter movement in about 890 was known as Qarmati, or the Qarmathians mentioned above. They were exponents of a communalist and revolutionary movement of the peasantry and dispossessed that arose in Iraq and eastern Arabia, and discarded all the normal Islamic tenets such as prayer, fasting and pilgrimage. In 930 they even raided Mecca and carried away the Black Stone from the Ka'ba. It was twenty-one years before it was returned. Having rampaged through Yemen at the end of the 9th century, they ruled briefly from Sana'a and Zabīd, both of which they effectively sacked.

A more substantial early line of Ismā'īlis, known as the Fatimids, moves our focus to Egypt. Starting in AD 909, they conquered large parts of North Africa, moving from west to east. They arrived on the outskirts of what was to become modern Cairo in July 969 under the fourth Fatimid Caliph, Al-Mu'izz (Fustat on the east bank of the Nile was already in existence). Legend holds that he ordered an area to be roped off and hung with bells which the soothsayers were instructed to activate when the stars were in propitious alignment. Thereupon foundations for a new city were to be dug. Weeks passed until one night the bells rang;

crows had landed on the ropes. All looked up at the sky and there, unusually prominent, was the planet Mars, one of the Arabic names for which is *Al-Qāhira*. Thus was named the new city, in English Cairo. The Fatimids remained in Cairo for another two hundred years until Salāh al-Dīn (Saladin) conquered the city in 1171.

An early representative of the Egyptian Fatimids in Yemen, 'Ali bin Muhammad Al-Sulayhi, established a dynasty known as the Sulayhids which ruled the country from 1064 to 1138, initially from Sana'a and subsequently from Jiblah. His influence spread through much of Arabia. 'Ali's son, Al-Mukarram, was reputedly indolent but the dynasty flourished through his singularly attractive and energetic wife, Sayyida Arwā bint Ahmad. She outlived her husband by some fifty years. Highly popular and respected, she ruled the country until her death in 1138, which effectively marked the end of the dynasty. She was known generally as Queen Arwā – in a sense, a real Queen of Sheba.

Meanwhile, back in Cairo the main Fatimid line itself fractured following the death in 1101 of its ninth Imām (the eighteenth since 'Ali), Mustansir Billah. His younger son, Musta'li, seized power from his older brother, the rightful heir, Nizār, who was outside the capital hunting at the time of his father's death. This caused a major split in the Ismā'īli progenitorial line. That of Nizār (Nizaris) continued the lineage eastwards through Alamūt in Persia (the Assassins) and on to India, where they became today's Aga Khanids who, as mentioned, do not recognize Hasan as the second Imām following 'Ali, nominating his younger brother, Husain, in his stead. The Musta'li line, who do recognize Hasan, remained in Egypt until Musta'li's grandson, Al-Tayyib, went into occultation (a phenomenon repeated throughout Shī'ism). Al-Tayyib's followers were thus no longer direct descendants but *dā'is*, earthly representatives or missionaries. They became known as Tayyibis. After Salāh al-Dīn Al-Ayyūbi (Saladin) conquered Egypt, he took it upon

himself to reconvert the Egyptians from Ismā'īli "heresy" to Sunni orthodoxy. As a result the Tayyibis fled to Yemen and many thence to India where some Hindus converted to this new sect. Those Indian Tayyibis became known as "Bohras" from their predominant profession as traders.

To maintain chronology we must digress briefly from the fortunes of the Tayyibis. Following his conquest of Egypt, in about AD 1210, Salāh al-Dīn sent a military expedition to Yemen under his brother, Turān Shah. It rapidly conquered Zabīd, Aden, Ta'izz and finally Sana'a. For the next half century Yemen was ruled by the expedition's followers, who were known as Ayyūbids. In 1229, the sixth ruler in this line, Nūr al-Dīn 'Umar Al-Rasūl, declared himself independent, thus establishing the Rasūlid dynasty. Its two-hundred-year rule was one of the most effective in Yemen's history, renowned especially for its architectural, cultural and agricultural genius. Examples of the first can be found in various Yemeni cities to this day, not least Ta'izz.

Reverting to the Tayyibis, a further split in their ranks occurred in 1590 as a result of their following two separate *dā'is*. One resulting sub-sect, the more numerous of the two in Yemen, though conversely with fewer followers in India, is known as Sulaymāni. Their chief *dā'i* lives in Najrān (now in Saudi Arabia), the centre of the large Sulaymāni Bani Yām tribe. There he is known as *dā'i qabā'il al-Yam* (*dā'i* of the Bani Yām tribes). His *mansab*, or representative, in India resides in Baroda, from where he collects dues for the Yemeni *dā'i*. (The Bani Yām have, or had, a rather curious custom whereby a member leaving on a long journey sends his wife to the quarters of a friend who is expected to "take his place" until he returns.)

The other sub-sect comprises the Dā'ūdis, whose *dā'i* lives in Gujarat. Conversely to the Sulaymānis, the vast majority of Dā'ūdis are in India, with only a relatively small number living in Yemen. In all there are

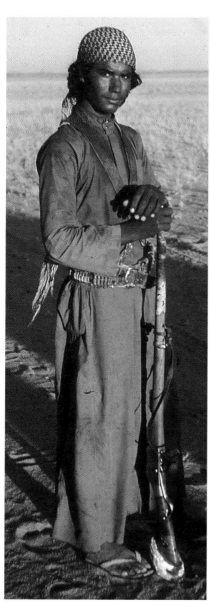

Sulaymani youth of the Bani Yām near Najrān. Note the ancient under-lever loading rifle.

thought to be about 80,000 Tayyibis of the two sects in Yemen itself. Most live in the Jabal Haraz area around Manākhah, where they are renowned for their hard agricultural labour. Others are scattered around the Hamdān district near Sana'a and in the vicinity of Yarīm. Against this, the total world population of Dā'ūdis is around half a million, mostly in India but spread also in Pakistan, Zanzibar, Tanzania and Kenya. Both subsects recognize the Tayyibi religious books produced before the split, but both have since been prolific in writing their own.

The Musta'lian (Tayyibi) Ismā'īlis in Yemen live separately from the Zaidis. Despite both being sub-divisions of the Shī'a, the Zaidis have treated Ismā'īlis generally with greater hostility than they have the Sunni Shāfi'is, sometimes describing them derogatively as "Qarāmita", Qarmathians. Given the periodic Ismā'īli insurrections against the Zaidi Imāms, this is hardly surprising.

I can conclude this section by recalling my meeting with the Indian Sulaymāni Bohra leader, *Al-Dāʿi Al-Mutlaq* (*Dāʿi* Absolute), as he was referred to in the Yemen media. When he made his official and well-publicized visit to Sanaʿa from Bombay in 1977, His Holiness Sultan Saif al-Dīn described himself to me as "the spiritual leader of the whole Sulaymāni Bohra community". It seems unlikely that such an event would have been possible in the days of the Zaidi Imāmate before the Republic. I recall too visiting a Bohra mosque in Penang, Malaysia, some years later. They were most impressed when I let drop that I had met His Holiness. I was told there were some forty Bohras living in Penang, mostly wealthy businessmen, thus living up to their name as traders.

The Jews of Yemen

Leaving aside the Zaidis for the moment, we turn once more to the Jews, that fascinating community that has survived in Yemen, despite periodic persecution, for centuries. I do this for two sound reasons. First, right up to their supposed final exodus in 1948–50, they were widely held to be the purest Jews in the world in terms of both lineage and religious observance. Second, the final section of this book comprises images of those remaining in Yemen, prefaced by my account of how I came to rediscover them and what I found. So this background is essential.

As we saw above, Jews are known to have existed in Yemen for centuries before Islam, in their own tradition as much as a millennium. But sorting fact from fiction remains a scholarly enterprise. Judaism was one of the proselytizing religions of the ancient world, and the Yemeni Jews could thus have been descendants of those originally converted by missionary rabbis. Their own stories of their origins in ancient Israel are possibly later inventions intended to explain their presence in Yemen and reinforce their solidarity as a distinct "people". The most popular legend

holds that they arrived in the 10th century BC in the wake of the Queen of Sheba on her return from visiting Solomon in Jerusalem. Another story asserts that they came around the same time as a result of the commercial and naval enterprises of Solomon and his ally, the King of Tyre, to Ophir, which some interpret as southern Arabia. But the strongest tradition among the Yemeni Jews themselves holds that they fled Jerusalem during the invasion of Judaea by Nebuchadnezzar, after the Prophet Jeremiah's warning of the forthcoming destruction of the Temple, thus around 597 BC. They believe that some 75,000 Jews retraced the steps of Moses and crossed the Jordan. Arriving in Edom, they turned south and continued until they arrived at a fertile and mountainous land, where they decided to establish a permanent home. This tradition further records that when Cyrus, King of Persia, liberated the Jews from their captivity in Babylon, Ezra instructed all the exiles to return and help rebuild their ruined temple. The Yemeni Jews refused, fearing a repeat of the earlier disaster, causing another exodus. Anyway, they were now settled happily in their new homeland, multiplying steadily, and had no desire to move.

An angry Ezra then placed upon them a curse that their days henceforth would be blighted, a spell that subsequent history suggests has proved effective. The Yemeni Jews in revenge refrained from naming their children Ezra. But despite their subsequent adversity, there is no country where Jews have preserved more effectively their culture and religion, the latter based almost entirely on the Talmud.

From the 4th century AD, under the Himyarite rulers who had converted to Judaism, the Yemeni Jews enjoyed special status, but that came to an end following the Ethiopian invasion in the 6th century. However, in contrast to the Hijazi Jews, after those of Medina failed to support Muhammad at the battle of Uhud in AD 625, the Yemeni Jews have survived and stayed the course. Indeed, they maintain that shortly

before Muhammad died in 632 he issued a decree via his son-in-law, 'Ali, that they were to be protected and their religious beliefs preserved, not challenged. The Yemeni Jews even give a date for this edict: 20 Ramadān 9 AH (AD 631). They were, however, obliged to pay the *jizya* (poll tax), the amount due depending on whether they were classed as "poor, average or rich".

It was not until the early 12th century that Yemen's Muslim rulers began to make life hard for the Jews. As a result in 1172 the great Jewish Spanish rabbi, Moses Maimonides, sent them his epistle, the *Mishna torah*. He called on them to remain steadfast and to be aware of false Messiahs, of which various had arisen. The Yemeni Jews were in fact yearning for a genuine one to lead them out of their misery. Whilst Zaidi Islam in the north remained basically tolerant, the Shāfi'i Sunnis and some extremist sects did attack certain Jewish communities. But the Jews remained resolute in not converting to Islam unless perforce through intermarriage or adoption. Later, from the 1850s, there were attempts by missionaries from Europe to convert them to Christianity. The Society for Promoting Christianity among Jews sent out men such as the Revd Stern, Dr Revd Joseph Wolff (an eccentric former Jew), and the American Revd Samuel M. Zwemer. The latter, visiting Sana'a in about 1890, found the city had forty-eight mosques and thirty-nine synagogues. However, these missionaries made little headway in their attempts at conversion.

Whilst their treatment has varied, over the centuries Yemeni Jews have lived under various restrictions lasting for the most part until, as then believed, their "final exodus". These embraced a prohibition on entering into any form of government service, including the armed forces, or acting as surety or guarantor even for one of their own kind. They were forbidden to carry arms or ride horses astride (this presumably to facilitate rapid dismounting in order to pay obeisance to

a passing Muslim). They were not allowed to build houses more than two storeys high, and their communities were normally limited to separate walled ghettos. But the most unpopular such edict stated that any child orphaned by a father had to be adopted by a Muslim and converted. Fortunately for them this was not always implemented.

Despite such restrictions the Jews, especially in the north, where they were known collectively as "Haidāns", were valued for their craftsmanship. They were accomplished metalworkers, armourers, gunpowder makers, tailors, shoemakers, stone hewers and builders. They were in demand especially as makers of window tracery, setting translucent alabaster into the apertures to admit light. This technique was used especially for windows facing south and west where the sun, shining through glass or open apertures, created an uncomfortable glare. The Jews were also valued as jewellers, crafting fine silver and gold ornaments worn by the Muslim women. Because nearly all such creative skills were in their hands alone, the Jews could not be spared, however despised or unpopular they might be. Even in the 1980s the government was providing those remaining in Raydah with silver, though somewhat debased, so that they could make gifts for official foreign visitors.

It is difficult to estimate the number of Jews in Yemen at any one time. In the mid-19th century Jewish intelligence put the number at 200,000, with 18,000 in Sana'a alone. The Ottomans at the end of that century estimated 60,000, but that was almost certainly too conservative a figure. The first migration of any consequence to reach Palestine was in 1881–82, facilitated by the reconquest of Yemen by the Ottomans ten years previously. The Jews were then able to make contact with their brethren in Constantinople, helped by the presence there of the eccentric mystic Laurence Oliphant, who sought the Sultan's support for settlement of Jews in the Promised Land. For those who did leave, the journey took eleven months: first by foot to Hudaidah, thence by ship

to Alexandria and then by another on to Jaffa. Some five hundred reached Jerusalem this way. A drought in 1907 caused a further exodus, and by 1911 almost another 5,000 had so emigrated. The period of the two world wars hindered any further significant moves. By the time the State of Israel was proclaimed in 1948, it was estimated that the Yemenite communities there totalled 35,000. In 1921 the Imām Yahyā had ordered that any further Jews who left should have their property confiscated, and in 1929 he forbade emigration altogether. This precluded the use of Hudaidah, so during this latter period most Jews wishing to leave made their way down to Aden and thence by ship up the Red Sea.

After the murder of the Imām Yahyā in 1948, it was hoped that his successor would take a more lenient view of Jewish emigration and a final exodus was planned. Pressure had been heightened by a malicious, and most improbable, story that some Jews in Sana'a had murdered two Arab girls and, in a ritual, thrown them down a well. A consequence of the rumour was a campaign of violence against Jews in the city. Further enmity was aroused by news of the founding of the State of Israel in Palestine.

The evacuation which did take place from 1948 to 1951 was known as "Operation Magic Carpet". It was co-ordinated by the United States and Israel with the administrative help of the British. The aspiring emigrés from all over Yemen first made their way down to Aden. There were some Jews already living there, as there were in Hadhramaut. In Aden they waited patiently in large camps, to be airlifted thence by a series of flights in US Skymaster aircraft, dubbed "angel's wings", to Lydda. The aircraft were able to carry 130 at a time, well above the average load, because of the emaciated state of their passengers. Whilst at the time it remained uncertain whether any Jews had been left in remote areas, it was described by the Israelis as "a total evacuation of Jewry from the Yemen".

Hopefully, this potted history will provide the necessary background for when we meet these Jews "in the flesh" in our final pages. While I may have been the first European to have designedly investigated and revisited them after their supposed total evacuation (a venture I undertook on my own initiative), and probably among the very few to have actually stayed in their homes, other explorers had come in the centuries before. The famous German explorer, Carsten Niebuhr, was the first to discover them, in 1759. Jacob Saphir, a Jerusalem rabbi who came searching for the Ten Lost Tribes, was followed in 1869–70 by Joseph Halévy, an Ottoman-born French-Jewish orientalist, and in 1883–92 by the Viennese Jewish orientalist, Eduard Glaser. All conveyed a picture of gloom and depression so far as Jews were concerned. Perhaps Ezra's curse had indeed continued to fulfil its malign intent.

The Ottoman Turks in Yemen

During Yemen's turbulent history there have been separate Ottoman occupations of the country. In 1539 a Turkish force landed in Hudaidah and managed after considerable opposition to install a governor in Sana'a, killing some 1,200 locals in the process. They were forced to withdraw in 1630. They returned briefly to the northern Tihāmah in 1849, but it was not until 1871 that they managed to rule Sana'a again. Towards the end of the century there were continuous uprisings of highland Yemenis against their rule. But in 1911 the Turks formally recognized the Imām as the secular leader of the Zaidi population. However, the Turks retained the right to appoint governors in the Shāfi'i areas. Following the collapse of the Ottoman Empire in 1918 they finally had to withdraw. But many individual Turks remained in Yemeni service, such as Freya's bandmaster friend whom we met earlier. The Ottomans left behind fine examples of their merchant houses in Mukhā, Hudaidah and Luhayyah. We shall see

some pictures of these later, but alas they are crumbling fast and soon little trace of them may be left. Turkish historians estimate that during the long periods of Ottoman occupation a total of some 70,000 soldiers were killed. Yemen was dubbed "the Turkish Graveyard".

Later 20th-century history

In 1933–34, a border conflict erupted between Yemen and Saudi Arabia and territory was ceded to the latter. Most significantly this gave Najrān, which Yemen had always considered its own, to the Saudis. It should be said that the Sulaymāni *dā'i* of the time, 'Ali bin Muhsin, the forty-fifth in their lineal counting, handled King 'Abd al-'Aziz with considerable tact, anxious as he was to avoid further conflict involving the Bani Yām. As a consequence, his successors spent much of their time trying to protect Yemen's Sulaymānis from Zaidi wrath.

In 1948 an uprising against the Imām Yahyā resulted in his murder, but the rebels, after destroying large parts of the capital, were defeated by his son Ahmad, who took his place. He extended Zaidi control over the parts of the country where it was weak or non-existent, and ruled with the iron hand of an absolute monarch. He established his seat in Ta'izz but travelled the country surrounded by his court. Having survived thirteen assassination attempts, he surprised everyone by dying peacefully in his bed, aged seventy-one, in September 1962. Republicans, who had long been waiting in the wings, seized power under a new President, Colonel Abdullah Sallal. They were supported by the Egyptians who, under the banner of Gamal Abdul Nasser's Arab nationalism, had their eye on driving the British out of Aden and the Protectorate. The Imām Ahmad's son and rightful heir, Badr, took to the mountains with his followers, known collectively as Royalists. They were supported in their eight-year war by the Saudis and others with a vested interest in preventing Yemen becoming

not only a socialist state, but also a vassal of communist powers. The large Egyptian forces were compelled to return home on the outbreak of the 1967 Arab–Israeli war. Meanwhile, in the same year the British hurriedly pulled out of Aden and the Protectorate having failed to crush local nationalist opposition and to set up a viable federation, effectively abandoning a newly independent South Yemen to a brutal socialist regime.

In the North, in November 1967, Colonel Sallal was deposed and replaced as President by Qādi 'Abd al-Rahmān Iryani, though in effect North Yemen was run for a number of years by a series of Consultative Councils. A peace treaty between the Republicans and Royalists was signed in 1970 providing for, in theory, a compromise joint government. In reality the Royalist element soon melted away leaving the Republican government intact. The Imām Badr and his senior entourage settled into peaceful retirement in Kent, in England – a far cry from the machiavellian environment of highland Yemen.

In 1973 Colonel Ibrahim Al-Hamdi, commander of the armed forces, became the effective ruler and remained as President until 1977 when, along with his brother, he was assassinated in an ingenious plot. A similar fate awaited his successor, Colonel Ahmad Husain Al-Ghashmi, the following year. Colonel 'Ali Abdullah Salih then assumed the Presidency and remains thus at the time of writing.

The two halves of Yemen, North and South, finally amalgamated in 1990. And that is where our brief history should end, for in these pages we are concerned only with a pre-1977 northern Yemen.

Geography

The pictures that follow are divided into four separate expressions of Yemen. Here we shall just summarize the physical geography of the country as a whole.

If one looks at a raised physical map of Arabia's entire rectangle one is struck by a thin elevated "L" running around its lower left hand corner. These are its high mountains, which occupy only some five per cent of the whole. But if one considers North Yemen alone (that part of the now unified country with which we are concerned), that "L" occupies some seventy per cent. It is those mountains, with their greenery, terraced slopes, precipitous gorges and perched villages, that make Yemen so topographically unique in the Peninsula, and, along with the mountains of Oman, recall most aptly those lines of Walter de la Mare's poem *Arabia*:

> They haunt me – her lutes and her forests;
> No beauty on earth I see
> But shadowed with that dreams recalls
> Her loveliness to me.

And it is the enchantment and drama of those landscapes that beguile so many of us into secret collusion with the sentiment in the final lines:

> Cold voices whisper and say –
> He is crazed with the spell of far Arabia,
> They have stolen his wits away.

Few countries, except perhaps Afghanistan, can have a more varied geographical make-up than Yemen. That central mountainous region traverses the country from north to south, and increasingly to the east, gaining its highest elevation towards the centre. Indeed sited at the highest point in all Arabia, at 3,760 metres (12,335 ft), is the supposed tomb of Nabi (Prophet) Shu'ayb, fifteen miles south-west of Sana'a. As late as March it can be covered in snow, as I myself have experienced. We shall see a picture of Shu'ayb's tomb later.

The slope on the eastern side of the central massif is more gentle than the escarpment on the west, and gradually opens out onto the great Arabian Desert that stretches to the Euphrates. The valleys on the western side, falling from 7,000 ft, provide the most fertile potential in all Arabia.

The approximately 30-mile-wide and 300-mile-long coastal region abutting the Red Sea is known as the Tihāmah. The name is supposedly Semitic in origin, meaning "deep". The locals say it means "hot earth". The 19th-century Arabic lexicon of the Revd J. G. Hava gives the meaning of the root letters as "exhausted – camel, to find unwholesome or suspicious". Territorially, for our purposes, the Yemen Tihāmah stretches from the Bab al-Mandab ("Gateway of Wailing" or "Gateway of Scars", perhaps because of the danger of shipwreck) in the south, to the Saudi Arabian border near Jizan in the north. But geographically the Tihāmah as a whole extends north into the Hijaz. Forming the eastern shore of the Red Sea, an extension of East Africa's Great Rift Valley, its flora and fauna shares much in common with Africa, as does the culture of its people, most obviously in their custom of building mud and straw circular and rectangular huts (‘ushshah, pl. ‘ushshāsh), as one sees on the African coast. Whilst some fruits and crops, including date palms and millet, can grow, compared to the interior it is relatively arid with high humidity and temperature. As the Umayyad poet, Jarīr, wrote:

> Let us enjoy the cool breeze of Nejd
> After we have suffered the smouldering heat of Tihamah.

The architecture of the Tihāmah, and its people with their more gentle way of living compared to their highland neighbours, are clearly portrayed in the pictures. And, despite Hava's Arabic derivation and Jarir's poetry, many visitors find it has a distinct, relaxing charm of its own.

Economy and agriculture

In the pre-Islamic era the economy was based chiefly on agriculture and on the trade in myrrh, frankincense and other aromatics, as well as spices such as pepper from India. The trade was based on locally grown frankincense and myrrh, and further profits were raised from taxes imposed on frankincense caravans passing through from Dhofar and Hadhramaut. A decline in this highly lucrative trade came as the sea routes began to replace the overland ones around the 1st century BC. A further blow was sustained when Christianity became the official religion of the Roman Empire in the 4th century AD, leading to a sharp reduction in the use of incense in religious ceremonies.

Trade in later centuries centred largely around the export of coffee from the Tihāmah port of Mukhā. This resulted in a brisk exchange with goods imported from Europe, India and the Far East. Whilst other exports included pearl and gold, imports embraced iron, steel, lead, guns and textiles. This trade was shared after 1600 chiefly by the Dutch and English East India Companies, and in the early 1700s by the French. The coffee trade has declined over the years since coffee trees, grown in the interior mid-highlands of Yemen and Ethiopia, were transplanted to other regions of the world. They have been replaced largely by *Catha edulis* shrubs, whose leaves are used for the mild stimulant *qāt*, and which require less maintenance than coffee trees.

Another aspect of Yemen's economy has been the export of its people. The country has a large population relative to the amount of food and other living essentials it can produce. This has resulted over the years in emigration to many parts of the world. As with the Lebanese, one finds Yemeni communities in parts of Europe, Africa, Asia and South America. They tend to live quietly within their own settlements. When I first went to Yemen, not long after the American moon landing, the

prevalent joke was about what Neil Armstrong really said as he stepped out onto the ground: "Good God, Yemenis!"

Emigration to Europe started soon after the opening of the Suez Canal in 1869. Many Yemenis found jobs as stevedores and below-decks firemen on ships that stopped at Hudaidah. Communities grew where the ships finally docked. In Britain that was especially in South Shields and Cardiff. I remember talking to Yemenis in South Shields many years ago and their asking my advice about buying a disused public house there, the *Hilda Arms*, to convert into a boarding house for visiting Yemeni seamen. And the Cardiff connection was brought alive for me when I made a three-hour hike to a remote Yemeni highland village, inaccessible to motor transport. I thought the inhabitants might be surprised to see a European; perhaps even their first. Meeting on the outskirts a middle-aged man I enquired after his health, hoping he would be impressed by my Arabic. He replied in a broad Welsh accent: "Fine and dandy thank you." It is estimated that some 50,000 Yemenis now live in the United Kingdom.

Highland Yemenis have also proved adept at working in the steel mills of Britain's industrial Midlands. They have a reputation as hard workers and being able to withstand heat. When I was living on the mountainous border of the former British Western Aden Protectorate, my house was a regular bed-and-breakfast stop for Yemenis from the remote neighbouring Upper Yāfaʿ Sultanate, not in fact part of the British administration. They were seeking overnight lodging on their way to, or from, their employ in the steel mills of Birmingham. I term all this as part of Yemen's economy because they are able to remit money back home far in excess of what they might have earned in their own country. And when they eventually settle back in Yemen, some receive pensions from their long-term employment abroad.

Subsistence agriculture occupies some seventy per cent of the

highland population. Crops grown include traditional grains such as sorghum (*dhurah*), bulrush millet (*dukhn*), maize and barley. Vegetables such as potatoes, including the sweet variety, carrots, onions, tomatoes, and others common in Europe, grow without difficulty, as do many temperate fruit trees such as apricots, pears, peaches, plums, pomegranates and walnuts. Grapes grow at altitudes between 6,000 and 8,000 ft, and date palms are seen both on the Tihāmah and in the foothills. The soil above 2,000 ft is conserved by elaborate systems of terracing representing

"… by an elaborate system of terracing."

thousands of years of labour, while fields in the lowlands depend on both monsoon rains and water channelled off uncultivated slopes and impounded by earth dams in the wadis. A growing problem in the future, especially with regard to the toilsome upkeep of the terracing, may result from the educated young having ambitions for higher-paid, non-manual work.

★★★

Both Freya and Alice have now decreed "That's enough", Freya adding "Thank goodness I didn't have to do that", whilst Alice, rolling her eyes, was rude enough to mutter "Too much" her way of warning me that this is far from intended as any sort of scholarly discourse. Both sense the reader is now impatient to see the pictures. But let us first dwell briefly on the history and detail of those remarkable screw-thread Leica cameras of which Freya and I were both devotees.

Introducing the world of Leica

THE EARLY screw-thread Leicas, so termed to differentiate them from later models with bayonet lens fixing, were the forerunners of quality 35 mm cameras. They were made in Wetzlar, Germany, a small town situated fifty miles north of Frankfurt. In 1849 the mathematician Carl Kellner founded a factory there for the manufacture of microscopes and telescopes. Ernst Leitz I (born 1871) later joined the firm and soon became its director. In the early 20th century, Leitz began to branch out and make cine-projectors. In 1911 he recruited Oskar Barnack, then working with the Zeiss company. Barnack had designed a small 35 mm camera which both he and Leitz were now keen to develop. The resulting protype sold initially in small numbers as there was some opposition from traditionalists who feared a loss of interest in their large-format plate cameras and associated film. But such opposition was soon dispelled by the high image quality obtained from these new 35 mm models.

The first such 35 mm cameras were made by Leitz in 1924, the factory now being run by Ernst Leitz II. They were introduced officially to the open market at the Leipzig Spring Fair the following year, during which 870 cameras were built. Initially, the cameras were engraved "Ernst Leitz, Wetzlar", the brand name "Leica" only being introduced a few years later. By 1930 the annual output had risen to 38,000, at which time interchangeable screw-thread lenses were introduced as an advance on the original fixed lenses. In a complicated numbering system, these screw-thread cameras carried the model numbers I, II and III, followed by a letter of the alphabet as that particular model was progressively modified. Thus a Leica I made in 1925 became a Ig in 1960. Similarly, the III series (the most common still in use today), which was started in 1933 as III, became IIIg at its finish, also in 1960. In 1954 the bayonet fixing lens was introduced as the M series, the idea being that it provided

a quicker change of lenses for users such as media reporters.

Leica aficionados, on being introduced to a fellow Leica owner, instinctively ask: "Are you screw-threaded or bayonet?" Possessors of the former feel rather superior, like the owner of a genuine vintage car as opposed to a later, post-vintage "classic" one.

By 1933, shutter speeds varied from one second to $\frac{1}{500}$ of a second and, by 1935, to $\frac{1}{1000}$ of a second. The actual lenses ranged from 28 mm to 135 mm for the screw-thread series and up to 800 mm for later ones. In total some seventy different types of lenses were made. The cameras have a complex window range-finder built into the body which can be used for any lens, whilst the built-in viewfinder is for 50 mm lenses only. A slide-in shoe bracket is on the top of the cameras to affix viewfinders for other lenses or various accessories. The total number of Leica accessories is unbelievably vast. Each one has a code word and a look through the list, starting with ABC00, passing through such as EQB00, LOOD0, UMD00, and ending with ZWT00, suggests there are a total of around 1,700 items. As an early guidebook remarks: "It would take the best part of a lifetime to become thoroughly acquainted with all the various accessories, not merely the different lenses."

Freya's Leica was a 1936 Leica 111a (no. 230857) which her memory tells her was bought in Berlin in 1933, but its number clearly dictates it was made in 1936 – either a memory lapse or she upgraded it a few years later. She always referred to it as "my little veteran". Like myself she preferred to use an early Elmar 35 mm/f.3.5 lens instead of the standard Elmar 50 mm one. That 35 mm lens has an astonishing depth of focus. Set at 3 metres at f11, everything is in focus from 5ft to infinity, thus enabling one to get clear images of both the near subject and distant background. When I carry both of my screw-thread Leicas, a 1938 111b and a 1951 111f, I leave similarly that Elmar 35 mm lens on the 111b and a more modern (1950) Summaron 35 mm lens on the other. Whilst

delivering a sharper image, the latter does not have that extraordinary depth of focus. Freya kept a yellow/green type "G" screw-in filter permanently on her Elmar 35 mm lens whatever the light conditions to enhance cloud and other effects. I later copied her.

Most Leica enthusiasts prefer to use a 35 mm lens in place of the standard 50 mm, which tends to give a squarer image. The only other lens Freya carried in her handbag was a 1933 Hektor 135 mm long-distance one. I carried that too, but in addition a 90 mm Elmar lens which served for mid-distance and portrait work. We both carried the universal multi-lens Vidom viewfinder for these alternative lenses. Whenever Freya approached a potential subject she would take this Vidom from her handbag, clasp it to her eye and compose, turning the milled ring on the finder from 35 mm to 135 mm until she found the composition to her satisfaction, then deciding which lens to use. The alternative to this Vidom is individual bright-line finders, which would, similarly to the Vidom, slot on to the camera. I found these gave an enlarged, clearer image and graduated to their use. But one had to carry individual ones for each lens; they were hard to find and expensive.

Although she never brought one with her on our travels, Freya told me that in the past she would set up her camera on a little tripod pointing towards a perfect setting. With a long extension-trigger lead she would, seemingly, be looking in the opposite direction as, say, a group of unveiled women came into view creating ideal foreground. I have experimented with a right-angle finder, whereby one is looking one way and the camera pointing another, but it is difficult to keep the image upright.

These early screw-thread Leicas were popular with other inveterate travellers such as the Swiss Ella Maillart and our own Wilfred Thesiger. But Thesiger later upgraded his to the bayonet "M" series. As a result I told him he was thus "expelled from the fraternity". The screw-threads

were also popular with war correspondents for their seeming indestructibility. One used to see pictures of such people with a battery of cameras round their necks, one of which would routinely be an old Leica. They reasoned that if they fell down a slit-trench following a tank, and everything went flying, the chances were that the only one still working would be the Leica.

Both Freya and I were singular in our determination to take only black-and-white photographs. Apart from the tonal range, use of light, shade and line, this medium, as we remarked at the outset, affords a more evocative image and a greater challenge to the viewer's imagination than colour.

When travelling in Hadhramaut Freya, as previously mentioned, would develop her negatives *in situ* lest the heat over a long period might affect undeveloped film. To do this, she carried a black light-proof film changing bag which in appearance resembles an old-fashioned pair of lady's knickers. The negatives would be printed professionally on her return home. We both preferred to use Ilford film. Although while in Sana'a I learned to both develop and print my own film, I was, and still am, a learner, and some of my resultant prints may have been affected. But it was a creative and relaxing sideline to my work. I made a dark-room in a roof room of my house and on some nights after dinner would go up there to work. As others will know, once in a darkroom one has no concept of time and becomes engrossed in creation. Thinking bedtime was due, I would clear and wash up, and go outside to discover not only that dawn had broken but, on occasions, it was almost time to go to the embassy.

I apologize to non-cognoscenti if they have struggled through the above detail. But to the keen photographer it may be of interest and, so far as I know, none of the countless books about Freya and her photographs have provided any similar detail about her camera and techniques.

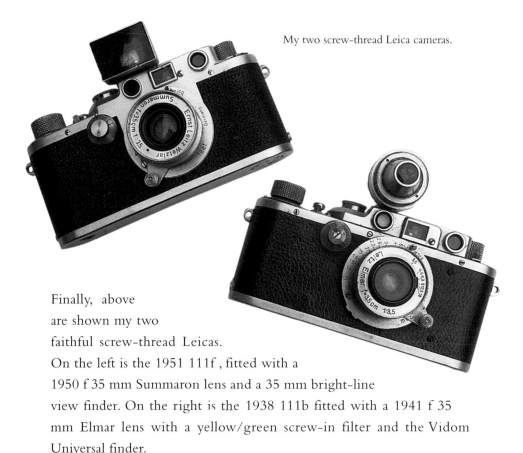

My two screw-thread Leica cameras.

Finally, above
are shown my two
faithful screw-thread Leicas.
On the left is the 1951 111f , fitted with a
1950 f 35 mm Summaron lens and a 35 mm bright-line
view finder. On the right is the 1938 111b fitted with a 1941 f 35
mm Elmar lens with a yellow/green screw-in filter and the Vidom
Universal finder.

And on the next page is an early leather Leica case for carrying
equipment in the field. It contains a variety of lenses including a 90 mm
Elmar, a 135 mm Hektor, a 50 mm Elmar and a rare 28 mm Summaron.
Also a Vidom, various bright-line finders, lens filters and lens hoods.

One of the early comprehensive photographic records of northern
Yemen was made by the German Jew, Hermann Burchardt, at the turn
of the 20th century. His photographs are held by the Museum für
Völkerkunde, Berlin. Alas, he and his companion Benzoni were killed
by brigands near Ibb in 1909. A few travellers may have made less prolific

My leather case with Leica equipment.

contributions in the final years of the 19th century. But the majority of the early photographers, such as James Theodore Bent and J. M. Molesworth, both in 1894, took scenes in the British-administered Aden hinterland Protectorates, where travel was safer. However, in 1911 and 1912, a Robert Deutsch took more than a hundred pictures of such places as Mukhā, Taʿizz, Jiblah and Radāʿ, all in the southern part of what was then Ottoman Yemen. And the Armenian Sarrafian Brothers, living in Beirut, published a set of sixty postcards depicting life throughout northern Yemen in about 1920. All these early photographers would have used glass-plate cameras.

Now to the pictures my own two little veterans have taken. It may be noted that there was never any use of flash, and that in every case (except for the initial montage of Sanaʿa) the camera has been hand-held. The selection is not designed as a condensed coverage of the various

regions. Rather they are chosen mostly as the sort of "portraits" Freya liked to take, avoiding where possible the inanimate, or illustrating some aspect mentioned previously in the text. The section on Sa'dah and the Jews includes, perhaps, some less-seen, even unique, images. Captioning the pictures has involved dredging up distant memories of some forty years ago. I hope and trust they have served me well, though there may have been the odd lapse in recall.

SANA'A

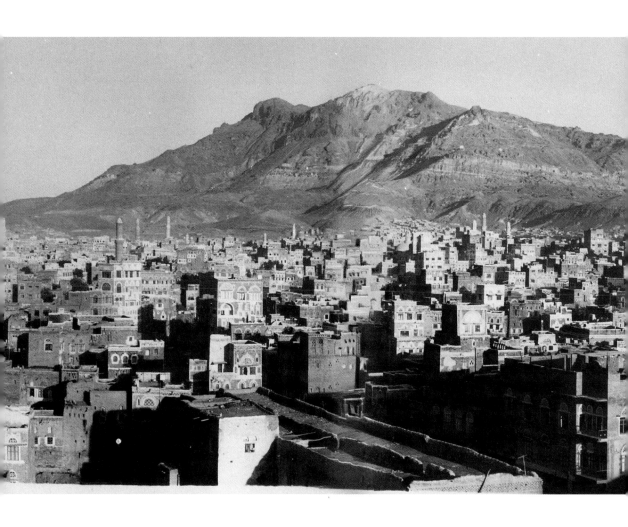

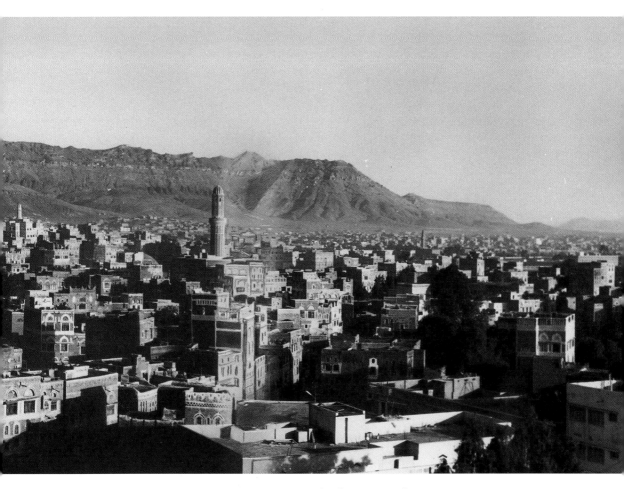

PANORAMIC MONTAGE OF SANA'A, looking east, from a series
of shots taken from the roof of the then American Embassy – a glorious
assembly of tall houses and even taller minarets. Jabal Nuqum, which
reaches over 9,000 ft, lies in the background.

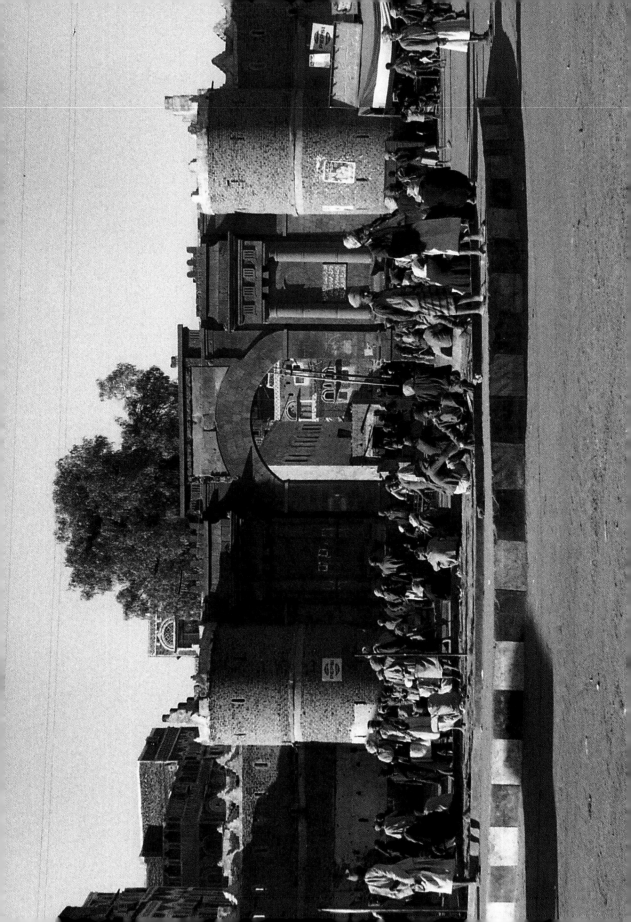

BĀB AL-YEMEN (Gateway to Yemen). A photograph, taken in 1970, without the foreground cluttered with lorries, cars and motor cycles – but not before Pepsi Cola came on the scene!

This is the only city gate that still survives intact. It was rebuilt in an Ottoman style by the Turks, first in 1870, and again in 1911 after being damaged in various sieges. In past centuries strangers to the city were only allowed to enter via this gate since it was believed to have special powers that would destroy anyone entering with evil intent.

THE AL-BAKIRIYYAH MOSQUE, with its seemingly leaning minaret, attached to the eastern wall of the city. It was built during the first Ottoman occupation (1538–1630) by the governor, Hasan Pasha. It was restored during the second occupation in the 19th century. The style is entirely Ottoman, except for the minaret which belongs more to the traditional patterned brickwork of the Yemeni Sanaʻa mosques.

Following page SANAʻA. A view of the eastern wall showing the Al-Bakiriyyah mosque to the right and the minaret of the Salāh al-Din mosque in the centre. Note also the old Ottoman barracks, Al-Urdi, the long single-storey building with its regularly spaced windows. Jabal Aybān is in the background.

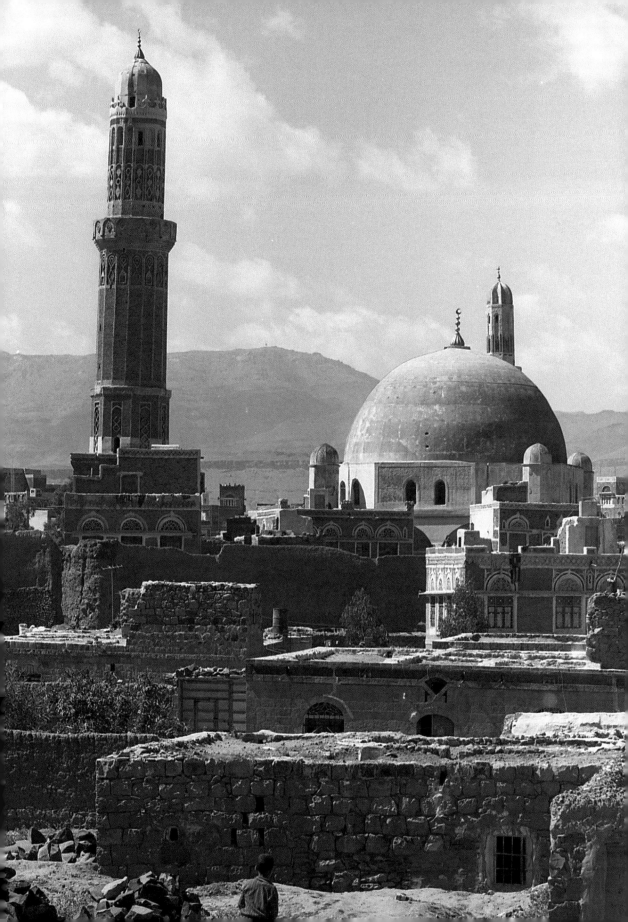

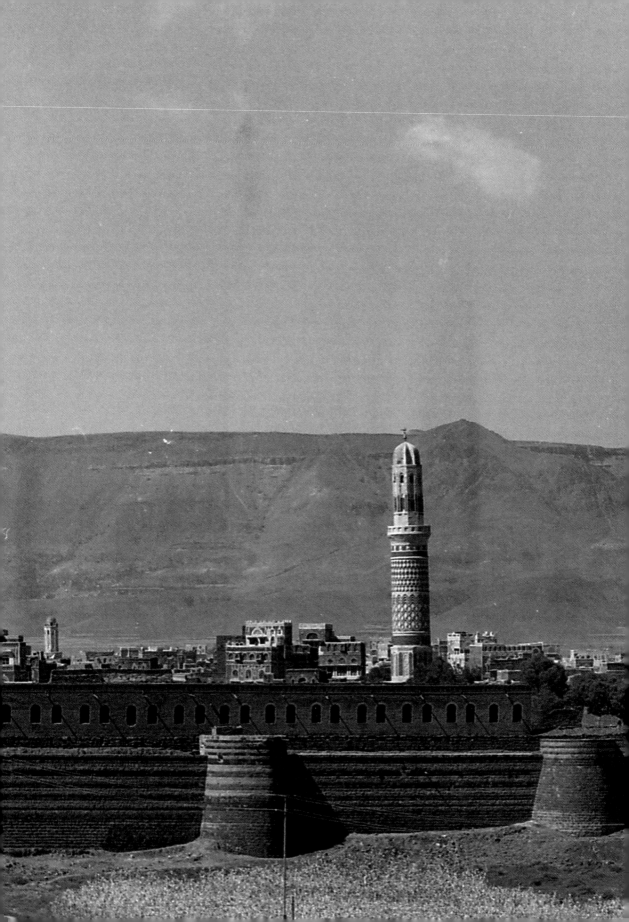

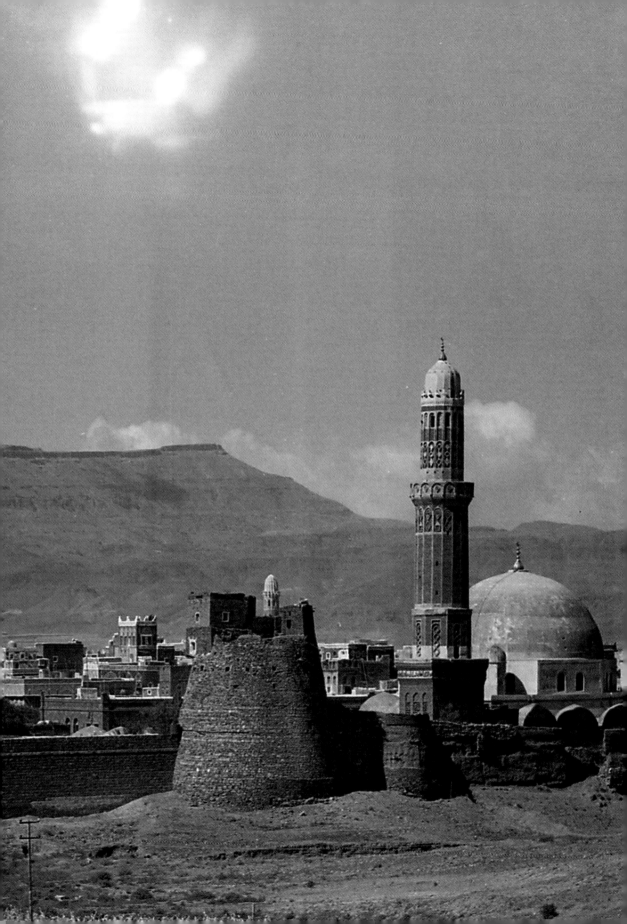

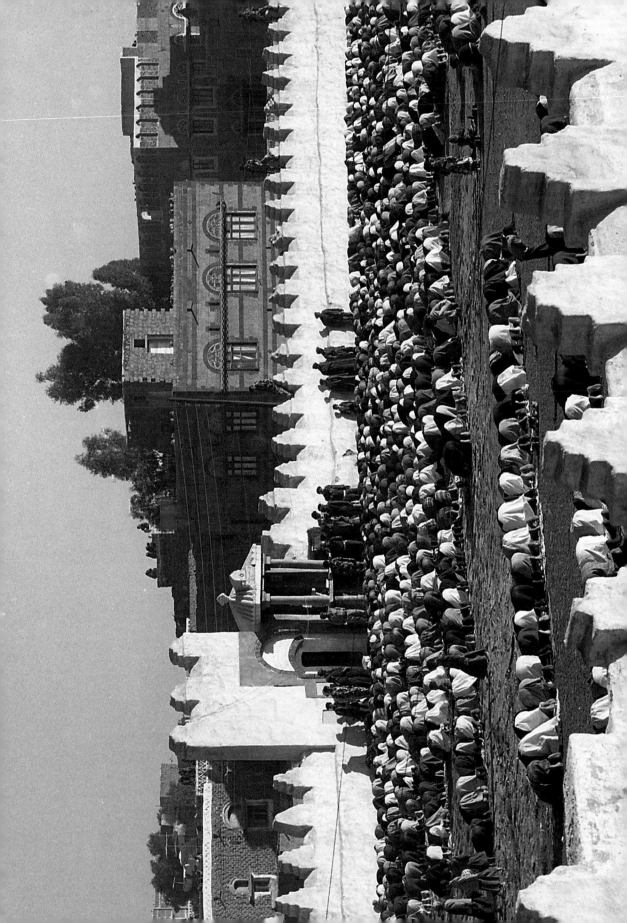

THE OPEN-AIR AL-JABBĀNAH MOSQUE, lying on the northern edge of the city, is traditionally used for communal prayer gatherings, especially the two main 'Eid festivals of *'Eid al-Fitr* and *'Eid al-Adhā*. It was built originally during the lifetime of the Prophet Muhammad but since extended, most latterly in the mid-20th century by the Imām Yahyā. The *mihrāb* itself was rebuilt in 1968.

This picture shows the *'Eid al-Adha* prayers being led by President Ahmad Husain Al-Ghashmi in 1977, shortly after the assassination of his predecessor, Ibrahim Al-Hamdi. There was still considerable tension in the city: witness the number of soldiers standing guard at the front.

SANA'A. A typical vignette of the old city which so often appears as a crowded jumble of tall houses and even taller minarets. The minaret here is that of the Salāh al-Din mosque, which we saw previously, the tallest and finest in the city. It was added to the mosque by the Ottoman governor of Sana'a, Sinan Pasha, in the late 16th century. On the top of the fluted dome is a bronze weather vane in the form of a dove or pigeon. We can also see, even in this small area, some good examples of the fine gypsum stucco work and tracery window patterns.

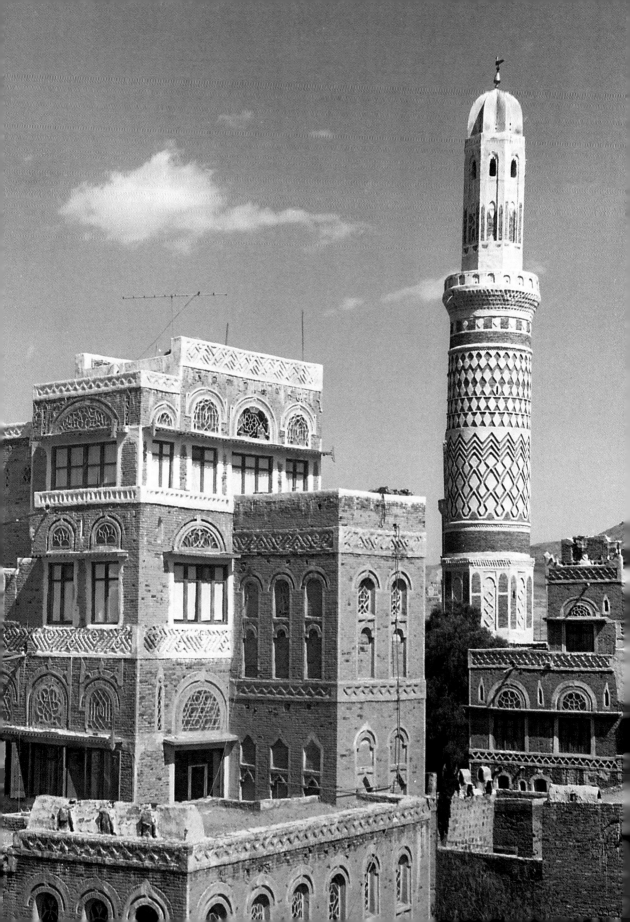

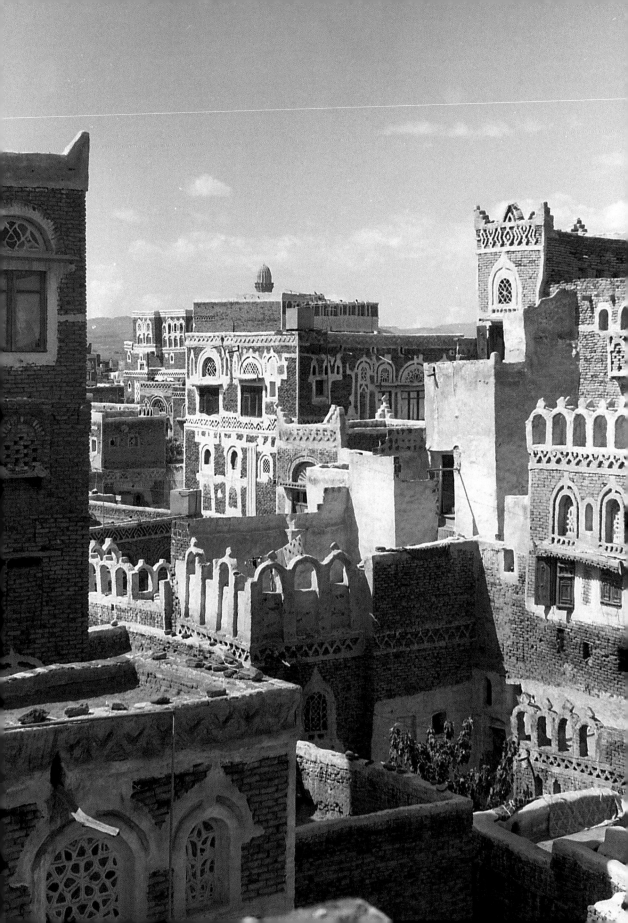

SANA'A. Another view across the old city showing a variety of window styles. The size reflects the amount of light required for the room, depending on its use. For example, a *mafraj* (sitting room) would have large windows, whereas rooms used for domestic purposes had smaller ones. The flat roofs are also sometimes used as a *mafraj* in the summer. The small open courtyards with the arch-topped walls, *hawi* or *hawsh*, are secluded areas for the use of women.

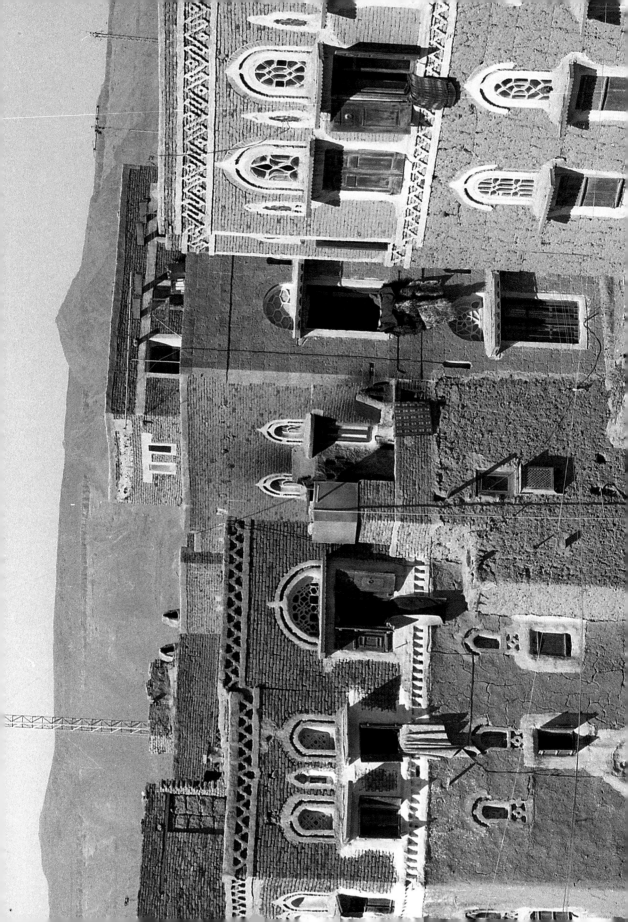

SANA'A. A more domestic view of the old city: bed linen and carpets being given an early-morning airing. Note the modern intrusions such as the television aerial and water tank, disturbing an otherwise centuries-old unchanging scene.

SANA'A. A girl standing in a back-street doorway. Note the faint patterns and inscriptions on the inside of the wooden shutters.

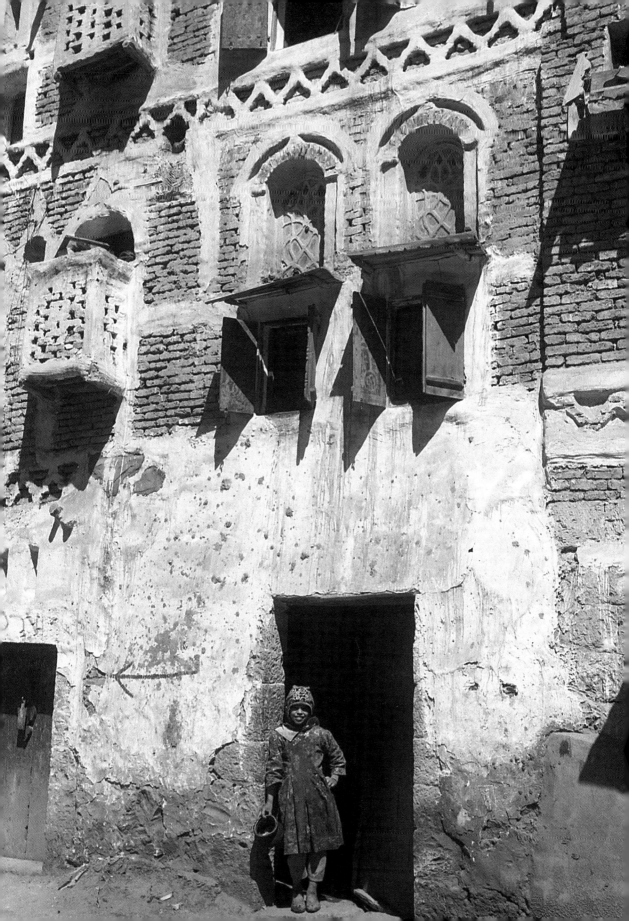

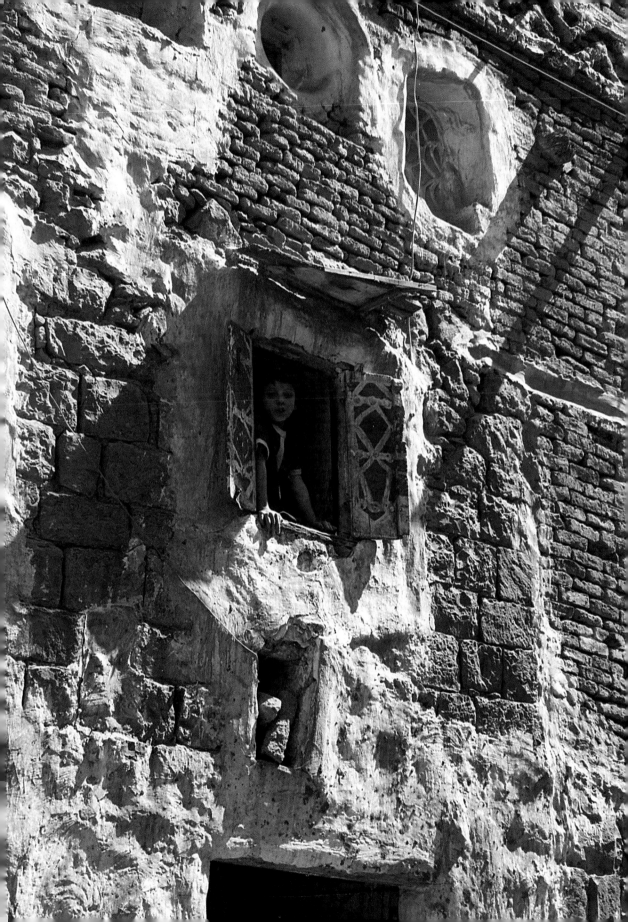

Opposite SANA'A. Girl at an upper window of a back-street house. Note the rather crude decoration on the inside of the wooden shutter. Every home, however poor or simple, has its maximum possible interior decoration.

Below SANA'A. Two pretty young girls. The one on the left wears a *qarqush*, a bonnet made from a square piece of cloth which can be folded so that it comes to a point at the back and can then be folded under the chin. Traditionally, under Zaidi law, a girl can be married at the age of nine, but this *qarqūsh* is always discarded on the night prior to her wedding to indicate that childhood has come to an end.

The girl on the right wears a common type of patterned dress. Whilst some patterned cloth such as this, with large irregular patterning, was made locally, especially in the Tihāmah, today it is imported.

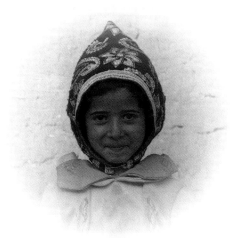 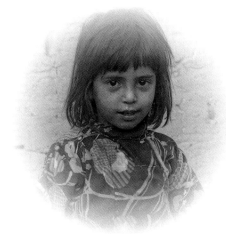

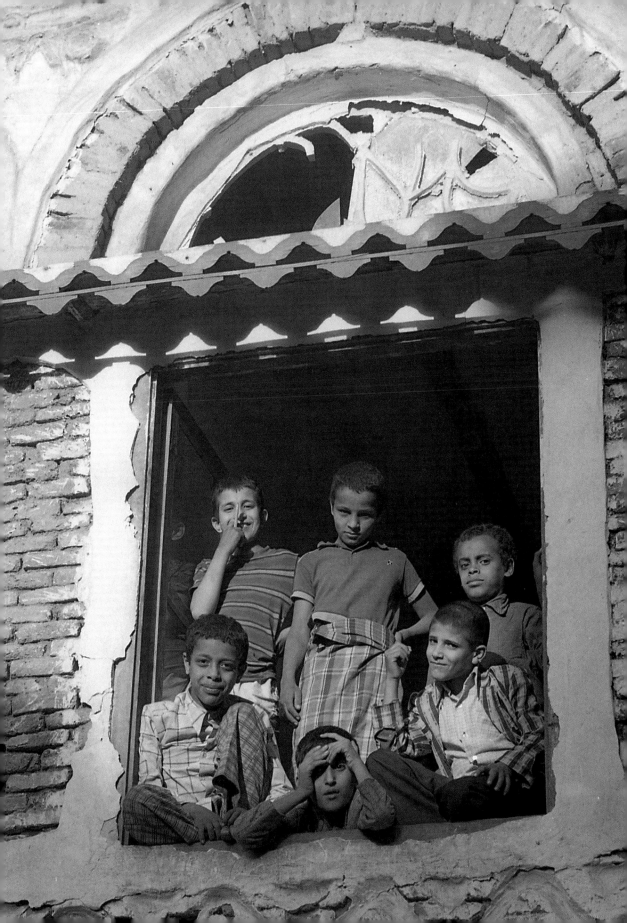

Opposite SANA'A. Young boys gathered at an upper window of the "Boys' Reformatory". Despite the cheerful and innocent look on some of the faces, several are incarcerated for serious, near homicidal, crimes

Below SANA'A, THE *SŪQ* at night. A bespectacled shopkeeper, his left cheek bulging with *qāt*, puffs on his hookah water tobacco pipe, or *huqqah* (also known variously as a *shūshah*, *narghīlah* or *mudā'ah*.) With his glazed eyes he seems to have gone into a typical *qāt* "oblivion" or trance.

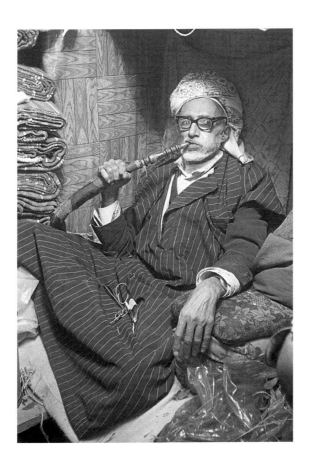

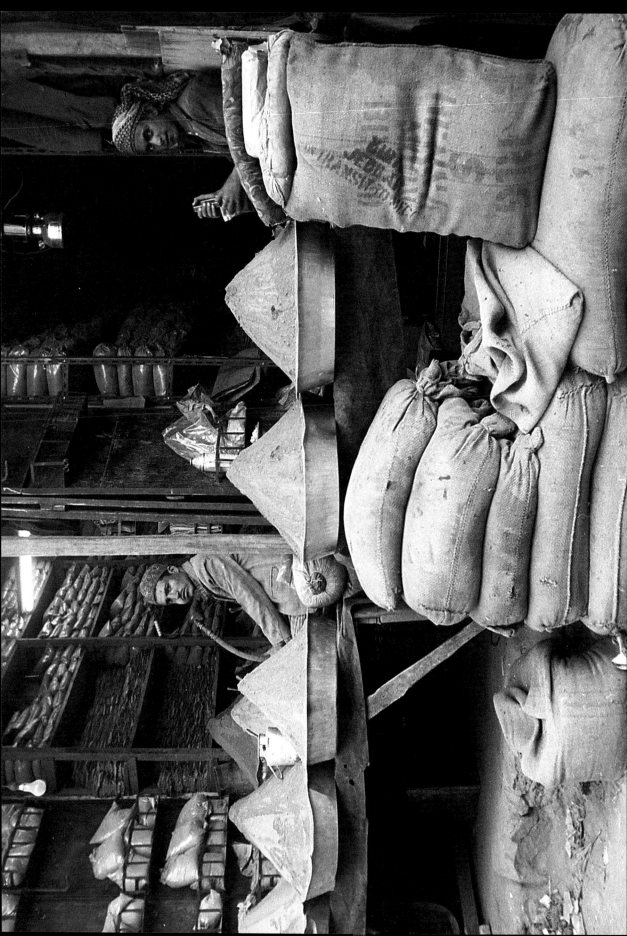

SANAʿA *SŪQ*. Two adjacent grain shops at night, the owner on the left enjoying his evening *qāt* session after a long day. Whilst *qāt* sessions are normally held in communal afternoon gatherings where the day's gossip is exchanged, if perforce the place of work cannot be left, imbibing can be solo and *in situ*.

OUTSKIRTS OF SANA‘A. A grandfather carries a sheep across his shoulders, his son, on his right, having dropped his black one, and his grandson on his left thinking it all a great joke.

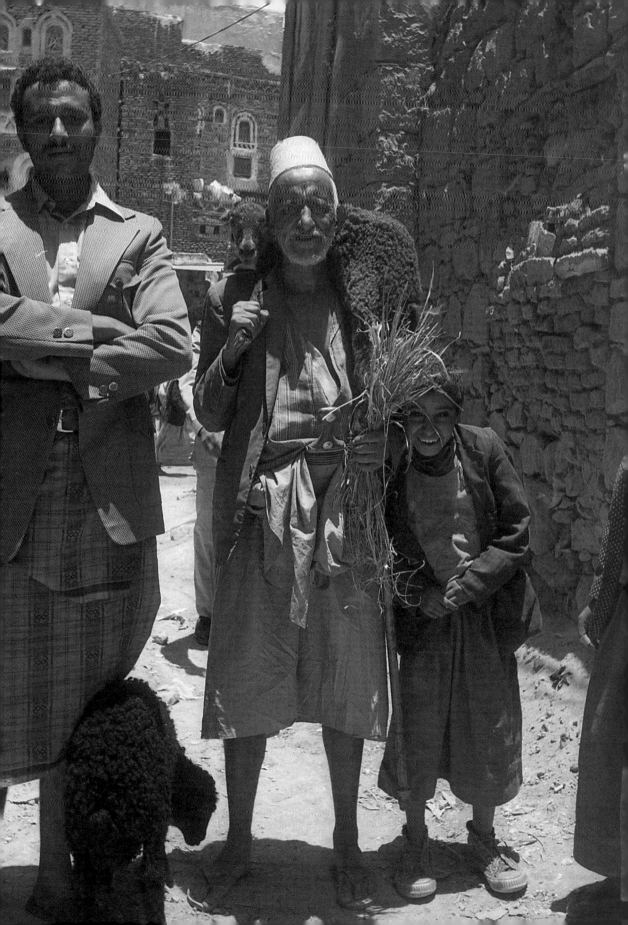

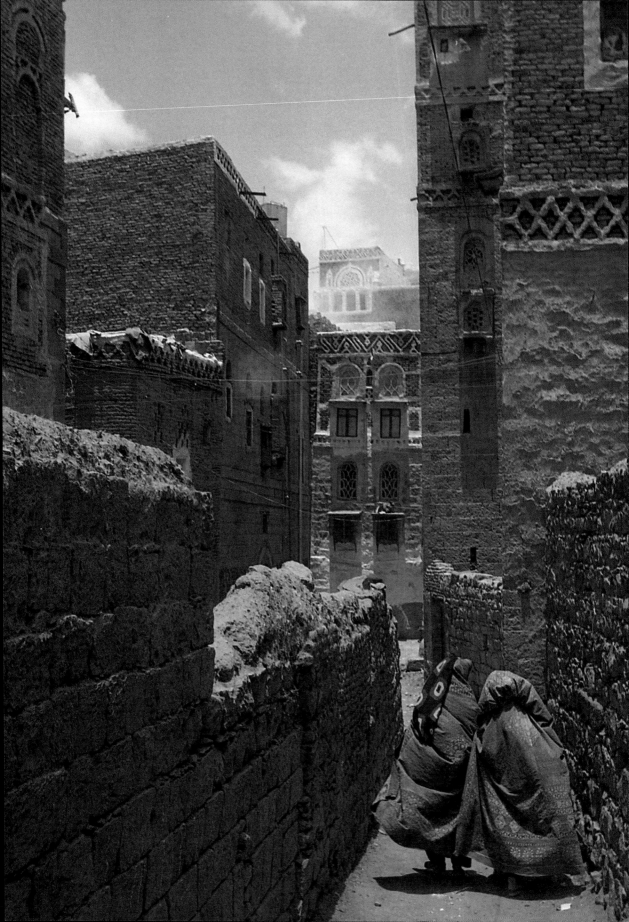

A SANA‘A SUBURB. Two women with billowing *sitārah*s (outer cloaks) walk down a narrow street. The large pattern seen on the shoulder or face scarf (*maqramah*) of the woman to the left, and the design on both of their *sitārah*s, is typical of that found on women's clothing in the highlands.

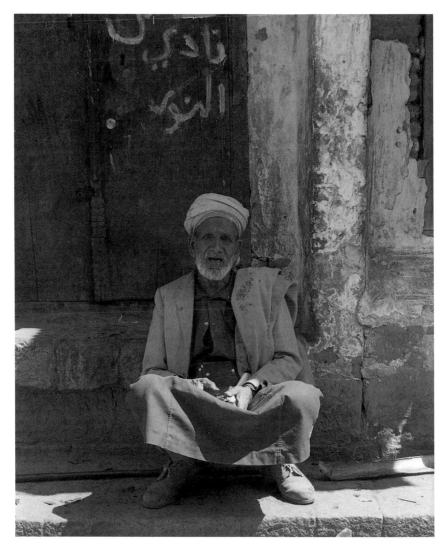

SANA'A. An old man sitting on a step outside a closed shop. The writing on the door proclaims "Long live the Club of Light", *Nādi al-Nūr*. It seemed unlikely he was waiting for some sort of night club to open! It is the name of a local football team and the graffito is calling for its support. Another local team is Nādi al-Salām, the Peace Club.

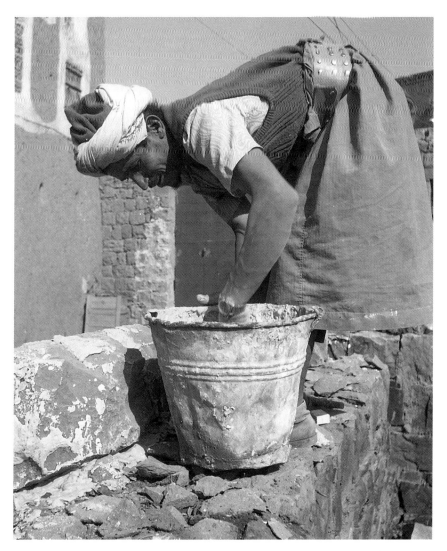

A SANA'A BUILDER mixes cement in a bucket prior to laying an additional brick layer. As will be appreciated from looking at these photographs of Sana'a, Yemenis are amongst the finest builders in the world. Most will have been apprenticed to a master builder for at least ten years.

SANA'A. A girl empties dung (*damān*) from a wheelbarrow in a poor mud-brick area north of the Bir al-Azab quarter. It is not clear whether the dung is from cattle or accumulated human night soil, which is dropped into pits in the lower storeys of some houses. It appears here that the dung is to be mixed with straw and then probably used as manure in small walled gardens of fruit trees. A class of Yemenis employed in dung removal are known as *dimmainah*.

Circular dung cakes made from camel droppings are brought to Sana'a and other highland towns from lower regions and sold as fuel.

The type of tower (generically *burj*) seen on the left is known as a *nūbah*. The square accommodation room atop has been added to the original. These cylindrical buildings were considered more stable than normal flat-sided ones. They may have been introduced by the early Ottomans.

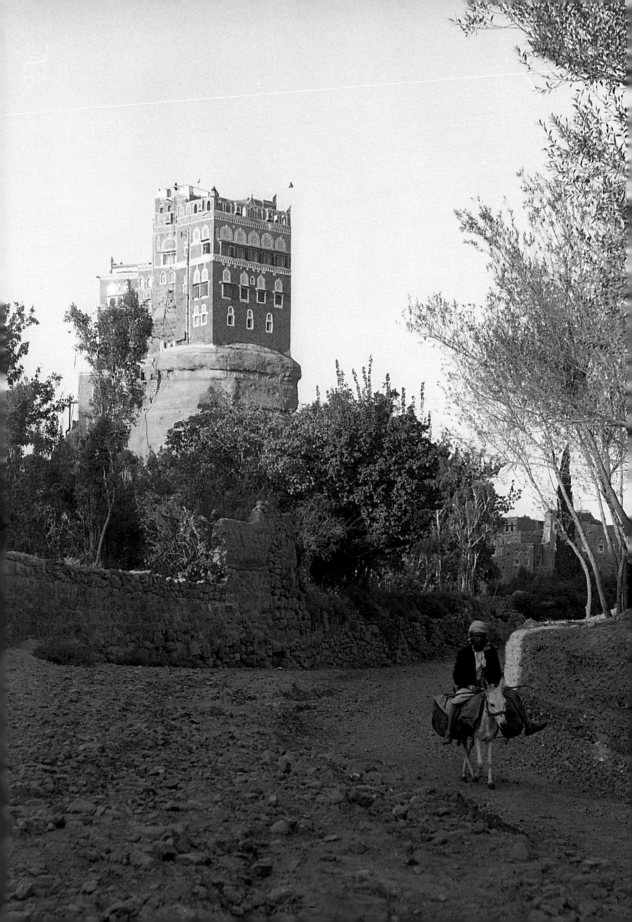

DAR AL-HAJAR in the Wadi Dhahr (lit. the back or rear wadi), some six miles north-west of Sana'a. It was built originally in 1786 by the Imām Mansūr 'Abbās, and was subsequently extended for use as a summer palace by the Imām Yahyā in the 1930s. Today it is used variously as a government guesthouse or conference centre.

Following page THE WADI DHAHR. A broad view showing the relative position of the Dar al-Hajar. Engravings and inscriptions found in the wadi suggest that it has been inhabited since very early times, perhaps even as early as 4000 BC. Today, whilst well populated, it is still valued for its quietness, its clear streams running through and its wooded fruit plantations. However, the wadi is liable to flooding, as occurred in 1975 when several lives were lost.

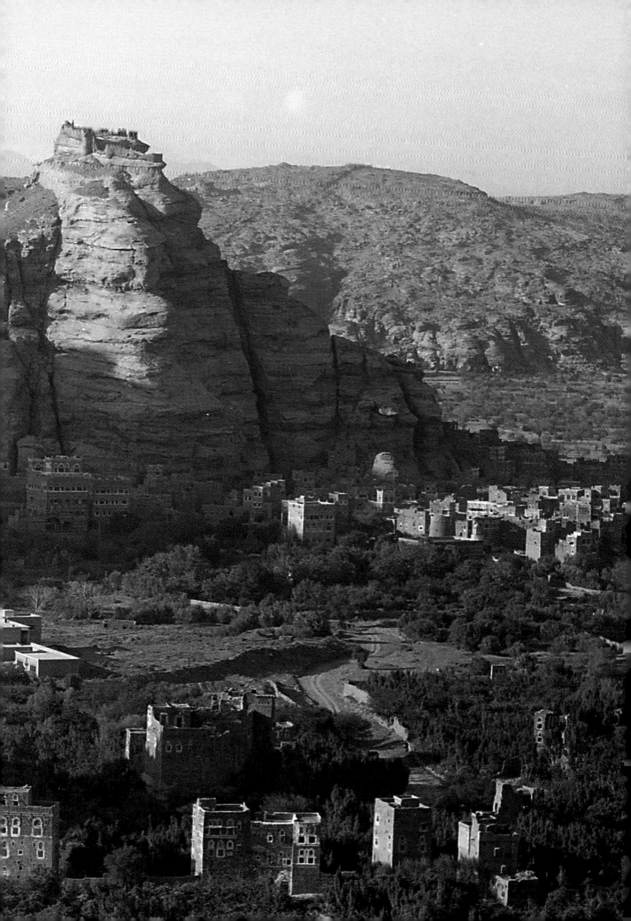

THE CENTRAL HIGHLANDS

THREE BOYS on the edge of the escarpment near the summit of Jabal Al-Nabi Shu'ayb, well wrapped up even at the height of summer. As in all mountainous climes, the weather is subject to sudden change. Both this and the following picture were taken on earlier climbs to the summit.

Sana'a 26 March 1977

My Dear Freya,

Today was a holiday and with the sun shining bright I decided to tackle the eastern, and more difficult, route to the top of Jabal Al-Nabi Shu'ayb, at over 12,000 ft the highest point in Arabia. This eastern route was longer than I thought and took me nearly three hours; only two by the direct one. Just as I reached the tomb of the Nabi, a rough stone building with a domed roof, a storm, the like of which I have not seen in all Arabia, struck. Thunder, lightning and then astonishingly a mixture of hail storms and snow to a depth of some four inches. I took refuge with the Nabi and donned all the clothing I had brought. Maddeningly, I had omitted to bring my camera; I am unlikely to record such a scene again. Had I sent you a photograph you would have assumed I was enjoying a holiday in the Alps. Then the clouds descended and enwrapped all. I debated whether to spend a night with the Nabi or risk a descent. Using my prismatic, I decided on the latter and slipping and sliding in the ice for the initial 1,000 ft I eventually reached Al-Da'ir where the faithful Mubarak was waiting. ... As a fellow mountaineer I thought you might enjoy this shred of vicarious travel ... We look forward to your return in the autumn.

Until then, best love from Hugh

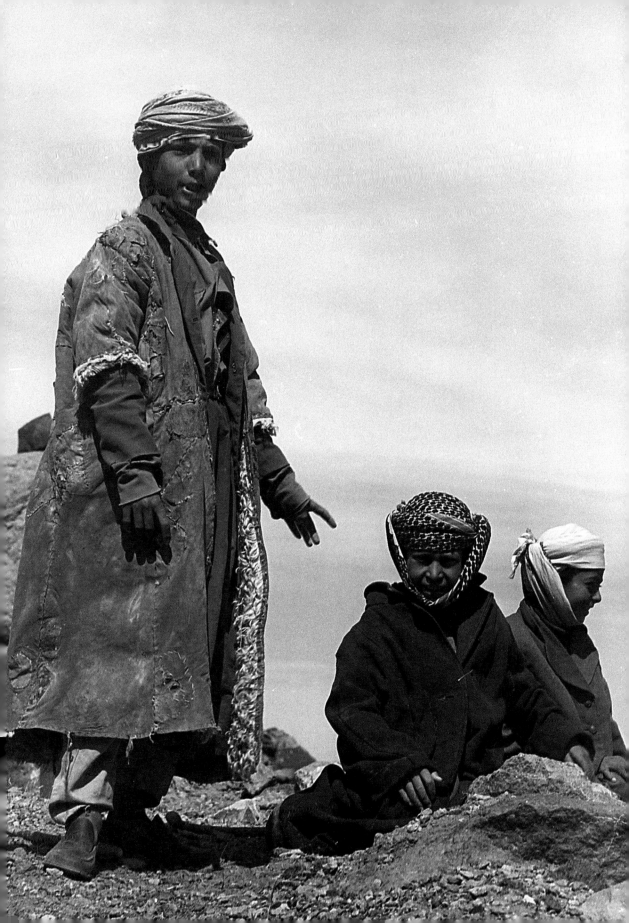

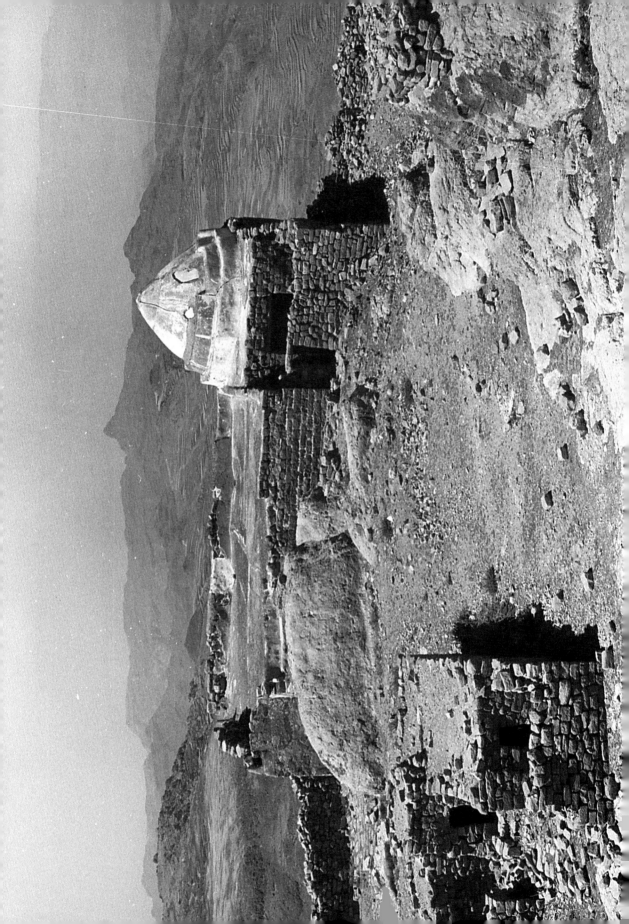

THE TRADITIONAL TOMB of the Nabi (Prophet) Shu'ayb on the summit of the *jabal* of that name, at 12,335 ft (3,760 metres), and 15 miles south-west of Sana'a. Shu'ayb is one of only three Arab Prophets, other than Muhammad, mentioned in the Qur'ān. The other two are Sālih and Hūd, whose tomb is in Hadhramaut. There are three references to Shu'ayb in the Qur'ān (VII, 85–93; XI, 84–95; and XXIX 36–37). All relate to his being sent to the People of Midian (in the extreme north-west of the Hijāz) warning them to mend their ways and follow the true God. They rejected him and were struck by an earthquake. Some exegetists identify him with Jethro, the father-in-law of Moses, who was a Midianite. Others repudiate this. And there is debate in learned circles as to whether this is the tomb of the Shu'ayb of the Qur'ān or of a lesser-known local oracle. If the former, his final resting-place is a long way from his earthly activity.

Asolo 13 April 1977

My Dear Hugh,

You kept me riveted by your glorious climb. I enjoyed it almost as much as if I had been there – and thirty years younger. I can quite feel your sort of panic when nature suddenly shows what she can do if she tries ... I think a descent from an unknown mountain in bad weather is one of the most frightening things ... Thank you so much for describing it all to me; it is lovely to be allowed to share ...

Love from Freya

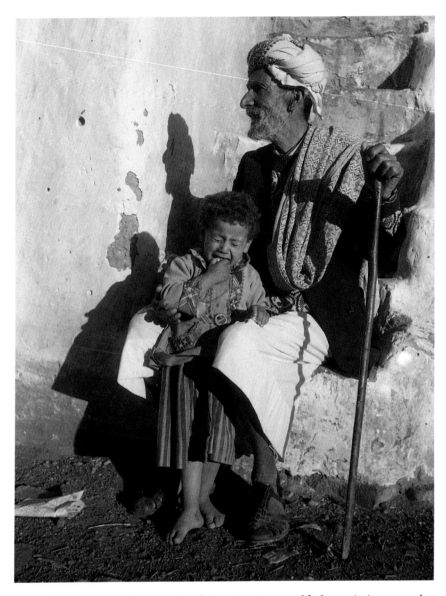

RAWDAH, six miles north of Sana'a. A grandfather, sitting on the
bottom of the steps leading to his house, consoles a weeping grandson,
who is unassuaged by the offer of a biscuit.

THE CRUMBLING RUINS of old Rawdah, north of Sana'a. Ironically, the nearby modern town is a sort of "commuter belt" garden suburb of the capital, where rich merchants have built grand houses to which they retire after a day's work.

RAWDAH. A defensive *burj* or *nūbah* on the outskirts of the town, with a later dwelling added on the top. The long shadows testify to the picture having been taken as the sun was setting. One can see the more modern residential quarter beyond.

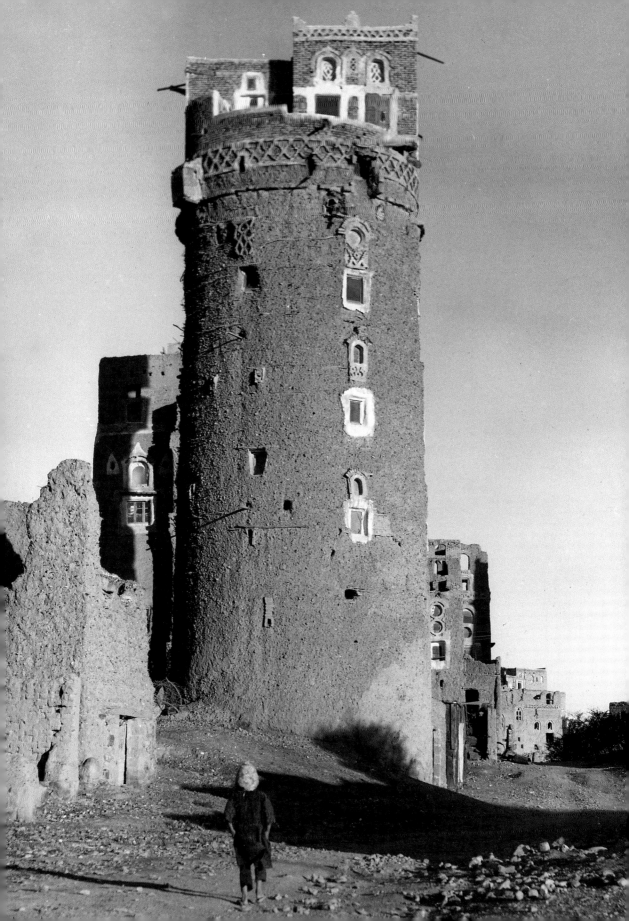

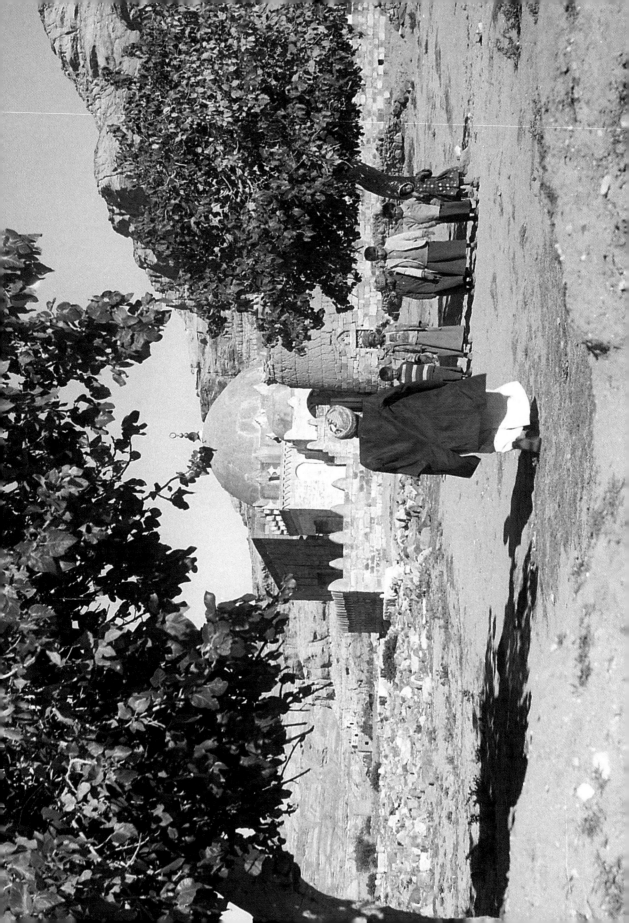

AL-GHIRĀS, ten miles north-east of Sanaʻa.

"Waiting for father". Children line up to greet their father outside a tomb, *qubr*, pl. *qubūr*. Such individual, often domed, tombs are the burial places of local prominent Muslims. They become centres of pilgrimage or visitation, *ziyārah*, especially on a specific day. They can also be used as places of prayer at any time. Very often, as here, graveyards are situated alongside.

The tradition of tomb or *wali* (saint) worship is much more common in the Tihāmah, as we shall see, than in the highlands, where the more orthodox at least might frown on such a practice.

AL-GHIRĀS. Three women, one carrying her child, on their way to visit the same shrine at Al-Ghirās. As this picture was taken shortly after the previous one, it may have been the specific day for pilgrimage at this tomb, or else it is perhaps just a popular local shrine.

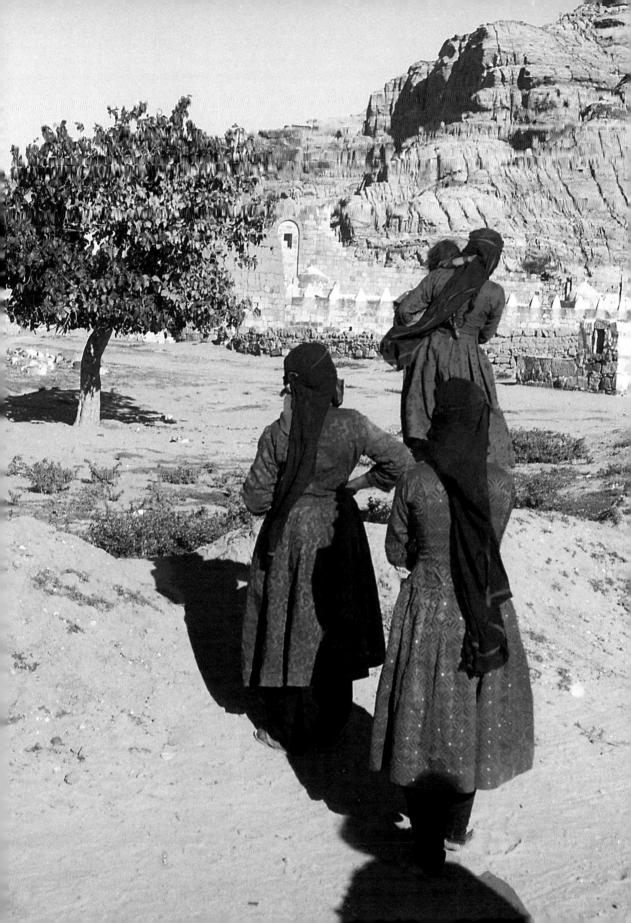

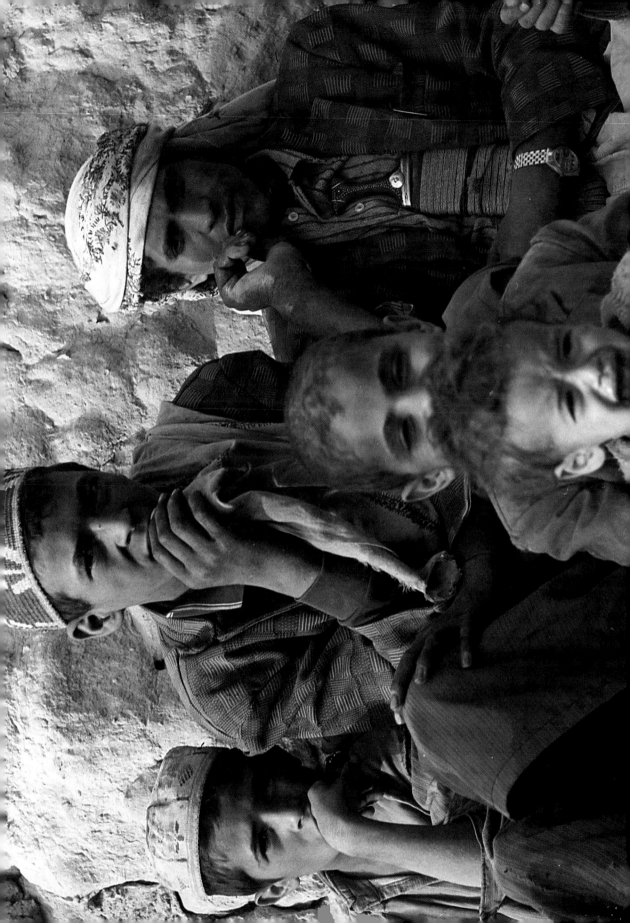

WADI BANI HUSHAISH, near Al-Ghirās. A group of thoughtful-looking boys ignore their weeping charge; they appear to be far too engaged in planning some sort of mischief! Highland youths tend to be of a more serious mien than their Tihāmah counterparts, as we shall see.

111

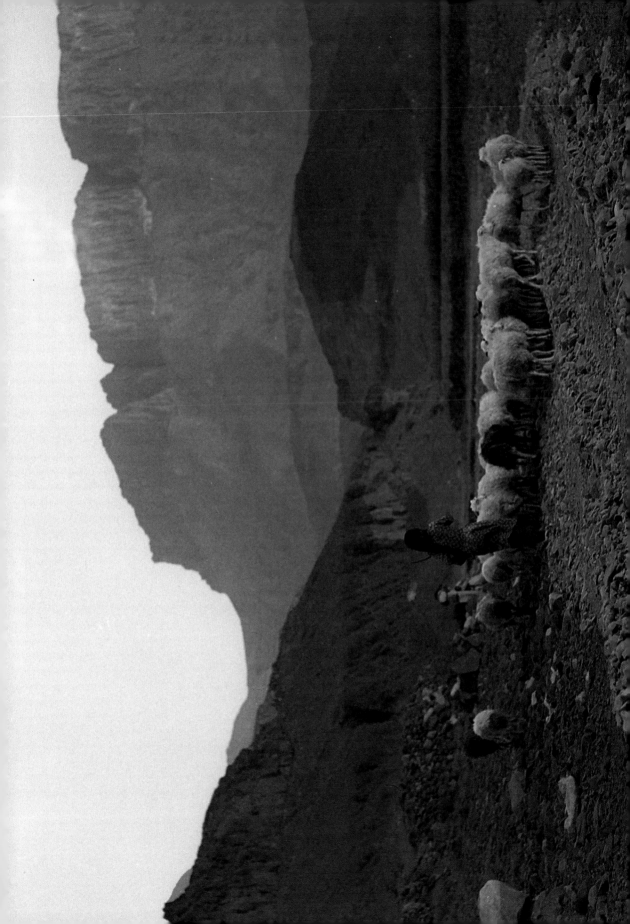

WADI BANI HUSHAISH. A young shepherdess minds her flock, with Jabal Sirr in the background.

Sheep are reared as milch animals as well as for meat and wool. The lambing season is in early summer. They are sent out to graze with hireling shepherds, usually the women of the house, during the day and, in the highlands, driven into the ground-floor rooms of the house at night. Most Yemeni sheep are of the fat-tailed variety. As can be seen, grazing is scarce and illness, even death, can be caused by eating sand or grit with the frugal herbage.

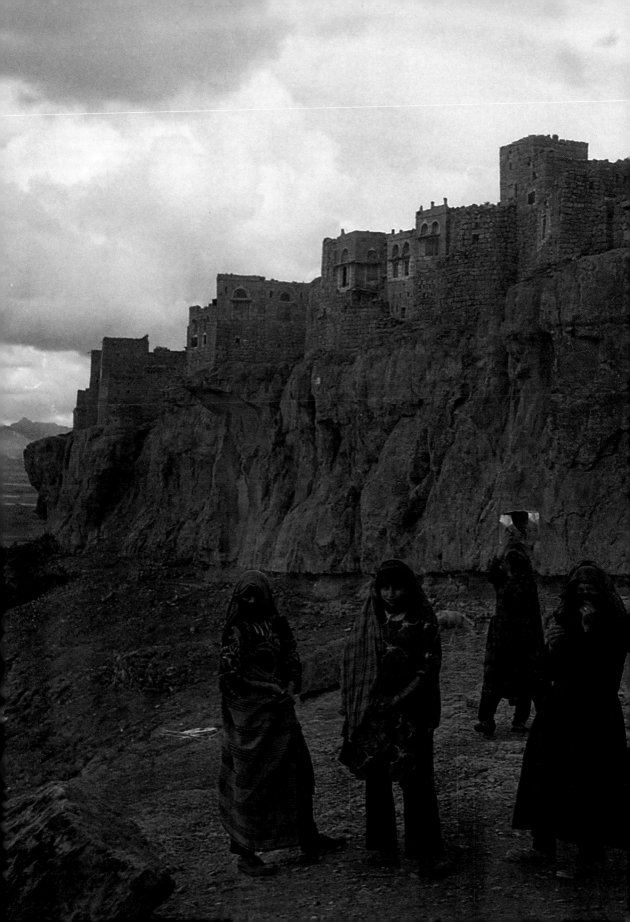

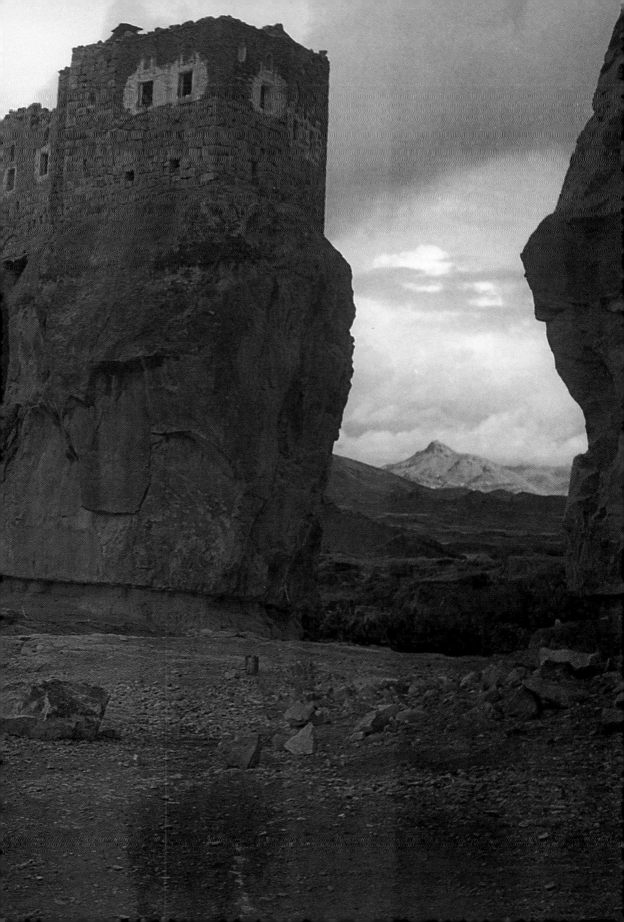

Previous page BAIT BAWS, the extraordinary hill-top village five miles due south of Sana'a, famous for its jewellery. This may date back to the time when half the population were said to be Jewish and the other half Muslims, the two happily integrated, especially the children. As we have seen one of the principle crafts of the Jews was the making of jewellery.

The village appears impregnable ...

Opposite ... but there is a path up! Two women with questing children inside that seemingly impregnable hill-top village. Whilst highland women are often veiled, many adopt the fashion of the woman on the right rather than the full *barqa'*.

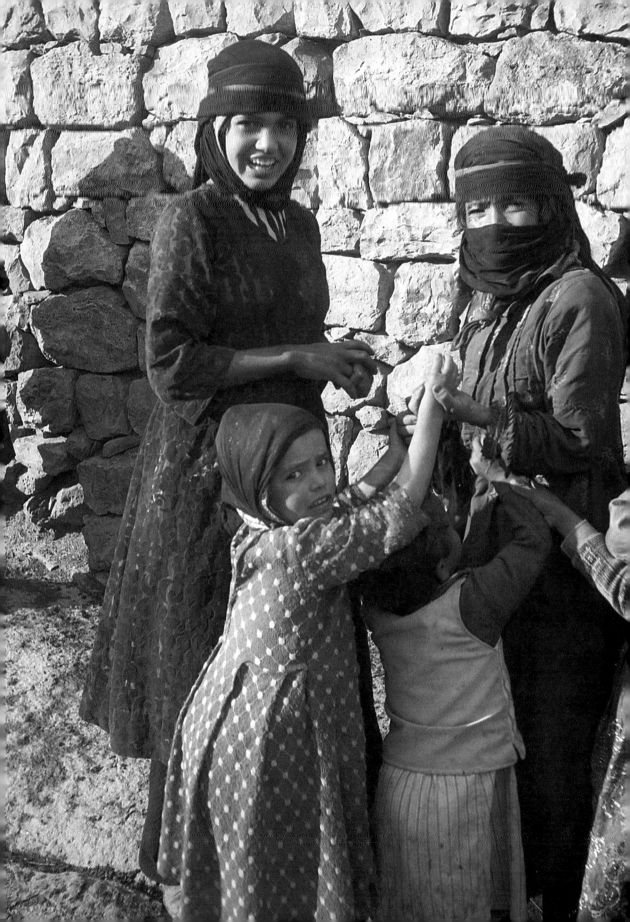

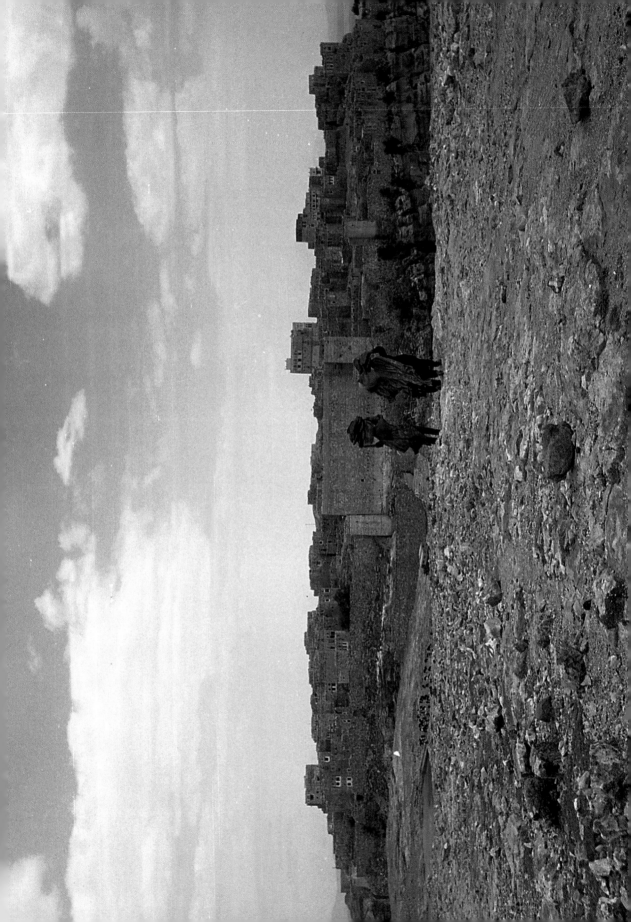

KAWKABĀN, 15 miles north-west of Sana'a. Its name means literally "two planets". The fortified city has a long and fascinating history. It sits atop an 800-ft pile of sandstone which has been gradually deposited over the millennia. To reach the city on foot entails an hour's walk along a narrow stairway linking it with neighbouring Shibām. It has the feel of a fortress town, which it is. A natural refuge from invading forces, many have sought refuge there including early Zaidi Imāms. It has been besieged by the Ayyubids under Salāh al-Din's (Saladin's) brother, Turān Shah, the Rasūlids and the Turks. Most latterly, when it declared for the Royalist cause after the overthrow of the last Imām, Badr, it was heavily bombed by the Republicans both from the air and by artillery. Many houses and mosques were destroyed and its population has never recovered its former numbers. The buildings are unusual in that their exterior decoration is made not from stucco carvings, as for example in Sana'a, but from variously coloured stones built into the brickwork.

SHIBĀM AND KAWKABĀN. The aforementioned stairway linking Shibām (seen sunlit down below) and Kawkabān, is a strenuous hour's walk, especially for those carrying a load.

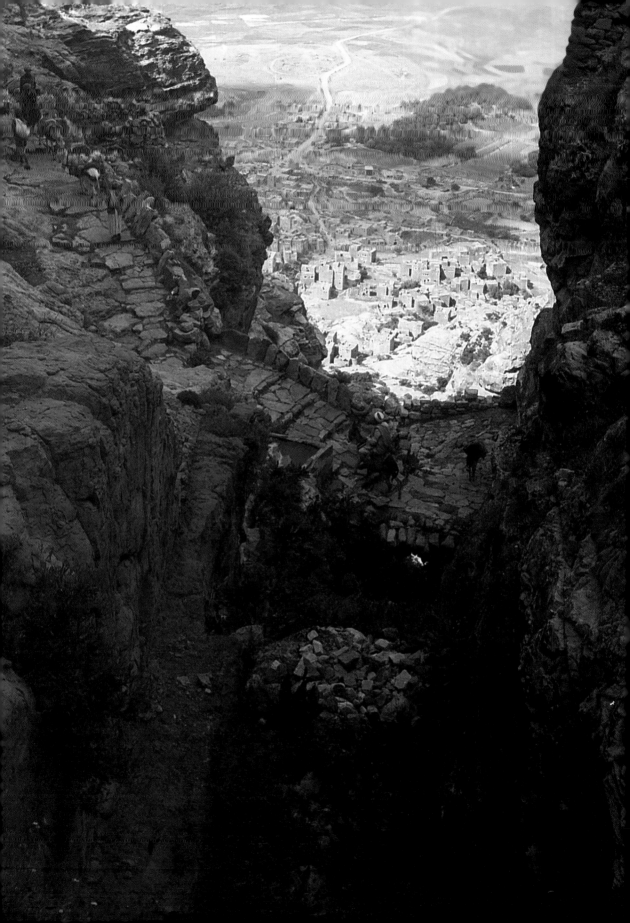

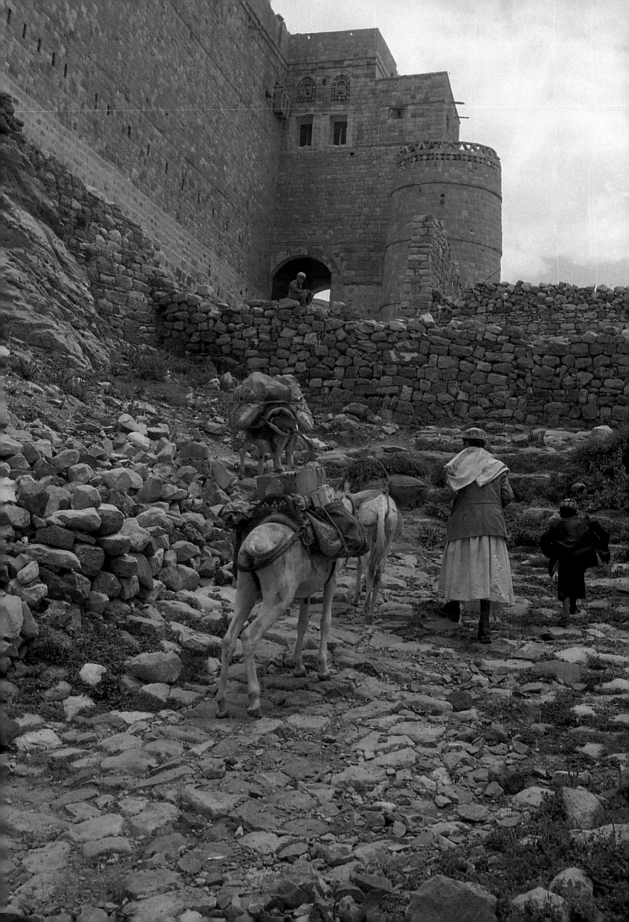

Opposite KAWKABĀN. A man, his son and two laden donkeys struggle up the steep path that leads to the well-defended walled gateway into the city.

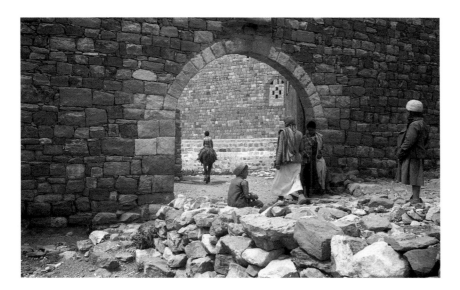

Above KAWKABĀN. Once through the gateway and into the city itself, one can see how even former window openings have been bricked up with only minimal openings left for ventilation; truly a fortified city throughout. The brickwork is mostly of dry stones without cement, except sometimes at base level.

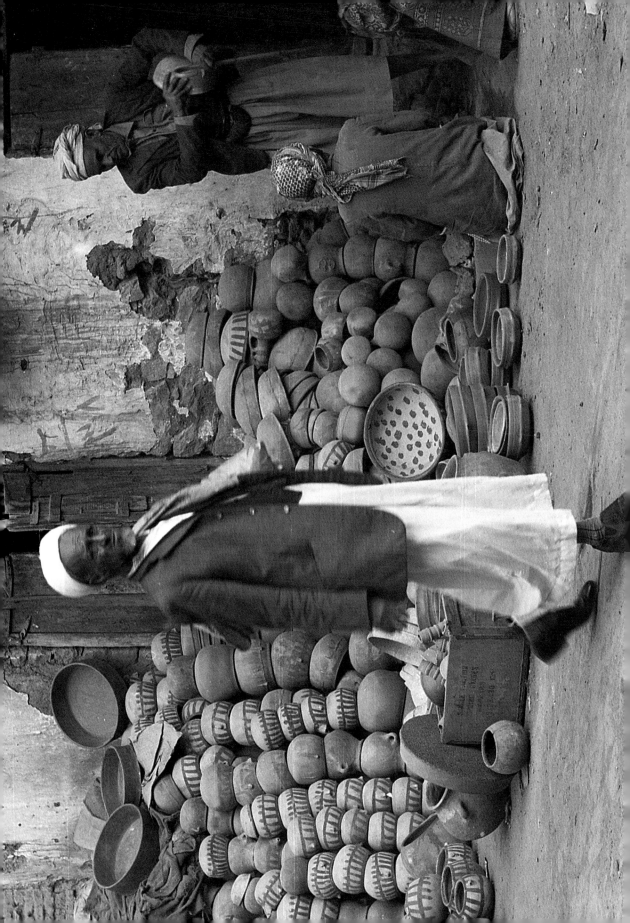

KAWKABĀN. Pottery stacked up outside a shop in the *sūq*. It may have been made locally, or at the Tihāmah town of Hays, south of Zabīd, which is famed for its pottery and as the main supplier to the markets of Yemen. However, Hays pottery is more often glazed. A mischievous purchaser might be tempted to insist on having one from the bottom layer of the stack.

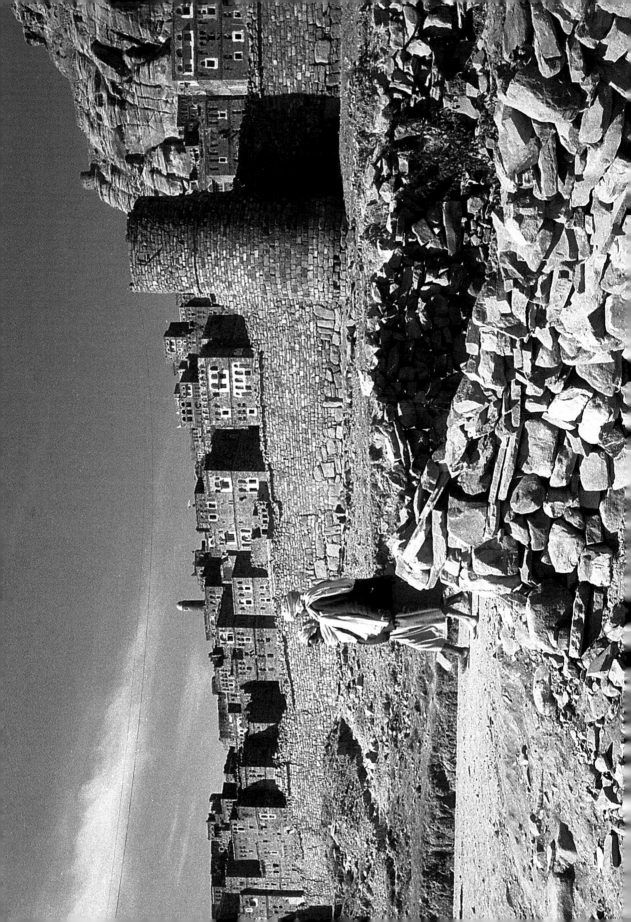

THILĀ. The city is packed snugly within its walls. Like nearby Kawkabān, it is heavily fortified and built of hewn stone. It has a strong Islamic heritage and, like Sana'a, is accredited with *hijrah* status; that is, in theory, that no conflict either religious or secular may take place within its walls. Alas in neither case has this always been so. There are several relics of the Himyaritic period including some large water cisterns.

Top THILĀ. A typical highland market scene – "Not enough, give me more".

Below THILĀ. Weighing out the meat with economic precision at a butcher's shop. Men usually do the meat shopping, most commonly for lamb, which is perforce sold on the day of slaughter. Markets are open most days of the week (except during Ramadān), including Fridays, apart from the main midday prayer.

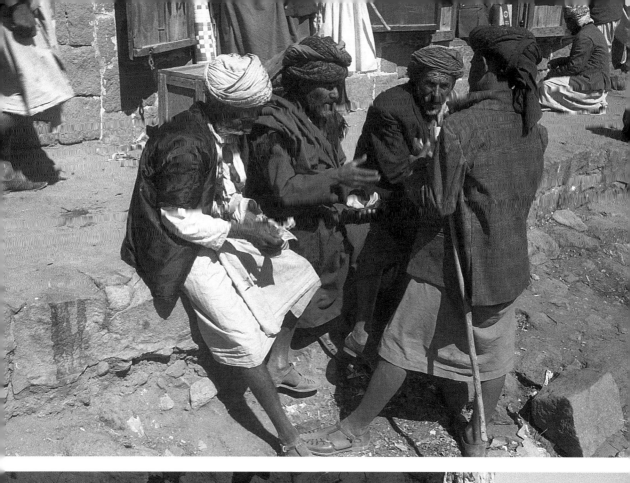

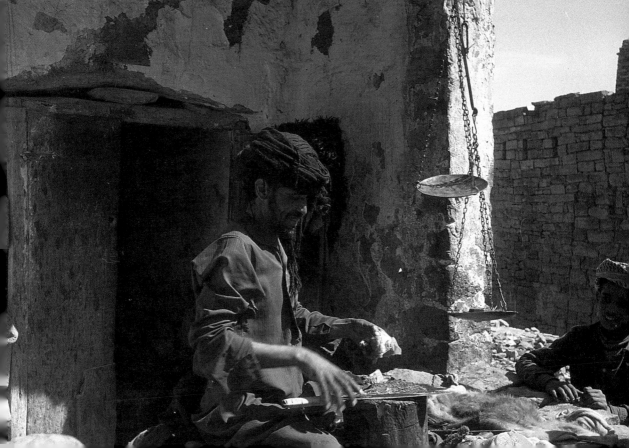

THILĀ. A local shaikh prepares for his afternoon *qāt* session, leaving the world to look after itself until the morrow.

There are several traditions relating to the arrival of the habit in the Yemen. All state it was introduced from Ethiopia, most popularly as a result of a goatherd noticing that his animals got lively after chewing the leaves of a shrub, *Catha edulis*, that grew wild there. The plant belongs to the same order, *Calastraceae*, as the English spindle tree. It thrives at an altitude of between 4,000 and 8,000 ft. Its import into Yemen is ascribed to a Shaikh Ibrahim Abu Zahrain (lit. "father of the two flowers") who, in AD 1430, brought it to Hudaidah after visiting Ethiopia.

The leaves of the plant are stuffed into a cheek, usually the left, until it bulges. It is then slowly masticated and the juice sucked through but not swallowed. The chewed remains, in the form of a green paste, are then spat out into a common spittoon. The small *qāt* leaves are often kept moist by wrapping them in the large leafy fronds of a banana tree.

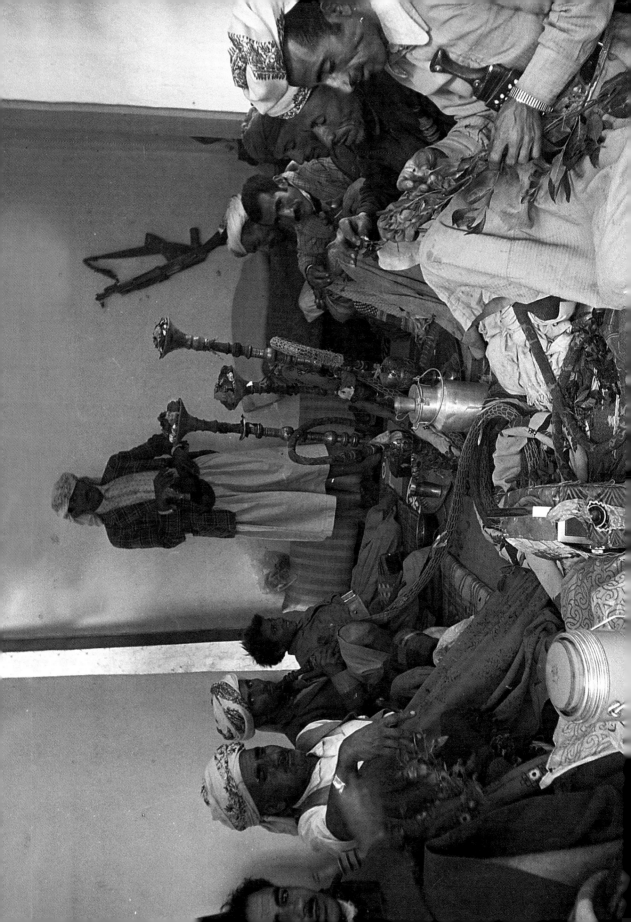

THILĀ. Our host from the previous picture is now joined by his friends. Every large house has at least one room dedicated to the chewing of *qāt*, with often a separate one for the women. Participants sit around reflecting the social order as they would in a formal *majlis*. A number of *madā'ah*s or hookah water-pipes are passed around for common use as news and gossip are exchanged.

Sessions begin after lunch and can last until dinnertime. Even the times of prayer can be adapted to avoid disturbance. The midday *Salāt al-ẓuhr* can be combined into the afternoon *Salāt al-'asr*. Combining the two is in fact quite common in Shi'a Islam (the Zaidis are a branch of Shi'ism) but this would be more difficult to reconcile with orthodox Shāfi'i Sunnism. One of the side effects of the constant chewing of *qāt* is the discolouring of the teeth and gums. More serious in the long term is a reduction of sexual virility and a gradual physical emaciation.

Yemenis have many rhyming couplets relating to the inebriating effects of chewing the leaves. One common in Sana'a is "*Qāt ya Higri wa tara'ani igri*", waggishly translated "A bunch of *qāt* and watch me trot". More literally "O you from Hagariyya (a local district) give me *qāt* and I'll get moving".

AL-'AIN, NEAR THILĀ. A woman walks through an arched gateway, a large pan on her head. Notice how this dry, hewn-stoned brickwork, so prevalent in this area, crumbles without constant maintenance.

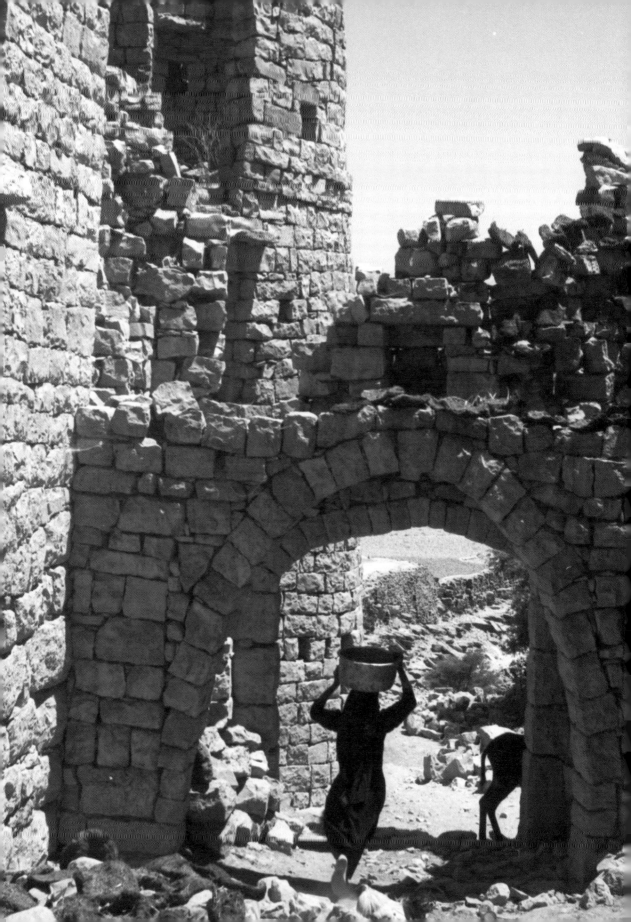

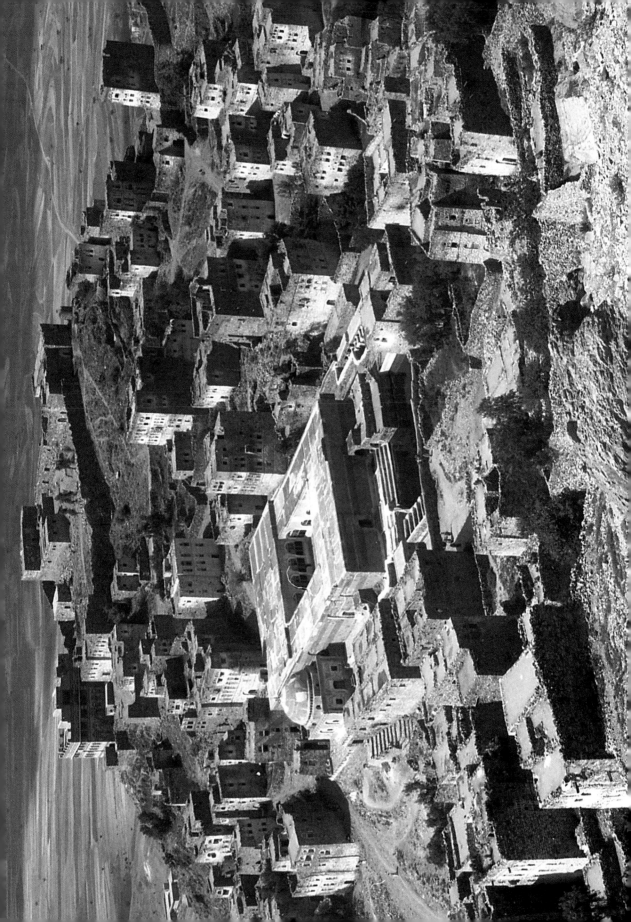

ANATOMY OF A VILLAGE. Dawrān, some 25 miles south of Sanaʻa, lies to the west of Maʻbar on the Sanaʻa–Taʻizz road. Notice how the houses cluster around the mosque in the centre of the community.

SOUTH OF IRYĀN. A typical small highland village perches on a hilltop with neighbouring terracing. Defence is enhanced both by its positioning and by the fortified circular tower, *burj* or *nūbah*, at its summit.

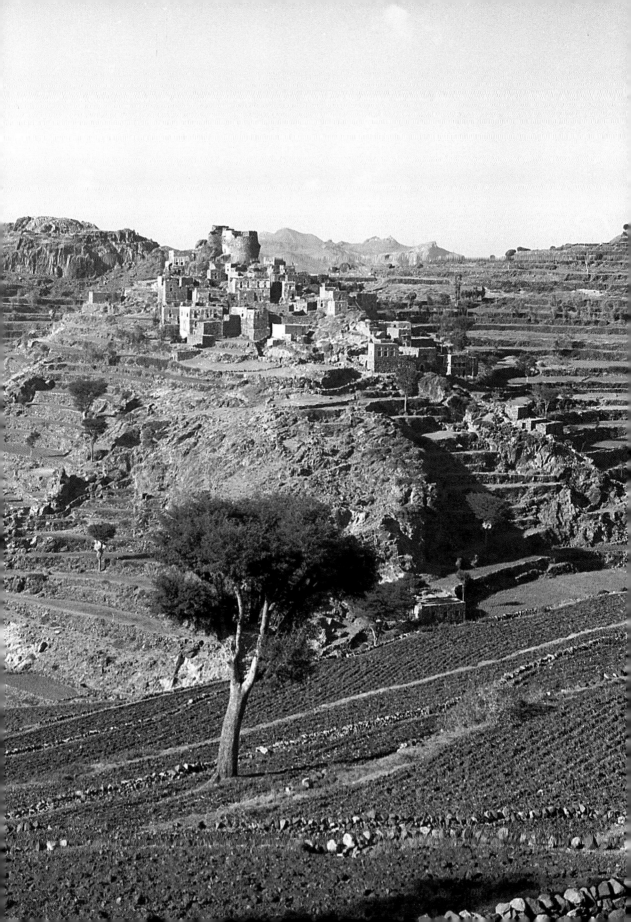

THE MOSQUE OF AL-JANĀD, ten miles north-east of Ta'izz, is reputed to be the oldest in Yemen. Erected in the lifetime of the Prophet, it was the first built outside the Hijāz. It was constructed on the orders of Mu'adh Ibn Jabal, one of the Prophet's companions and his chief legate, who was sent to the Yemen at the start of the Islamic era. At the time Al-Janād was an important provincial centre, probably preceding Ta'izz as such, and was ruled by a Persian governor.

It has been extended and renovated several times, most recently, as seen, by the Saudis. The minaret, some sixty-five feet high, less the facing, is thought to be original and much of the masonry in the interior has been preserved. On it can be seen several inserted Kufic inscriptions, some upside down possibly because the builders were unable to read that script. And in other ornamentation, as is common throughout the Yemen, several six-pointed stars have been carved. There has long been debate as to whether these represent magic symbols or have been made by Jewish masons. We can consider this again when looking at such inscribed on houses in Zabīd, in the Tihāmah.

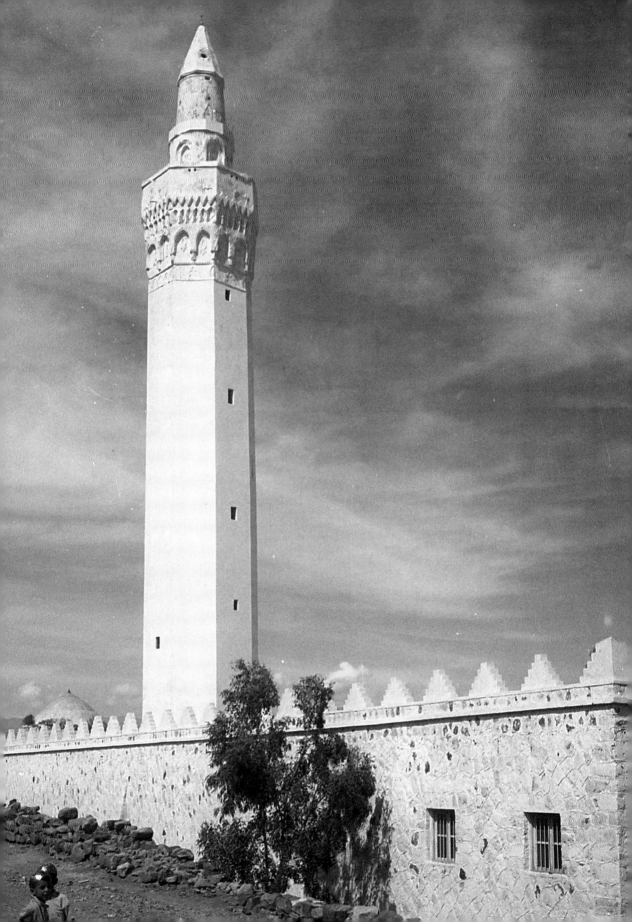

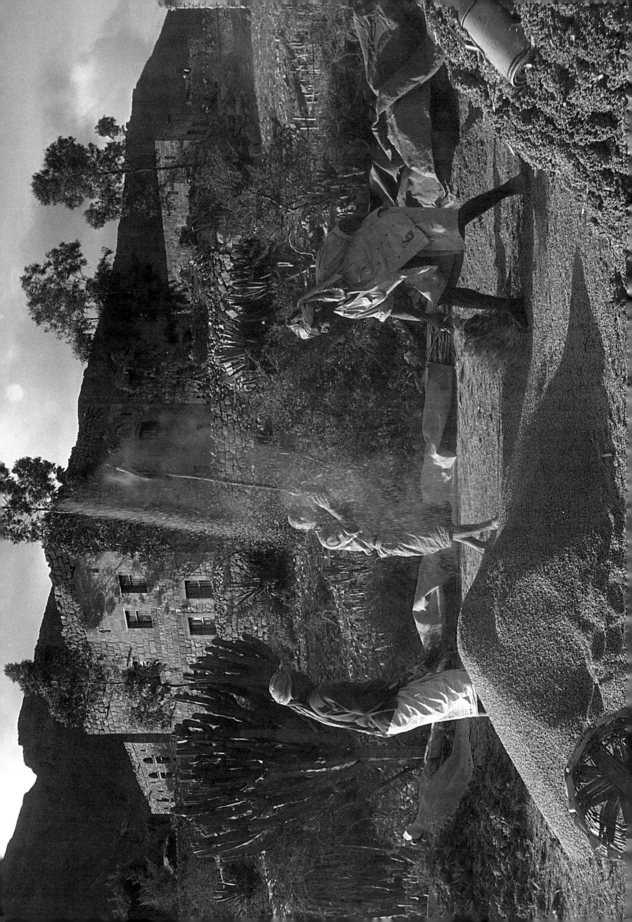

WINNOWING MILLET at Dhī Sufāl, near Ta'izz. The dried millet is tossed during a mild breeze when the chaff is blown away, leaving only the de-husked grain. The chaff can get into the back of the throat and burn the skin.

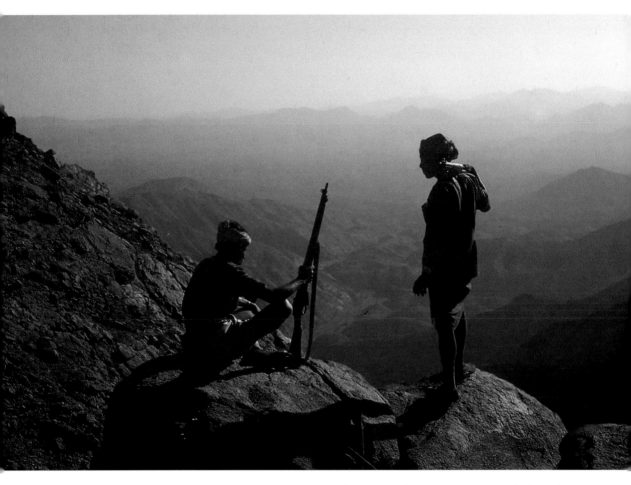

Above TWO TRIBESMEN on the 7,000-ft escarpment of Jabal Radā‘ gaze northwards and down into the province of Al-Baydā.

Opposite A TRIBESMAN ON JABAL RADĀ‘ wearing the cloth head-band typical of the area, and holding his most precious possession – his rifle.

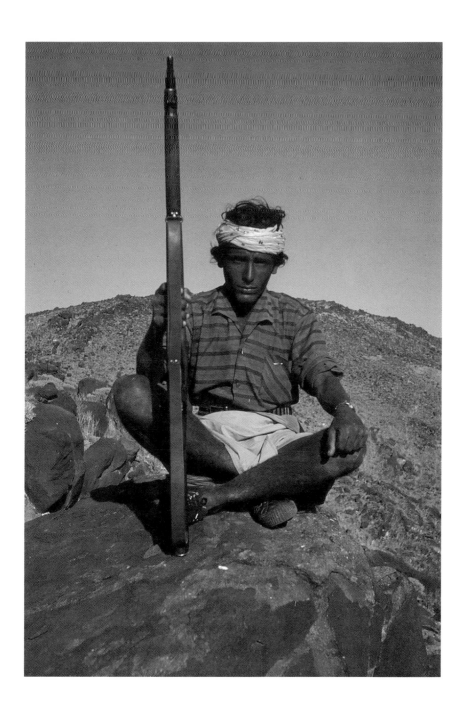

145

THE KEEPER OF THE LIONS at the Imām Ahmad's old Salāh palace on the south-eastern edge of Ta'izz. This keeper told me (in early 1971) that he had served three regimes: the last years of the Imām Yahyā, the Imām Ahmad, and the Republic. Legends abound as to how the Imām Ahmad deployed his lions. Some say they escorted him in procession, collared and led in chains by slaves. This keeper claimed the lions were chained on either side of the passage-way leading to the Imām's "throne-room". At full stretch, there was a twelve-foot gap through which the visitor had to pass. It was a test of his loyalty to note whether or not he flinched. Certainly the lions seemed tame enough and allowed the keeper to fondle them like a pet dog. I counted fifteen lions in their cages and from the numbers of cubs it was clear that they were still being bred.

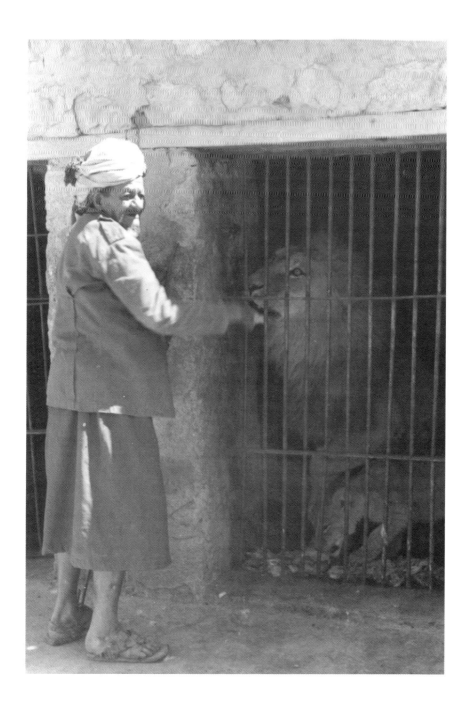

147

THE TIHĀMAH

Above ZABĪD. Donkey carts enter the Bāb al-Sihām (northern gate). Zabīd has four town gates opening north, south, east and west.

Because of its proximity to the sea and landing sites, the Tihāmah has been Yemen's principal point of invasion for foreign powers intent on advancing to the hinterland. Thus several of its main towns such as Zabīd had well-fortified, irregularly shaped curved walls with ingenious defensive gate systems. Whilst they were built in the first place by the local Shaikhs, they were subsequently reinforced by the invaders themselves to prevent their being ousted either by the highland Zaidi Imāms or by subsequent foreign attackers. Most of the defensive structures seen today result from the last Ottoman period, after 1850.

The people of the Tihāmah are of a less warlike nature than their mountain cousins, having evolved, as a result of trade and maritime contact, increasingly as a mixture of Arab and East African stock, with others from the Indian sub-continent and the Far East.

Below ZABĪD. Bāb al-Sihām, viewed from the inside. Note the intensely small burnt brickwork, a common feature of Zabīd and other Tihāmah towns.

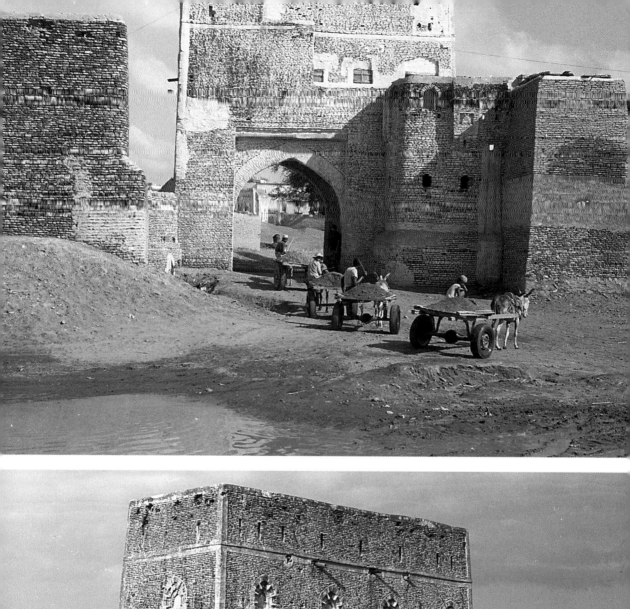

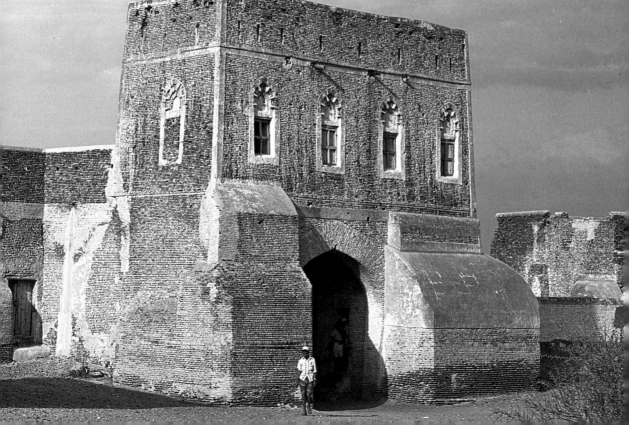

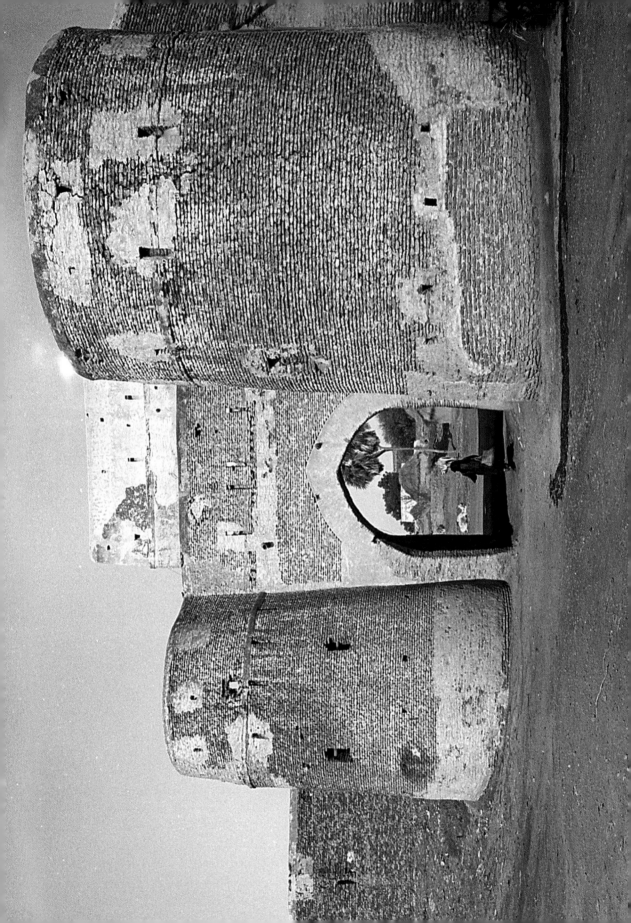

ZABĪD. View of, and through, the eastern gateway, Bāb al-Shabāriq. Note the repair to the crumbling brickwork at the base of the right-hand tower, or *nūbah*. (A tower-like structure built into a defensive wall is normally termed a *nūbah*, possibly a Turkish word, rather than a *burj*.) Sun and kiln-dried mud brick is less stable than the cemented brick and hewn-stone work of the highlands, especially when, as appears here, there is no strong foundation layer. The defensive structures from the Ottoman period are clear.

ZABĪD. A rather more domestic view of the Bāb al-Shabāriq, with rugs hanging out to dry. This suggests there may be domestic or *mafraj* accommodation within the gate structure.

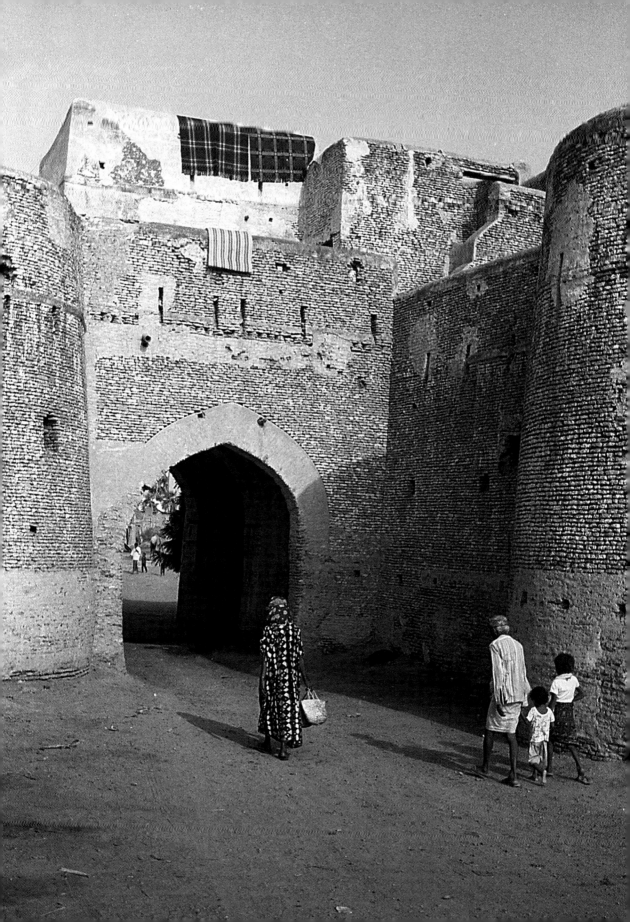

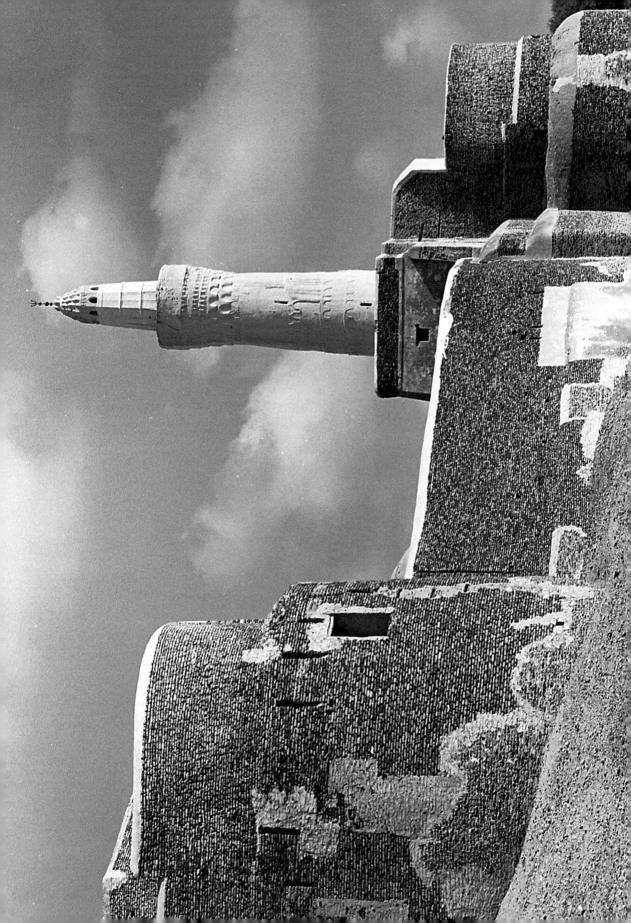

ZABĪD. The south-east walls and citadel showing the minaret of the Al-Iskandariyyah mosque. The picture gives an idea of the typical irregular curvatures of most city walls.

Above ZABĪD. A young boy about to enter his house through its courtyard. Most of the Tihāmah houses are of one or two storeys only. The majority are left unrendered except for the lower walls. The facades, cleverly moulded from the bricks, are left in their natural colour.

Below ZABĪD. Decorative scrollwork above doorways. As mentioned, the Tihāmah may not have such dramatic brick and stucco decoration as Sanaʻa, but few opportunities are lost to enrich both wood and brickwork with intricate carving and designs, which are more suited to its lower structures.

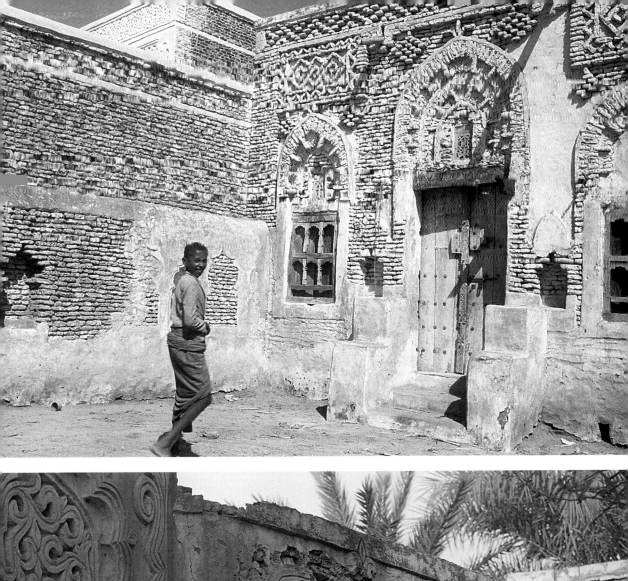

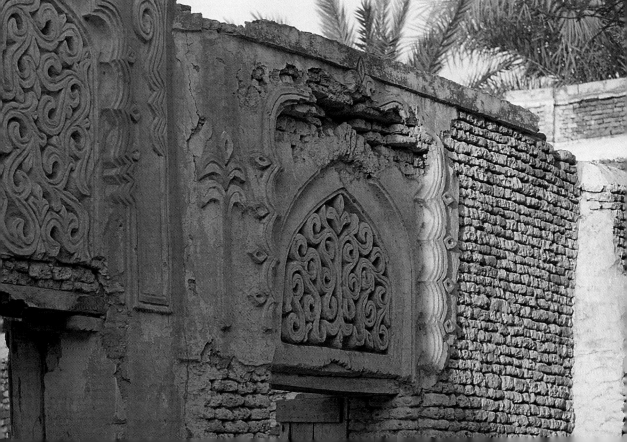

ZABĪD. Details of a decorative house façade. Such are geometrically patterned from brickwork and plaster, deeply incised and always symmetrical. Known as *naqsh*, they are often covered, as here, in a coating of lime wash. In their appealing format they are worthy rivals to the brick artwork of Sana‘a.

Note the two six-pointed "Stars of David" beneath the water chutes. The one on the right has "Allah" written in the centre, and the one on the left "Lives". There has been much debate and speculation about the origin of this star, common throughout Yemen especially on the walls of mosques. Some suggest it is the work of Jewish masons which was subsequently copied by the Arabs. Others, that it is just an ornamental emblem of antiquity, even a magical sign. This seems more likely since it is common to see it also on the brasswork of those so-called Arab chests, which in fact are made mostly in India and Persia and are not the work of Jewish craftsmen. Another suggestion is that a builder and craftsman may find it easier to gain symmetry with two super-imposed unilateral triangles than by drawing a five-pointed star – as many of us did when children!

ZABĪD. Four girls chatting by a doorway, with the customary carving on the woodwork. Note the expressions of pure contentment on their faces, the result perhaps of being at peace with themselves.

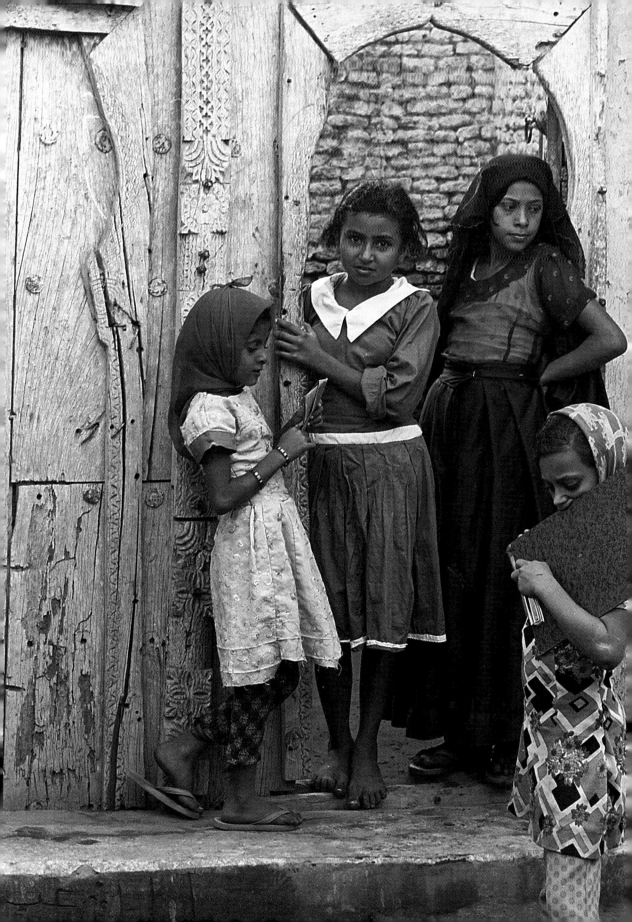

ZABĪD. A lone woman carrying an object on her head disappears down a narrow brick-lined alleyway. Zabīd has such a labyrinth of winding lanes and alleyways that even the locals sometimes get lost. This was Freya's favourite picture.

There are times when we all feel the need to write to a woman and tell her how beautiful she is. Zabīd is very "feminine" and early one morning I was moved to do just that.

> I don't suppose you know you are one of the most beautiful towns left in Arabia; I suspect you are too coy and modest to think about it. You are filled with a gentle, courteous, smiling people. You cannot much like those hard men of the hills and I hope they never control your ways. There is a sort of faded grandeur about you but an activity that belies your age. The wrinkles on your face are only just beginning to form; you need little rouge yet.
>
> Last night we slept out on one of your roofs and heard the gentle throbbing of distant water pumps. Soft sounds came from the house below. A girl's laughter; the mother of the house gently chiding those in it, maybe for not hurrying to the evening meal. The Idhaan came and faded, occasioning a padding and shuffling in the streets.
>
> Snug in our own beds I looked up and saw Sirius, Procyon, Castor and Pollux struggle through a cloudy sky to tell us where Orion lay. I slept contented feeling I was among friends, and woke only when a young man in the courtyard below made his dawn reading from the Book.

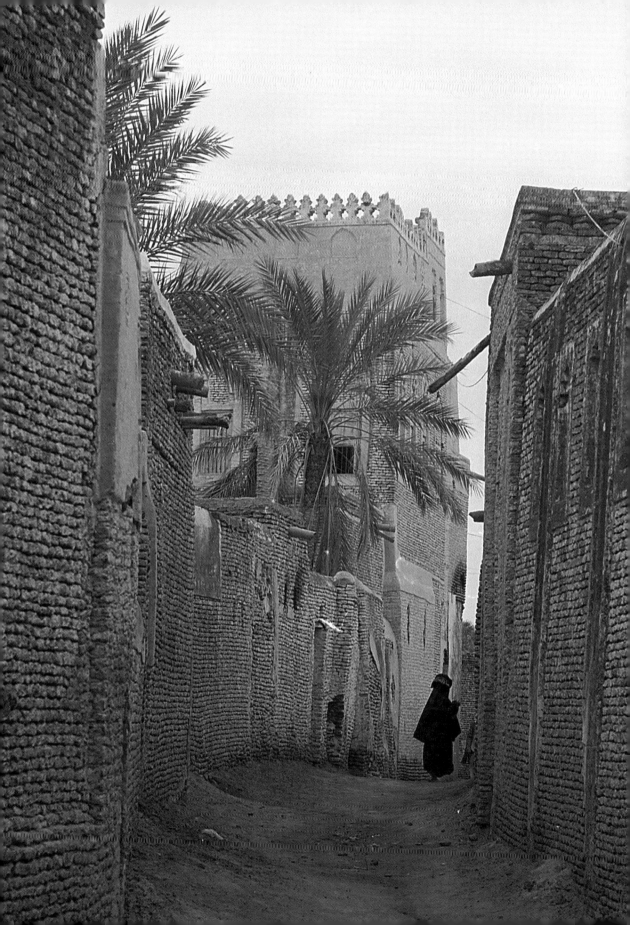

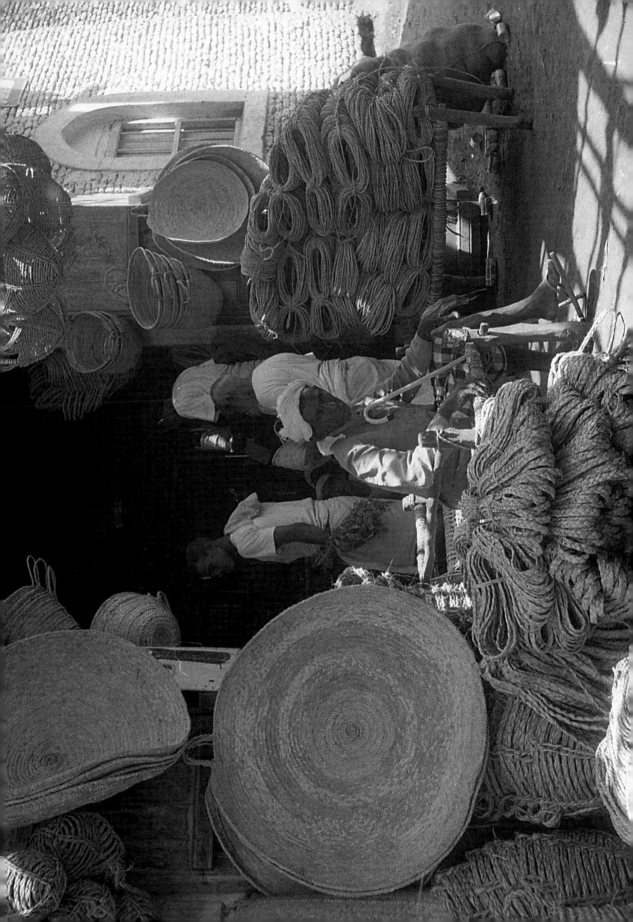

ZABĪD *SŪQ*. An old man with his walking stick sits outside a rope and basketware shop. On display hanging at the top are muzzles, *fidāmah*, for camels and cattle; circular eating mats, *tabaqah*; baskets, *zanbīl*; and ropes, *habl*, or, by a length, *tūl*. Note the youth entering carrying a bunch of *qāt*.

The matting and ropes are made either from the fronds of the *dawm* palm or from long grasses found chiefly in the Wadi Mawr, inland from Al-Luhayyah. Bait al-Faqīh, to the south, is a large centre of trade for basketry. Weaving is often done by people individually working in their homes.

We shall see a picture of a man weaving the long grass of the Wadi Mawr when we move on to the northern Tihāmah.

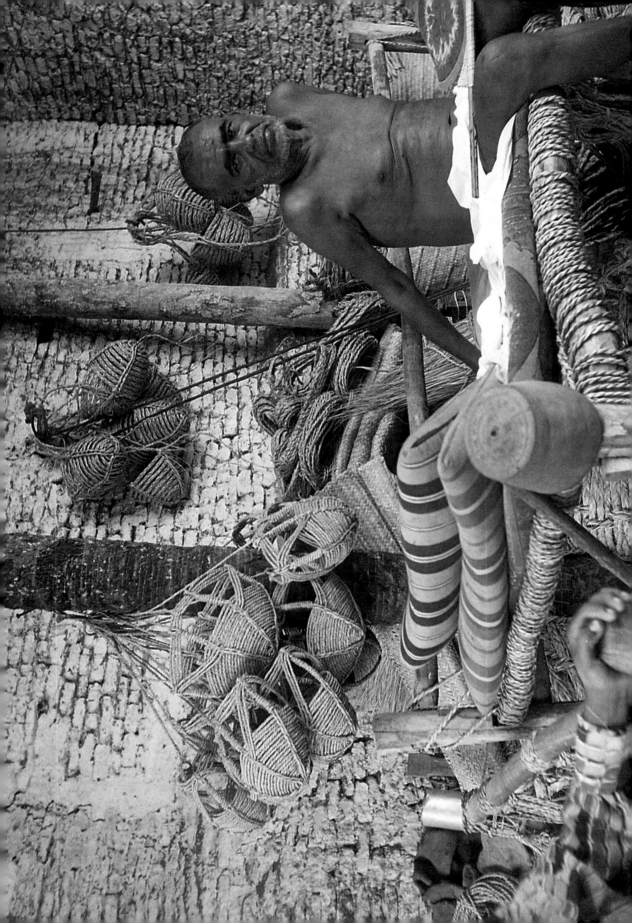

ZABĪD SUQ. A shop owner sits on a typical wooden rope-strung Tihāmah bed, of the kind known in India as a charpoy. These are used as couches during the day, when they are covered in carpets, cushions and rugs, and at night as beds. Tihāmah furniture tends to be high, in order to assist ventilation away from any reflected heat from off the ground. The minimal attire of the man is an indication of the intense Tihāmah heat.

Note the cattle and camel muzzles, and a typical Tihāmah fez-shaped hat, *kūfiyyah* (normally meaning a turban or headcloth) hanging on the bedpost. These hats are made from fine cane or bamboo, *khayzarān*, rather than straw. If the hole in the centre for ventilation is blocked, they are so tightly woven they can hold water for a while.

ZABĪD. The interior of a rope and basket shop with a man sitting on a somewhat unstable bed. Note also the roof construction of the inner room, formed by a latticework of timbers as ceiling joists. Tihāmah houses are much dependent on such timber. The shorter poles can be taken from mangroves, grown in swamps, such as off Al-Luhayyah; alternatively they can be taken from the *'ilb* tree (*Zizyphus spina-christi*) which grows throughout the Yemen. The larger supporting poles are probably from palm trees.

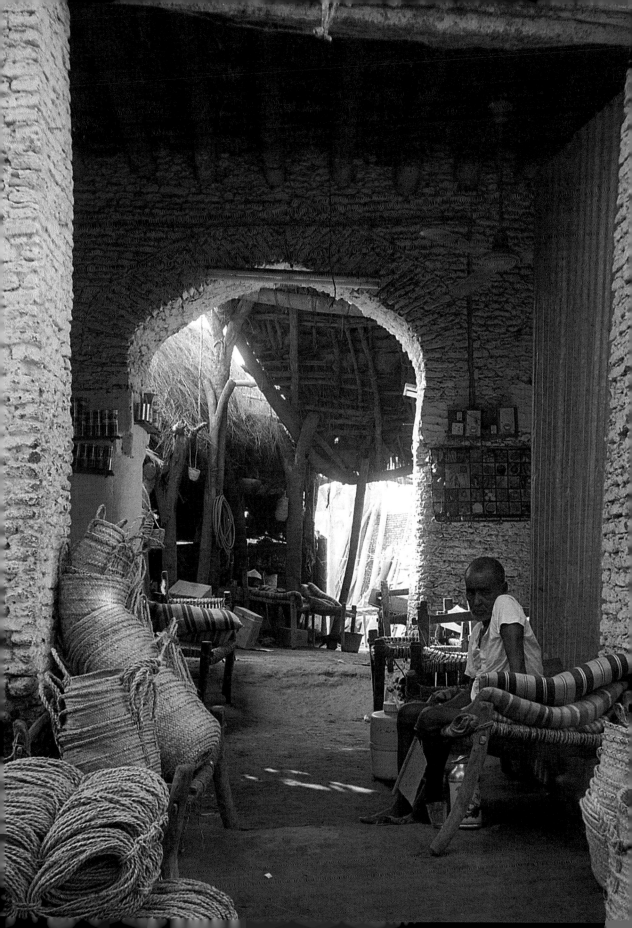

ZABĪD. "Take up thy bed and walk." A man carries his bed and a kettle past a dilapidated doorway in a back street. Beds in the Tihāmah seem a very personal possession; it is common to see men carrying them from one house to another.

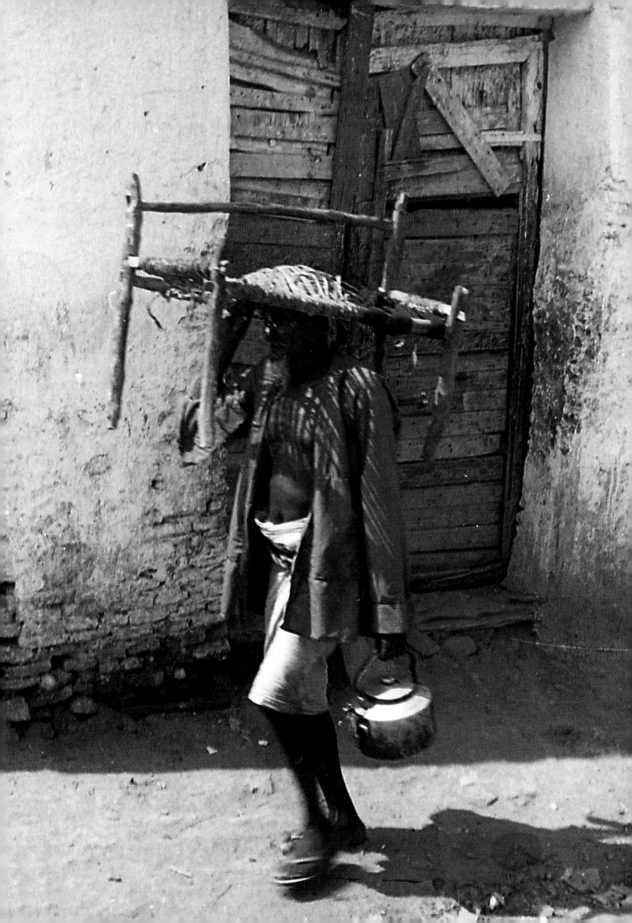

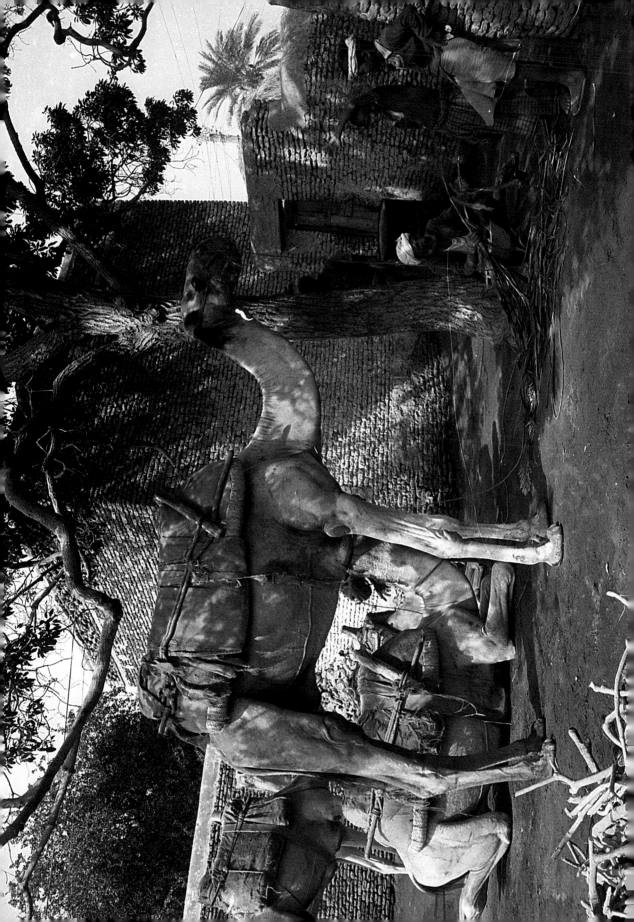

ZABĪD. A typical caravanserai. Note the muzzled camel and the pile of firewood for the use of visitors. Camels are used not so much for riding but for the transportation of merchandise between the towns and up to the highlands.

ZABĪD. Inside the Al-Ash'air, or Great Mosque, built in the 9th century AD by Muhammad Ibn Ziyād, the founder of the town. Based on the Great Mosque of Mecca, it has a similar simple courtyard and undecorated arches.

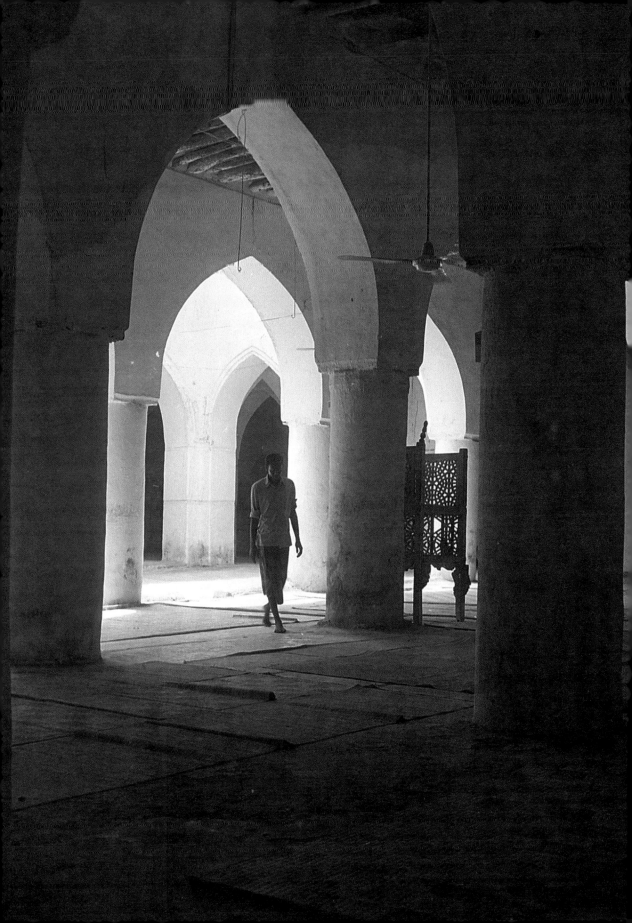

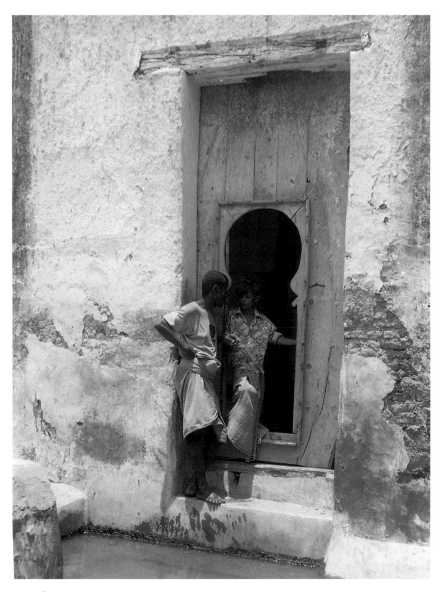

ZABĪD. Man and boy converse at the keyhole-shaped wooden doorway beside a *mīdā'ah*, or mosque water basin, used for ritual ablution, *wudū'*, before prayer.

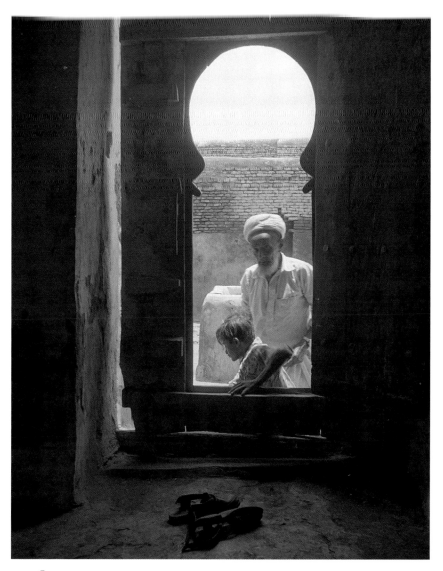

ZABĪD. An elderly man and a boy about to exit from the *mīdā'ah*, or mosque washing pool, and regain the anteroom to the prayer hall. This attractive keyhole pattern of wooden doorway is common in the Tihāmah. (Reverse side of the doorway in the previous picture.)

ZABĪD. A boy sits on the steps to a mosque pulpit, *minbar*, reading an Islamic textbook. Note the carved decoration on the front of the wooden stair treads.

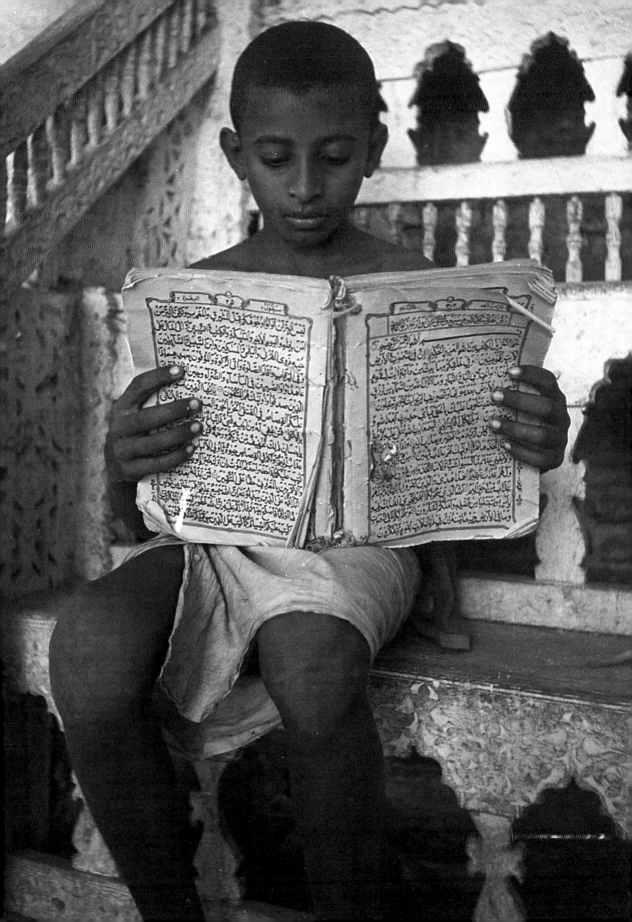

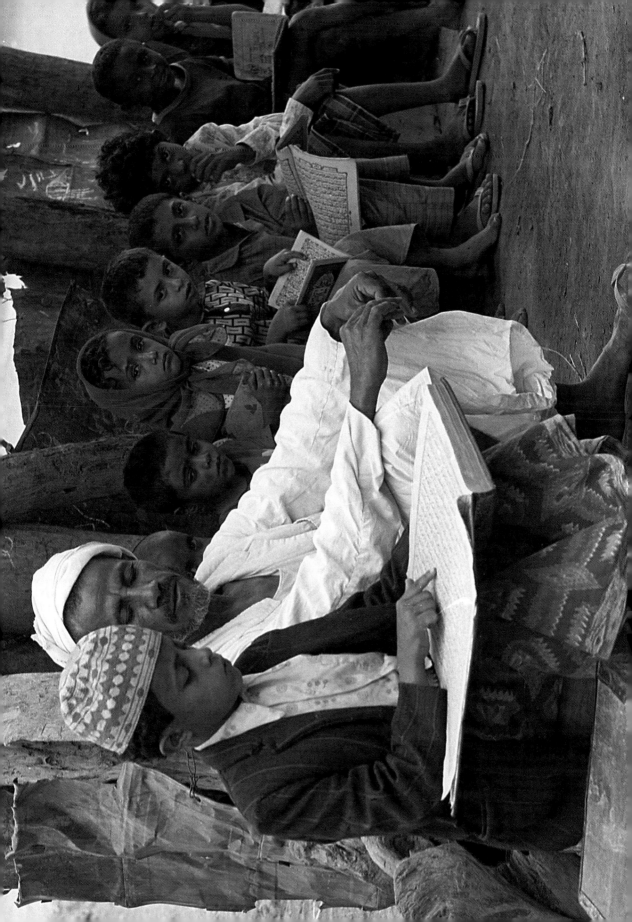

ZABID. An open-air mixed Qur'ān school for young students. The children's faces suggest a dilemma as to whether to risk the teacher's displeasure by momentarily lifting their eyes from their texts! Zabīd continues to be a seat of Shāfi'i learning

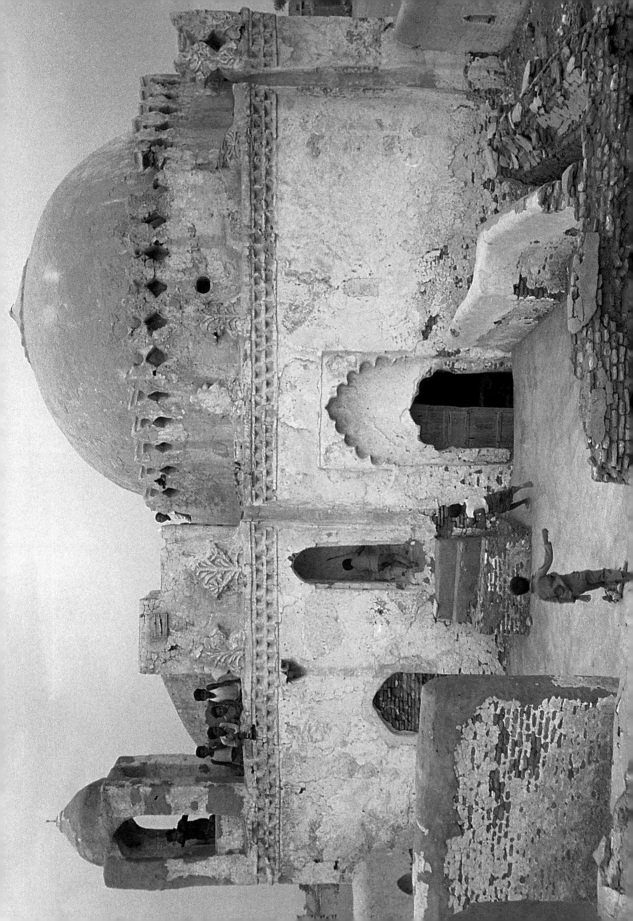

SOUTH OF ZABID. A small madrasah mosque-cum-walī with young boys running up to its minaret. Zabīd itself claims to be the oldest seat of religious teaching in the Arab world, specializing in Sunni Shāfiʻism. Its university was founded in AD 819, pre-dating Cairo's Al-Azhar by 152 years. It taught other subjects in addition to Islamic theology and claims to be the birthplace of algebra. There are said to be some eighty of these madrasah-mosques still in existence, many with fine libraries. They usually contain the tomb of their founding donor. The small classrooms lie off one long side of the courtyard. To the left of this picture can just be seen the top of the entrance to one of them.

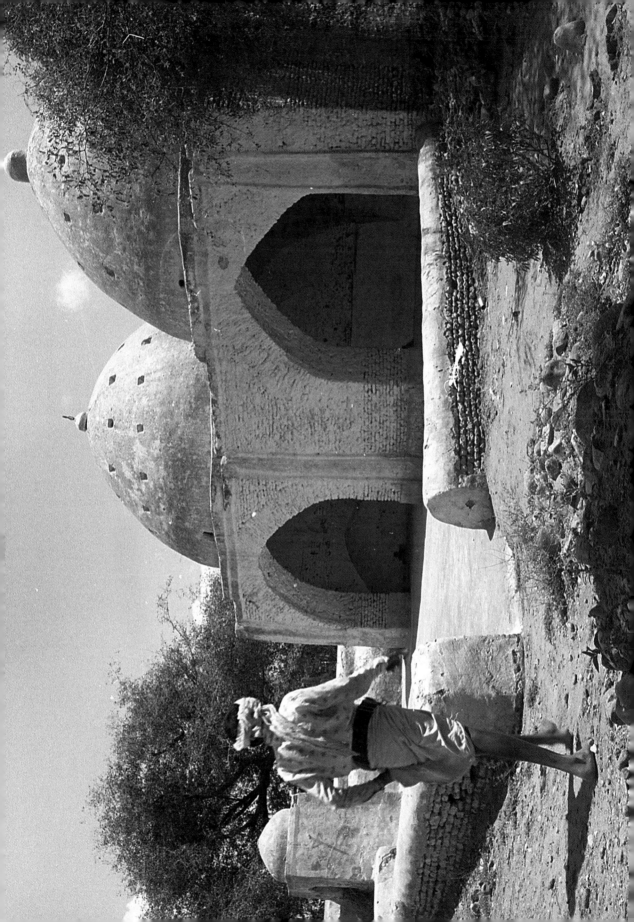

ZABĪD. A boy walking towards the twin-domed Wali Al-Haddah. A *wali* means literally "a man close to God" or a "saint" in the more popular and Sufi aspects of Islam. In Yemen, especially in the Tihāmah, where there is a strong cult of Islamic sainthood, the word is often used to describe his shrine or tomb, more correctly a *qubr*. (*Wāli*, with a long first syllable, also means a person in authority, such as a regional governor).

Visits to *wali*s are often made in the hope of receiving benefaction, especially prior to the birth of a child or in the case of illness. These Islamic "saints" were believed to possess magical powers of healing. The domed tombs can also be used similar to a mosque. And whilst they can be visited at any time, most have a specific saint's day.

Above NEAR AL-JARRĀHI. A three-domed *wali* is slowly disappearing under the advancing sands. *Wali*s are ubiquitous in the Tihāmah and some, like this one, are seemingly abandoned. The number of domes seems to denote the ranking of the *wali* or saint, rather than the number buried therein.

Below NEAR AL-JARRĀHI. A young boy walking past a well-head next to Wali al-Musāwa. Most *wali*s outside the towns have their associated well for the use of those making a visitation, *ziyārah*, in lieu of the usual washing facilities, *mīdā'ah*, at a mosque.

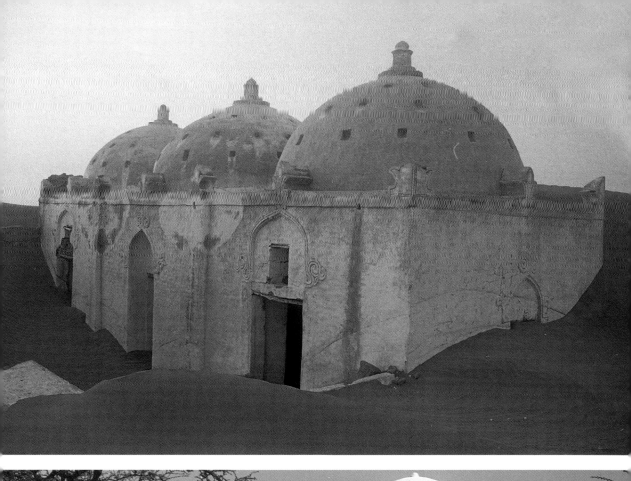

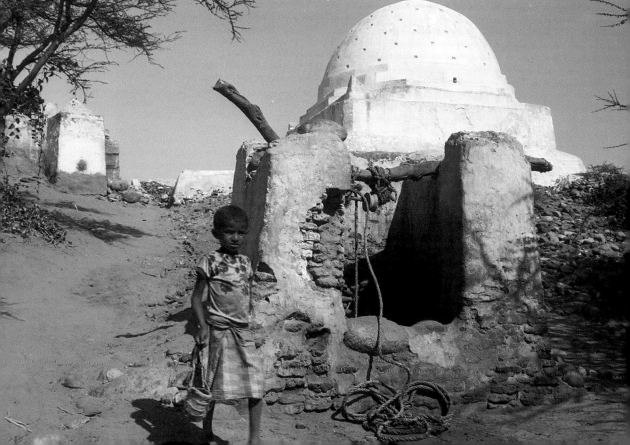

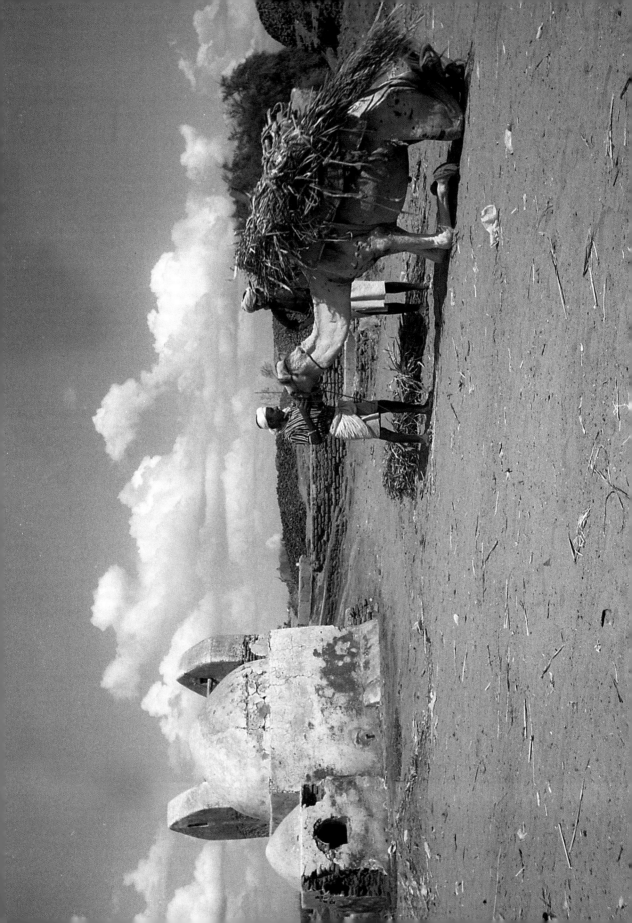

NEAR BAIT AL-FAQĪH. A camel carrying brushwood seemingly makes obeisance to a small *wali* by kneeling.

NEAR, HAYS. The ancient graveyard of al-Akhdū' at Maqbanah, near Hays. This style of cemetery, where each tomb seems to reflect the life or status of the deceased, is peculiar to the Tihāmah.

NEAR HAYS. A little boy with his topknot of hair, a local tonsure practice peculiar to small boys and known as *qunzaʿah*, meaning a tuft of hair or a cock's comb. Originally it was a sign that the boy had yet to be circumcised, but as it is now universal practice in the Yemen to circumcise boys shortly after birth, this is no longer so, though it is still seen in parts of East Africa. Today it seems mainly a matter of hygiene, for example to avoid head lice. But in folklore it is said to foil a *jinn* so that the parent can seize the boy away if an evil spirit attempts to abduct him.

Note the small round tomb in the top right hand corner.

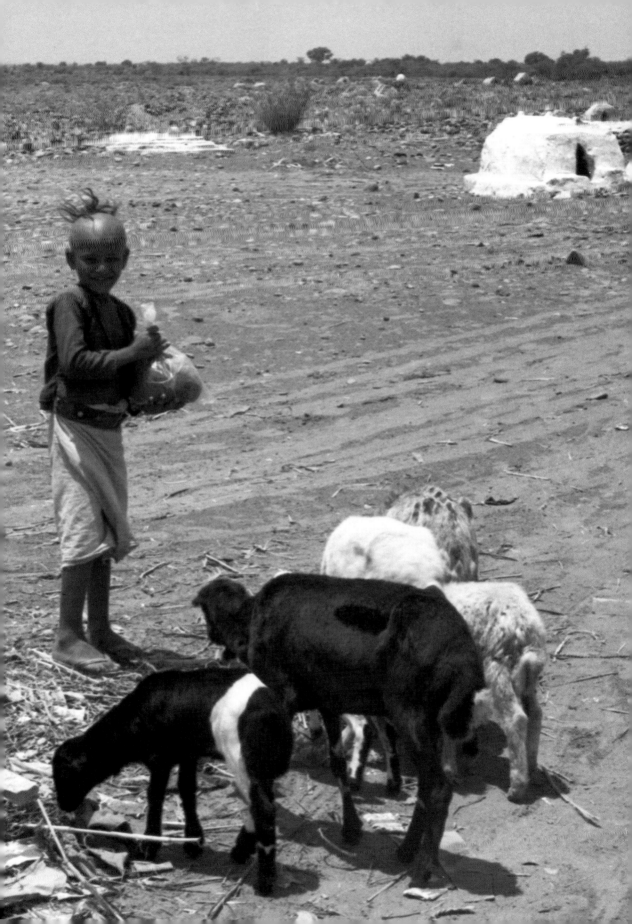

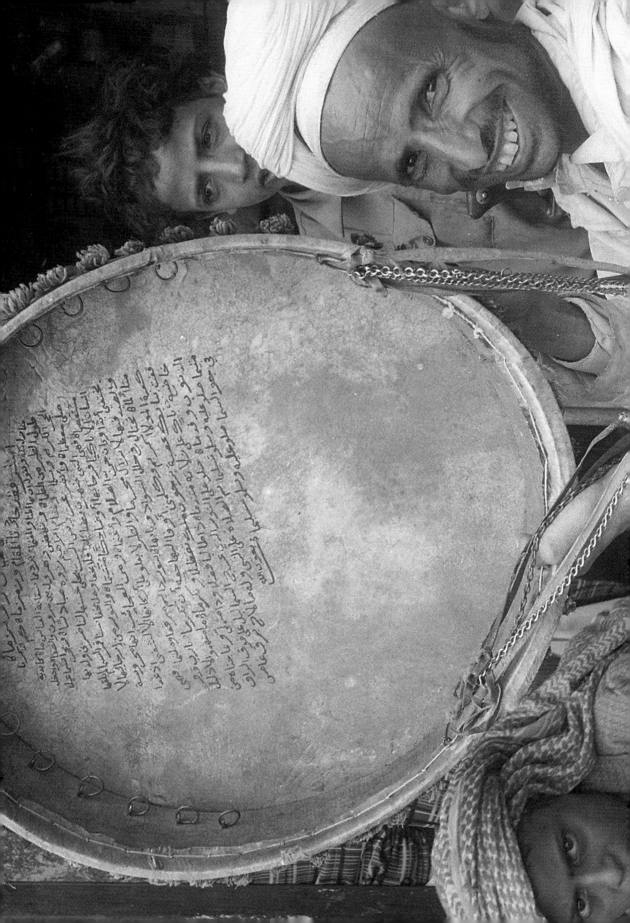

MADĪNAT AL-'ABĪD, Tihāmah. A Sufi *madāh* or panegyrist shows off his drum, *tār*, on which is written some Islamic eulogy. These mendicant fakirs will tour the *sūqs* and other crowded areas singing or chanting Islamic poetry or texts in the hope of a small monetary reward.

A MOSQUE at Al-Jarrāhi, south of Zabīd. Al-Jarrāhi, though much smaller than Zabīd, was another early seat of Shāfi'i Islamic theology. It was also a staging post for those travelling along the road linking Mukhā to Hudaidah and places farther north.

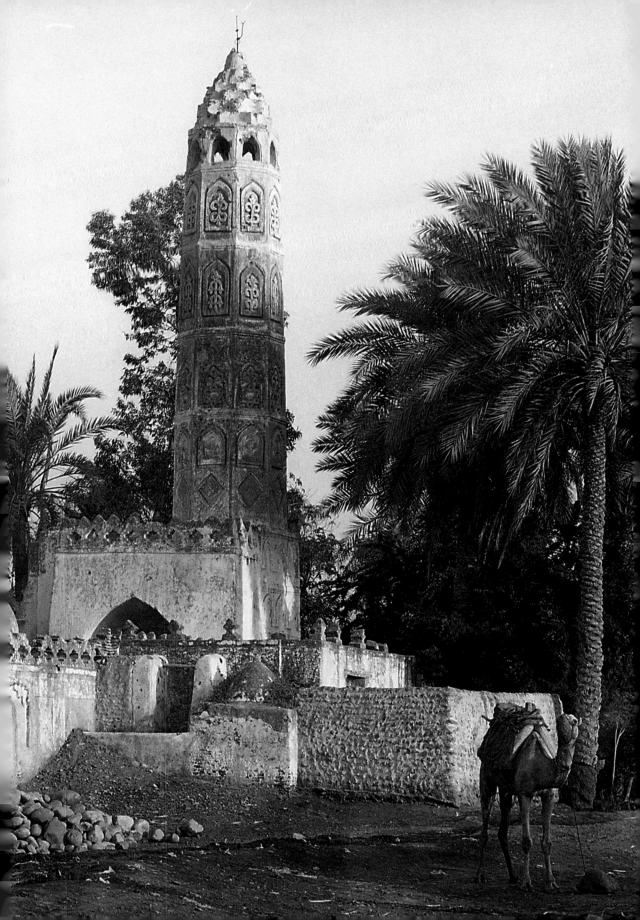

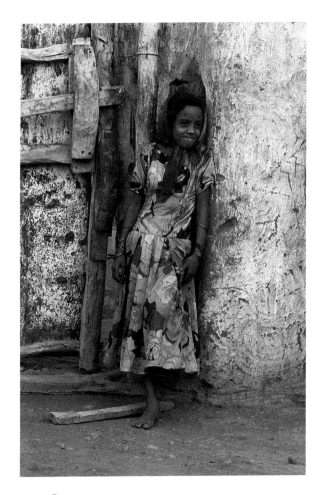

Above AL-JARRĀHI. A girl with a whimsical smile standing on one leg and leaning against a somewhat crudely plastered wall. Note the simple, but effective, wooden door latch.

Opposite NEAR Al-JARRĀHI. A boy takes his fill from a row of earthenware water jars (variously *qārūrah*, pl. *qurārir; dann*, pl. *dinān*; or *qullah* pl. *qulāl*). Such jars are filled and placed communally for the use of passers-by.

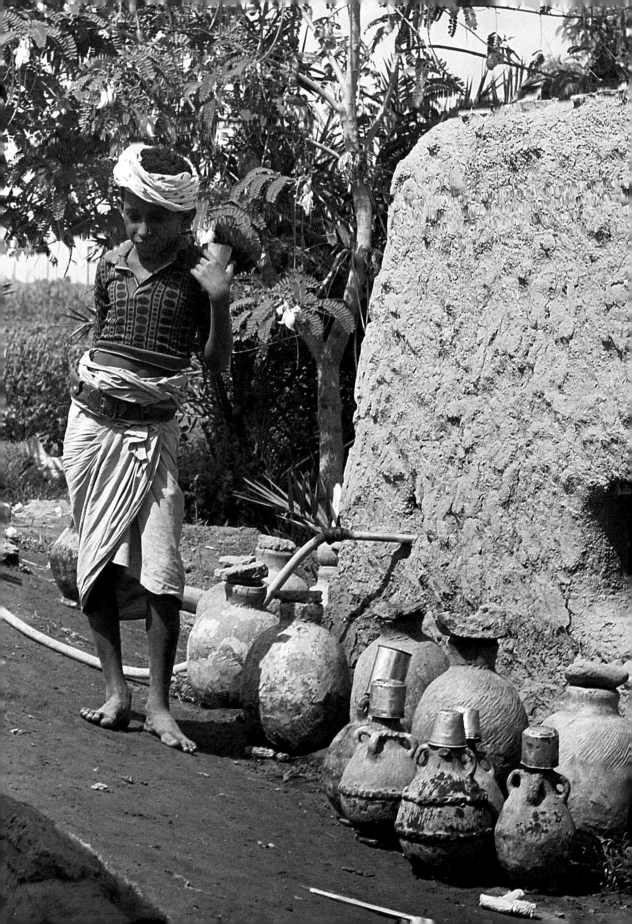

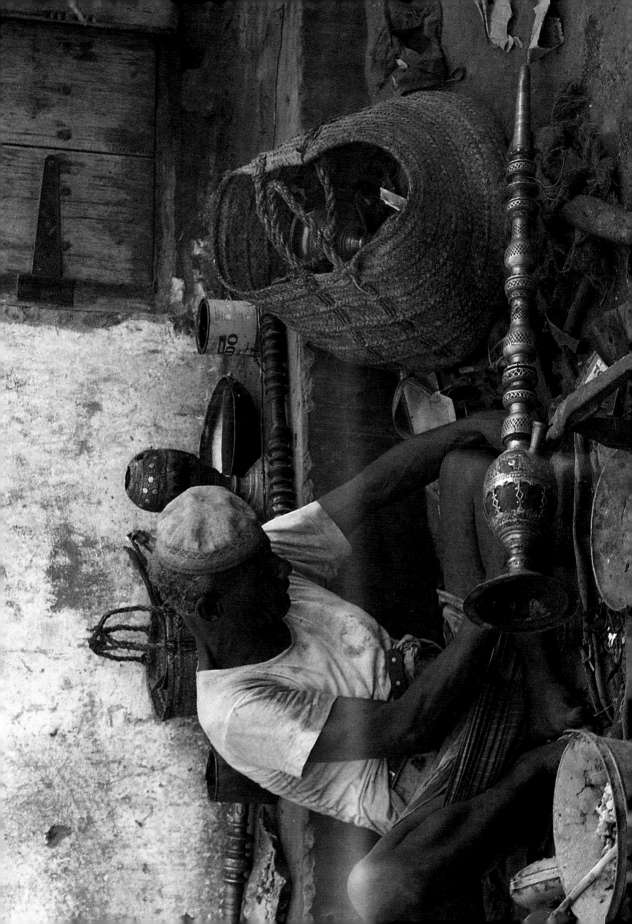

BAIT AL-FAQĪH. A man seated at his roadside "workshop" repairs a *madā'ah*. He helped me make a sketch detailing the names for the various parts of the pipe.

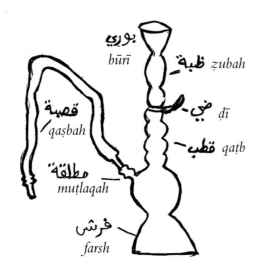

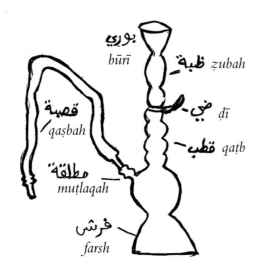بوري
būrī

ظبة *ẓubah*

ضي *ḍī*

قطب *qaṭb*

قصبة
qaṣbah

مطلقة
muṭlaqah

فرش
farsh

BRICK MAKING near Bait Al-Faqīh. Due to a lack of stone in the area, buildings in the Tihāmah are constructed from brick, (*tūb*). They are essentially of two types. The better ones are made from a mixture of straw (*tibn*) and clay (*tīn*), the inferior type from clay alone. Water is the mixing agent.

The style of building dictates which kind of brick is used. Manufacture takes place in an open wadi. The bricks, varying in length from five inches upwards, are placed first in the sun to dry for about three days, longer in the winter. They are then stacked and fired in a kiln pit for another four to five days. From the scattered pieces of straw seen in the picture these bricks may be of the superior type. The mould for the bricks can be seen behind the man on the right.

BĀJIL. These open-air markets are a common feature throughout the Tihāmah, especially around Bājil. Each location has its dedicated day of the week. They are also social venues vital for the exchange of news and gossip.

NEAR BĀJIL. A boy standing in front of a large cattle market. Cattle in the Tihāmah are mostly small and have a hump on the back near the head. They have a close resemblance to those found in East Africa. They are used not only for the provision of milk but also for drawing water from deep wells, especially when used for irrigation, and for ploughing.

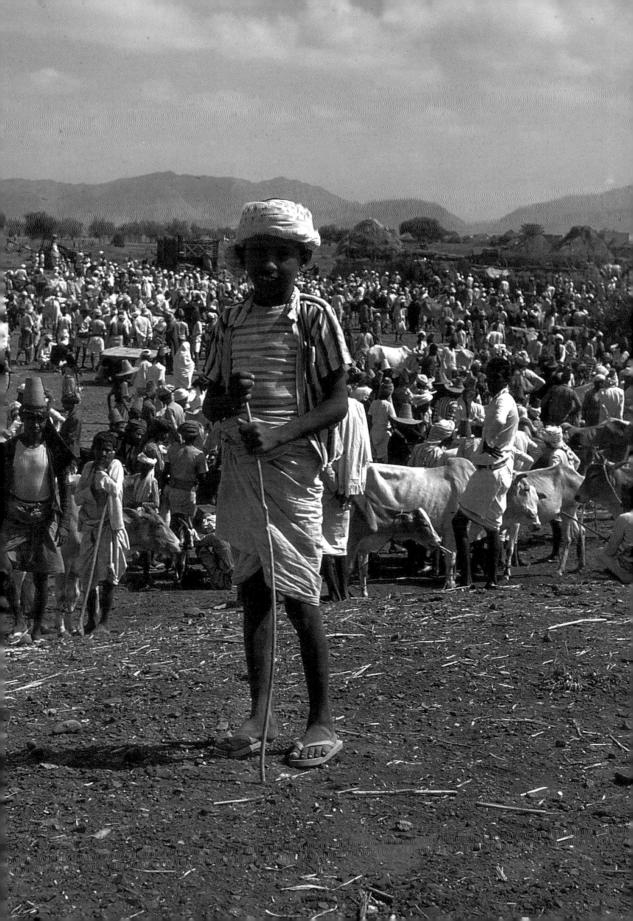

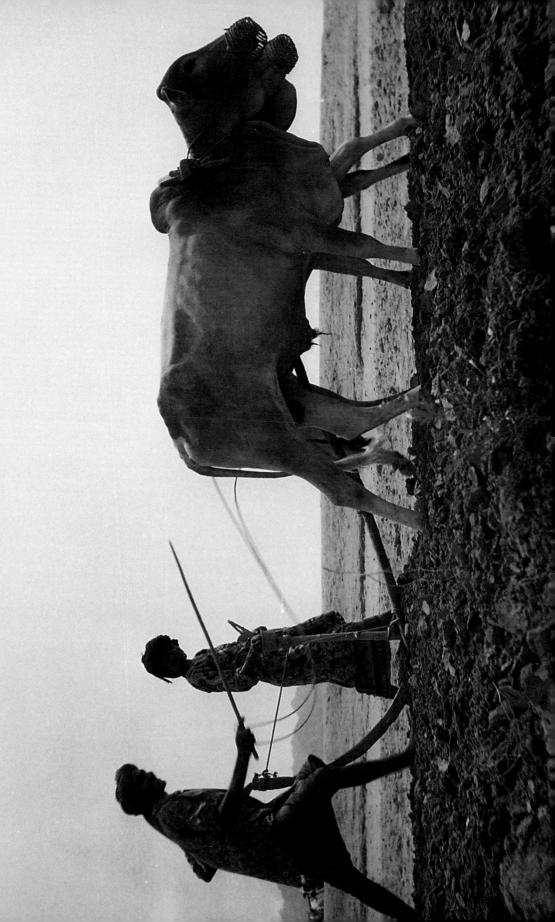

NEAR HAYS. Ploughing, using a chisel plough, and sowing take place simultaneously. The grain, as can be seen clearly from this husband-and-wife team, is sown through a funnel and tube. It is likely that either sorghum or millet (*dhurah*) is being sown here.

Note the use of the cow's front hump in harnessing the plough and the straw-woven muzzle (*fidāmah*), which we saw in those pictures of Zabīd *sūq*, being employed on the mouths of both cattle.

A BOY AT A WELL-HEAD near Wali Husainiyyah, six miles north of Zabīd. Note the simplicity, yet strength, of the pulley construction. The use of the wooden triangular object the boy is holding is not clear. It seems unlikely it has to do with drawing the water and is perhaps connected in some way with his animals waiting nearby.

This picture, as in other Tihāmah images, captures the essence of a beauty that emanates from unadorned simplicity.

Above WALI HUSAINIYYAH north of Zabīd. The same well-head as in the previous picture, but here a man is filling two rows of earthenware water vessels laid out in a V-shape to allow space for the pulley ropes. His wife and daughter are helping. The twined rope carriers are for the pots which may be carried on a shoulder, or more likely slung across a waiting donkey.

Below NEAR HAYS. A well-head in a wadi with a large number of camels in the background. Note a similar basic construction as seen in the previous picture, though this well-head has plaster facing to secure the stones. Here they are filling water skins (*jahal*, pl. *jihāl*) rather than earthen vessels. This suggests the group live farther away, are of a more nomadic nature, and are using camel transport.

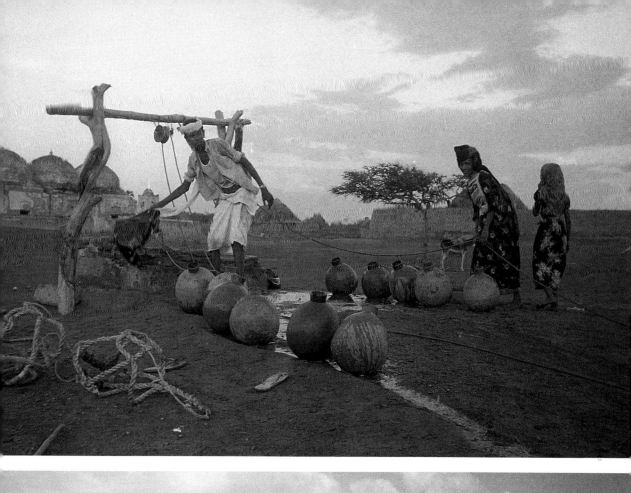

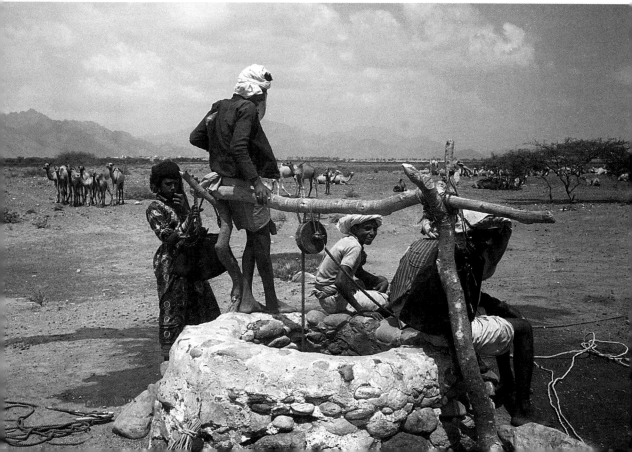

MUKHĀ. Roof domes and minaret of the Al-Shādhili mosque. Shaikh Ali bin 'Umar Al-Shādhili was a pious Muslim Sufi who settled in the area in about AD 1430. His religious orations attracted a large number of disciples who gathered there and built huts around his residence. This was the foundation point of the city, rather than the coffee trade which succeeded it. However, Al-Shādhili himself was a great advocate of coffee, proclaiming it kept people awake for their devotions and religious studies. Coffee in Yemen is still sometimes referred to as "Shādhili". But history suggests it was in fact first brought to Arabia by one Jamal al-Dīn Al-Dubāni, a *qādi* in Aden. During a visit to Abyssinia he noticed that people who drank it seemed in especially good health. On return to Aden he became ill and so sent for some. He found on drinking it that his health improved and he felt especially lively. From Aden the habit spread northwards to Yemen.

Mukhā itself had no claim to antiquity. It was the export of coffee from its harbour (it is grown in the highlands) at the start of the 17th century that put it on the world map. Both the English and Dutch East India Companies established factories (trading posts) there and carried out a lucrative trade with India and the Far East. They were followed by the French in the early 18th century, but by around 1763 the English Company had taken most of the trade from their European rivals.

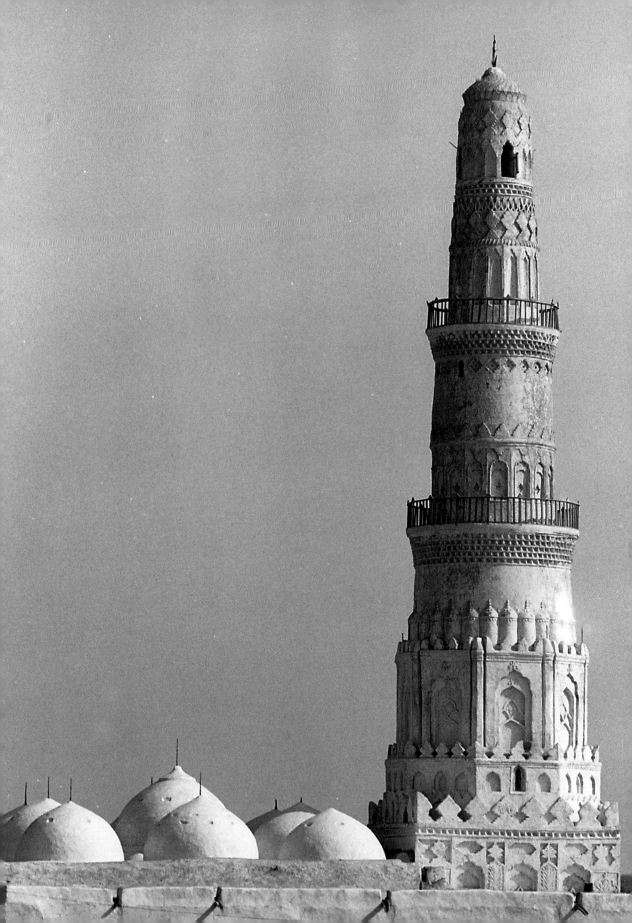

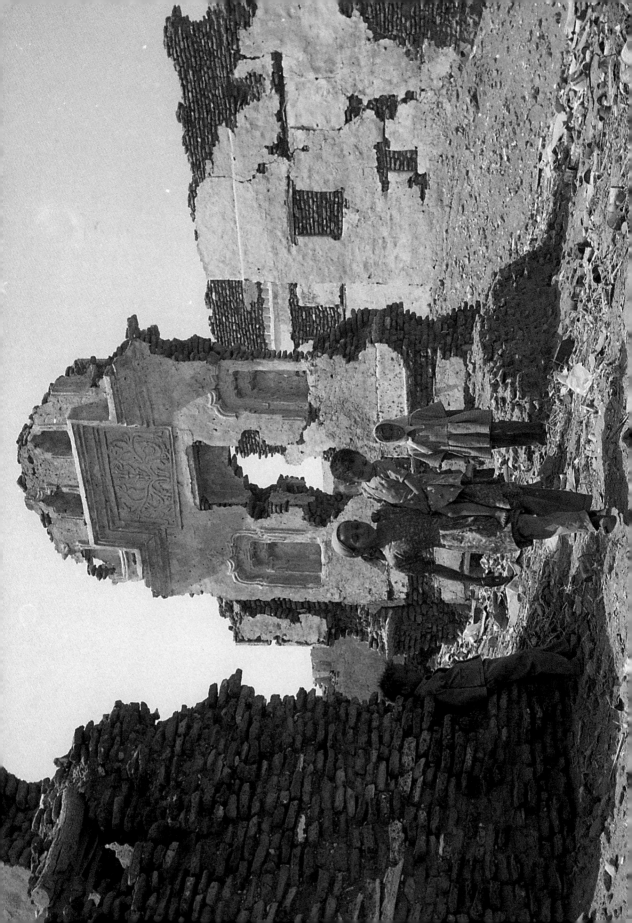

MUKHĀ TODAY has a forlorn and abandoned aspect, as evidenced by these ruins of what was probably a rich merchant's house. Note the decorated lintel above the doorway.

Visiting the remains of the old city today it is difficult to imagine its prosperous past with its palaces, ostentatious merchants' houses, mosques, grand open squares, and the large camel caravanserai needed both to transport the coffee down from the highlands, where it was grown, and to take back imports that had arrived from all over Europe. Apart from coffee, other exports included incense, ivory, mother-of-pearl and gold, whilst the imports from Europe included iron, steel, textiles and, above all, firearms.

It was the development of Aden in the mid-19th century and the transfer of Yemen's main entrepot from Mukhā to Hudaidah that caused the town's demise.

Despite its desolate air, cheerful children are omnipresent among the ruins of old Mukhā. The apparent lack of parental supervision seems a pleasing reflection on the secure atmosphere of Tihāmah society.

MUKHĀ. Two boys walking past the lone Zainab minaret with an abandoned building to the right. The parent mosque is deemed to have crumbled into the sands and disappeared. True, over the centuries the sea has gradually receded increasing the general sand level. Indeed one can see the sand gradually encroaching on the base of the neighbouring building.

However, one can understand those who are sceptical about the minaret ever having been part of a mosque as there is no obvious face indicating where it was so attached, unless it stood independently, though that is unusual. Not surprisingly some locals maintain it was once a lighthouse, the more so since the Arabic word for a minaret, *minārah* (from *nūr*, light), also means a lighted beacon. And before the sea receded it would have been relatively near the shoreline. Whatever the case, despite scholars' doubts, "lighthouse" is the caption on modern local postcards depicting it.

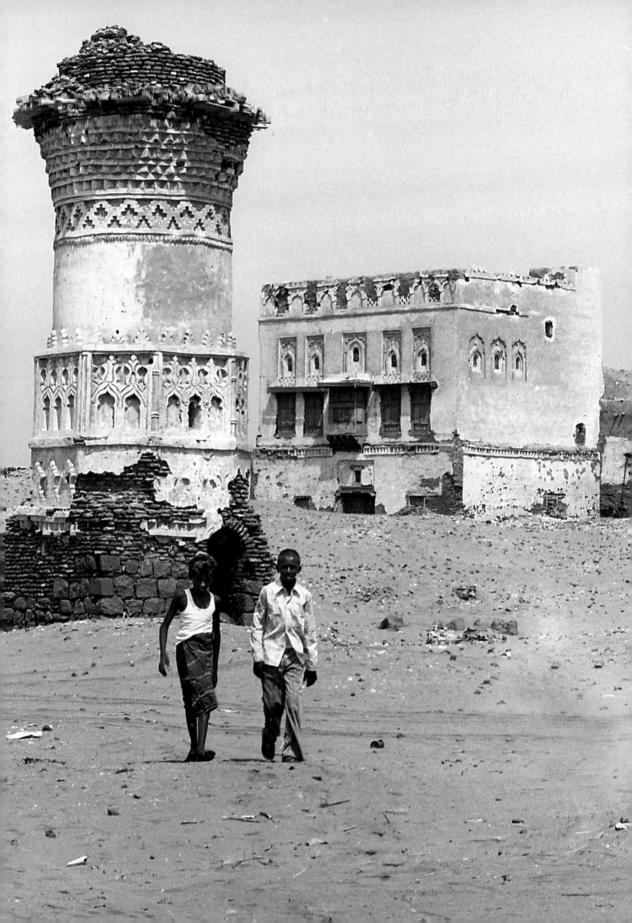

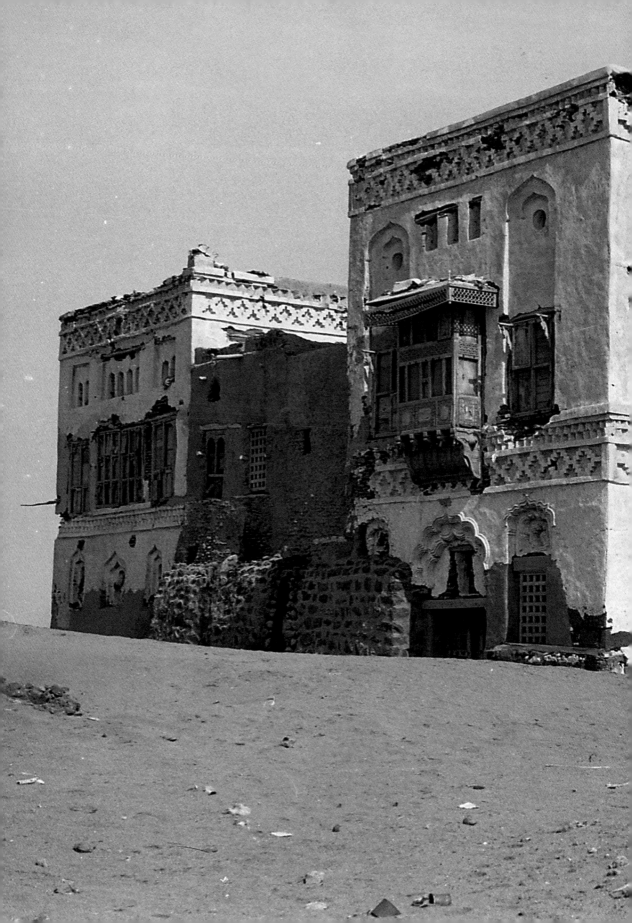

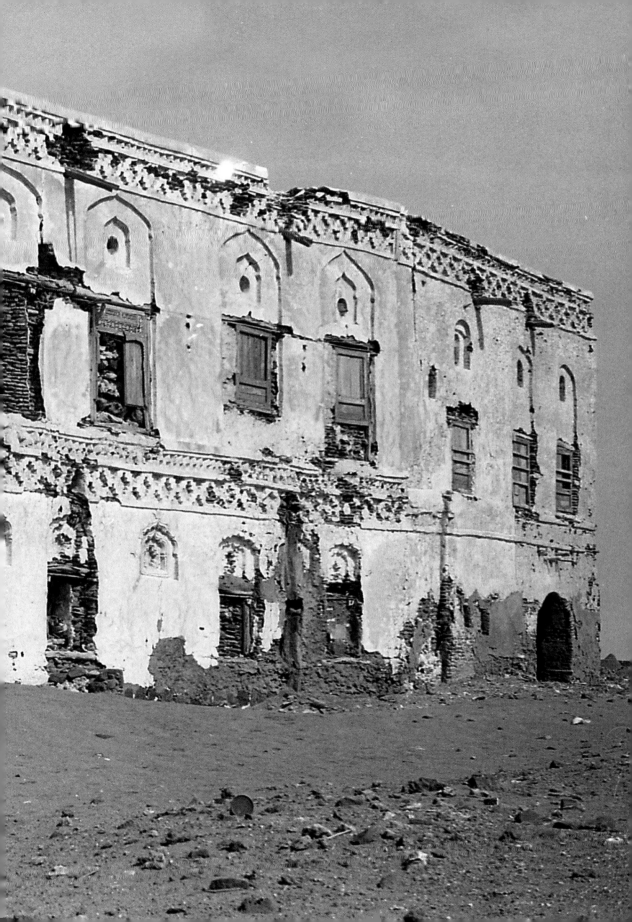

Previous page MUKHĀ. A derelict old building, one of the most substantial that still stands. It was probably some administrative headquarters combined with a warehouse, rather than the house of a prosperous merchant.

Opposite MUKHĀ. Detailed study of a decorated window frame set in an abandoned house. Note the button carvings under the sill. Tihāmah and Red Sea architecture was especially noted for the protruding carved wooden windows, the finest examples of such *mashrabiyyah*s being in old Jeddah.

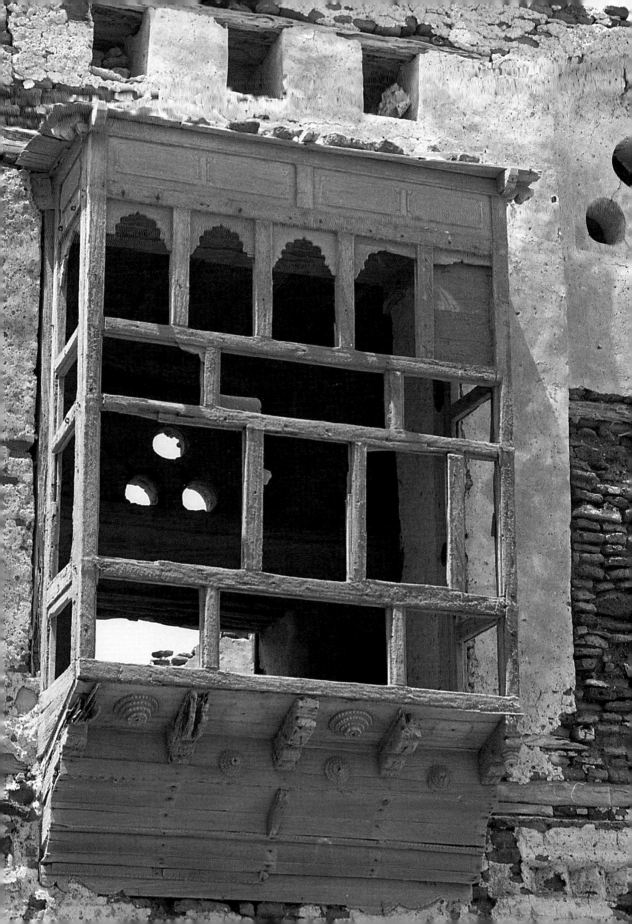

Above MUKHĀ. Children playing outside the Masjid al-Hammām, a mosque on the extreme south-east edge of the town. In its heyday, there were reportedly more than three hundred mosques in Mukhā. Although in a fair state, this one has a somewhat unused air about it.

Below MUKHĀ. Children enjoying a game of football outside the tower (*burj*) in which Freya Stark was housed by the governor of the town when she made an overnight stay on her way from Aden to Sana‘a in 1940. We made mention in our Prologue of how she was overcome by nostalgia when she saw it. She related to me the following story when revisiting the site thirty-six years later:

> As a guest of the Governor I had been given a comfortable bed and was falling asleep when I saw a lone figure creep into the room. Frozen with terror I feigned sleep as the figure, which I then recognized as the Governor himself, drew near. He then placed something cold and metallic against my face before creeping out again. Suddenly the object burst into sound; it was a cylindrical music box. I thought I was coming closer to losing my virtue that night than at any time before, and in retrospect since, including the nights I spent with Stewart.

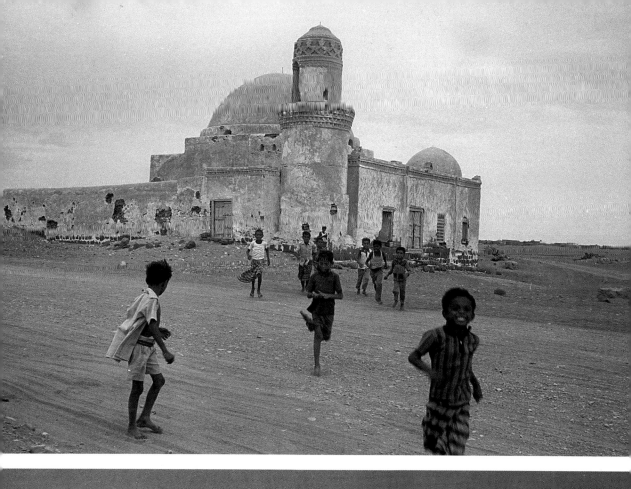

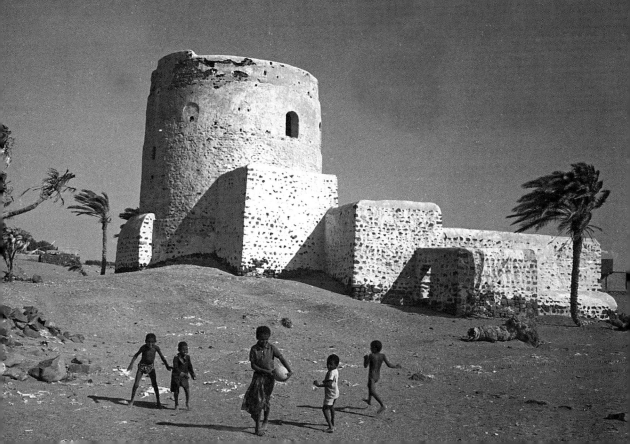

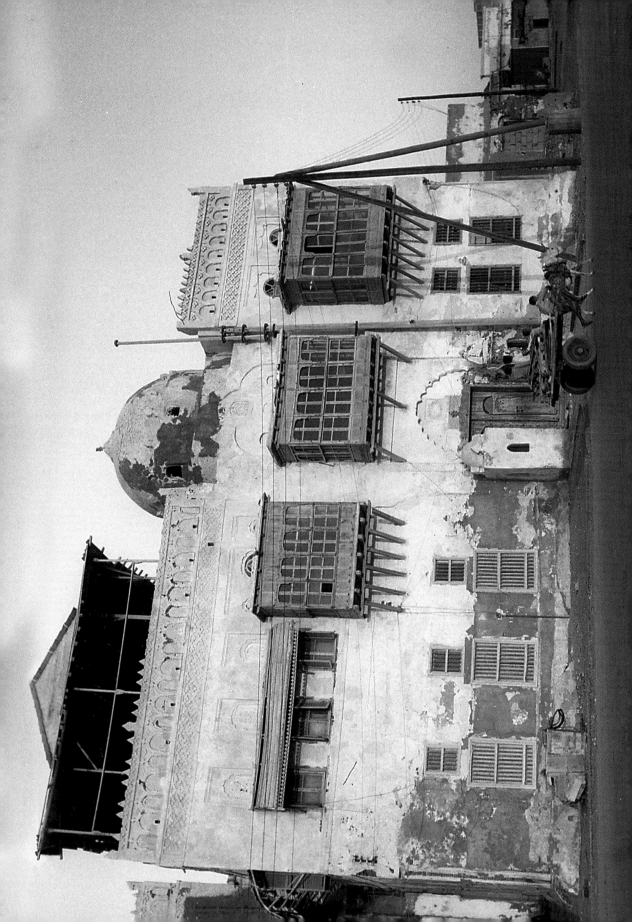

HUDAIDAH, the Governor's old palace. Travelling progressively northwards, we now move from the southern to the northern Yemeni Tihāmah. The large Red Sea port of Hudaidah can be considered the boundary point between the two.

Hudaidah grew in importance after the second Ottoman invasion, in the 1840s, when it became the chief Turkish base and port of entry. It took much of the trade away from Mukhā. In 1918, at the close of the First World War, it was bombarded and occupied by the British who, in 1921, handed it over to the Idrīsi ruler of 'Asīr (then independent but now forming south-west Saudi Arabia) who had been loosely allied to the British during the war. The common interest was a fear of a Turkish advance on their respective territories. The Imām regained it in 1921, only to lose it again briefly to the Saudis during their war with Yemen in 1934.

What is often known as Red Sea architecture has an obvious strong Ottoman influence and differs widely from that of the highlands. Richly carved protruding wooden window boxes (*mashrabiyyahs*) are a common feature. Some of the interior decoration of the houses reflects Indian and other Far Eastern influences, a result of sea trade. As elsewhere along the Red Sea coast, many houses are in a very poor state of repair and may not last long.

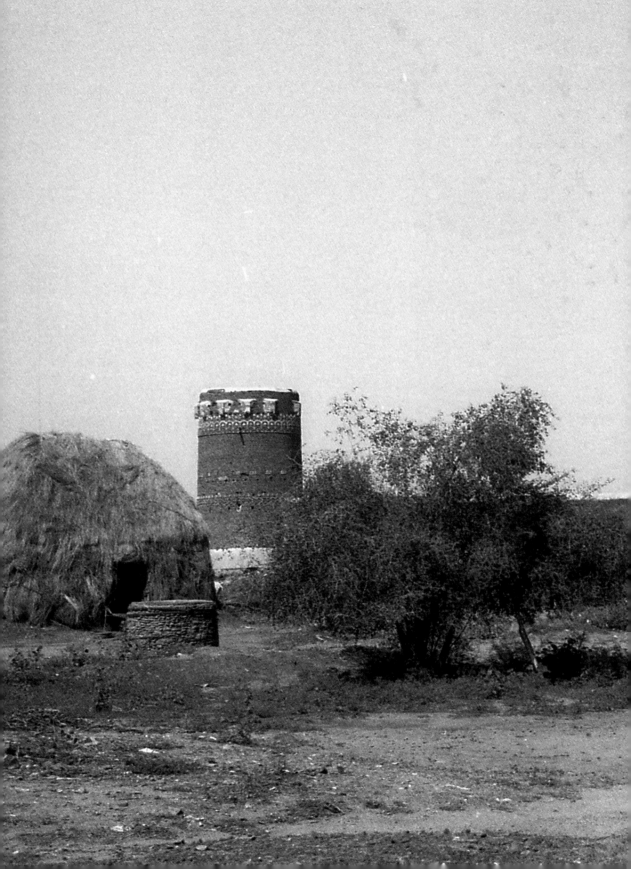

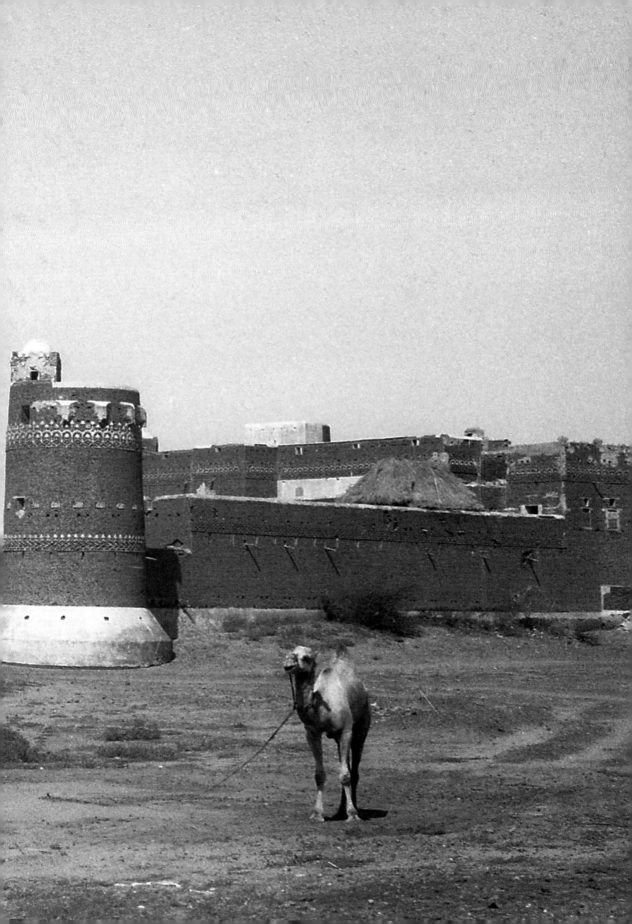

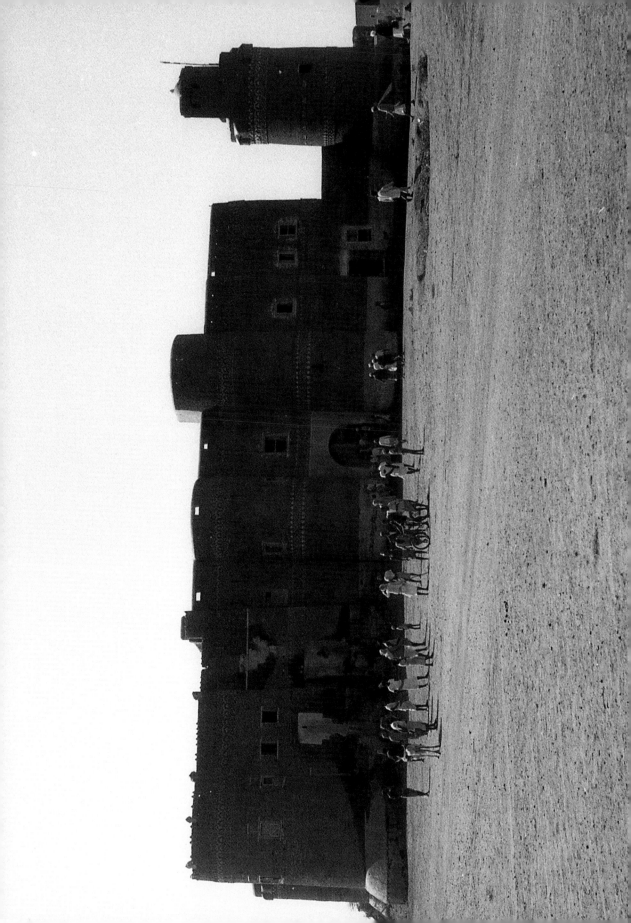

Opposite THE FORT AT AL-DAHI from the south-east. Whilst the town dates from the second Ottoman period the fort itself, as seen here, was built in 1934 at the time of the Saudi–Yemeni war. The mud bricks were taken mostly from the ruins of the nearby mediaeval town of Al-Mahjām, like Al-Dahi in the Wadi Sirdūd. At the time of the Rasūlid dynasty (AD 1229–1454), Al-Mahjam was the northern capital of the Tihāmah, a twin to Zabīd in the southern part.

Previous page THE FORT AT AL-DAHI from the north-east. Al-Dahi lies some twenty-five miles north of Hudaidah on the edge of the wide Wadi Sirdūd. As was common in several Tihāmah coastal towns it grew up around the tomb of a great saint or *wali*, Ismā'īl Al-Hadhrami, who died in AD 1296. It is the scene of a large visitation, *ziyārah*, each year. Carsten Niebuhr spent a whole day in the town in early 1763, after landing at Al-Luhayyah and making his way south. In his book he notes the mosque "built around the tomb of Ismā'īl".

Niebuhr also comments on the manufacture of earthenware "prepared in the open air without a furnace", a tannery and the manufacture of indigo "of poor quality and sold at a cheap rate and used by local women who wear blue shirts and drawers". (There seems a suggestion the blue might remain when they took them off!) Most of these crafts, including pottery, are still practised but in an updated manner.

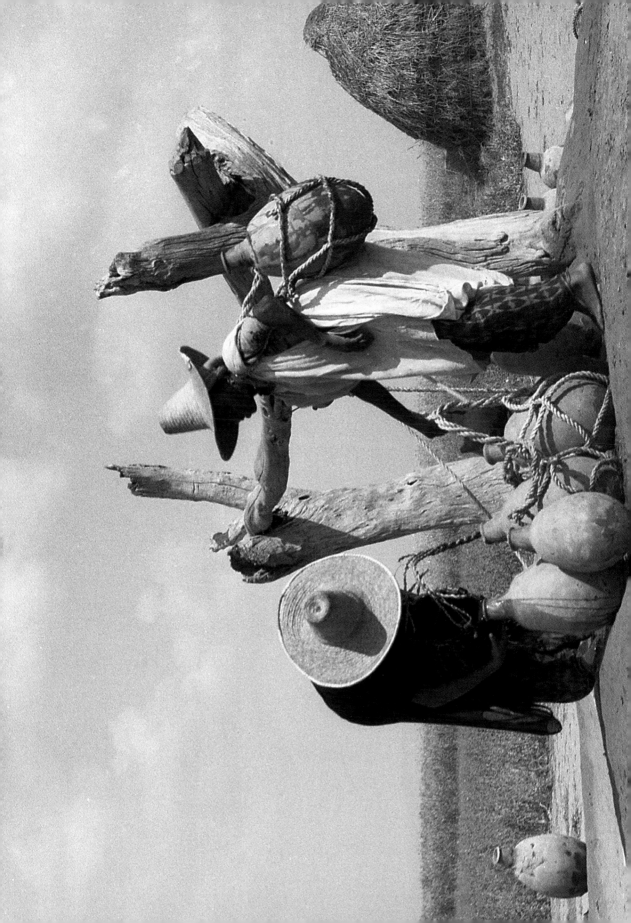

NEAR ZAIDIYYAH, northern Tihāmah. Two women drawing water from a well-head wearing the broad-rimmed straw hats, *zullah*, appropriately named from the Arab word *zull*, shade. An umbrella is a *muzallah*. Note the rope vessel carrier slung across the woman's shoulder. (We saw some on the ground in the picture on p. 215.) Quite a weight when the vessel is full.

FREYA STARK deep in conversation with a Tihāmah woman near Zaidiyyah, both of them wearing broad-brimmed *ẓullah* hats!

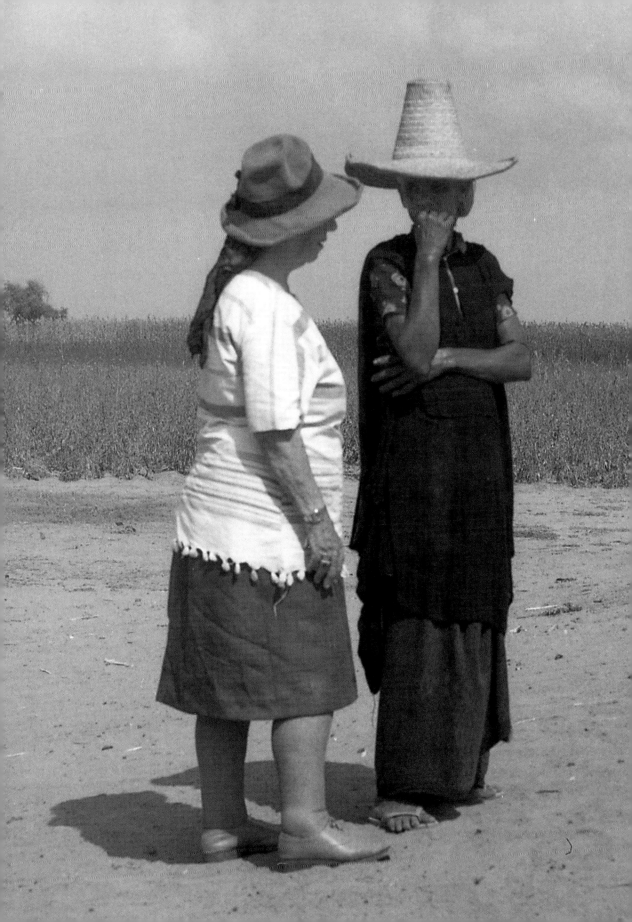

Opposite WADI MAWR, inland from Al-Luhayyah. A man squats while weaving dried long grasses into rope, or basketry cordage. We saw the results in the *sūq* at Zabīd. The long grasses used grow in the wadi.

Following page NEAR AL-MU'ARRAS, northern Tihāmah. Cattle stand in an extended line in front of conical straw thatched huts, *'ushshah* (pl. *'ushshāsh*) or, more generically, *'arīsh*, which are of African appearance and likely origin. The roofs are supported by a central pole and the top of the dome is tied by rope. The inside walls are lined with *dhurah* (millet) stalks coated with clay, which are usually painted in colourful designs and arabesques and hung with mats. The floors are raised and coated with clay to withstand cooking fires. High rope-woven Tihāmah beds arranged in circular fashion provide the furniture and complete the domestic effect. The huts are sometimes surrounded by thorny brushwood stockades, *zarībah*s, both to define territory and to confine animals.

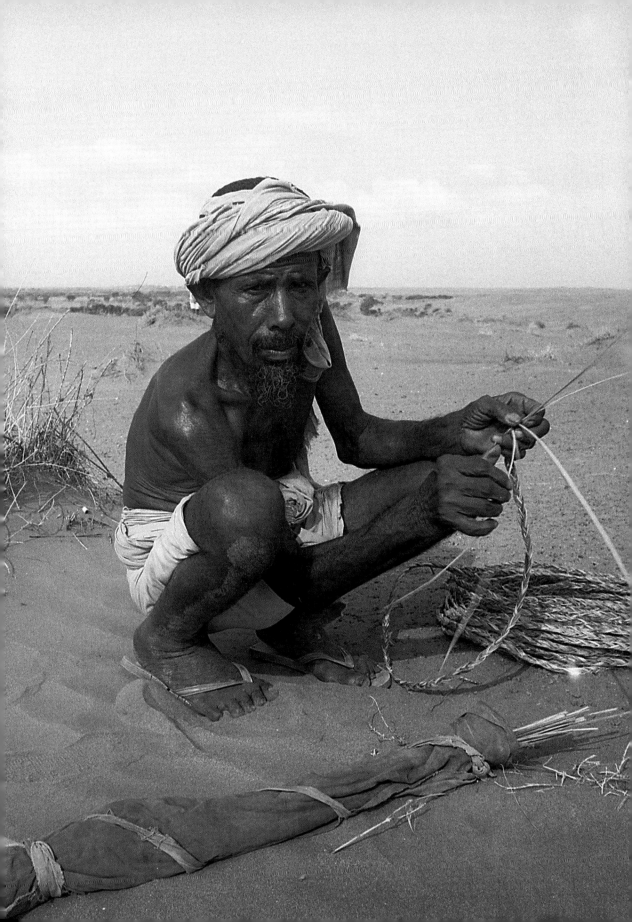

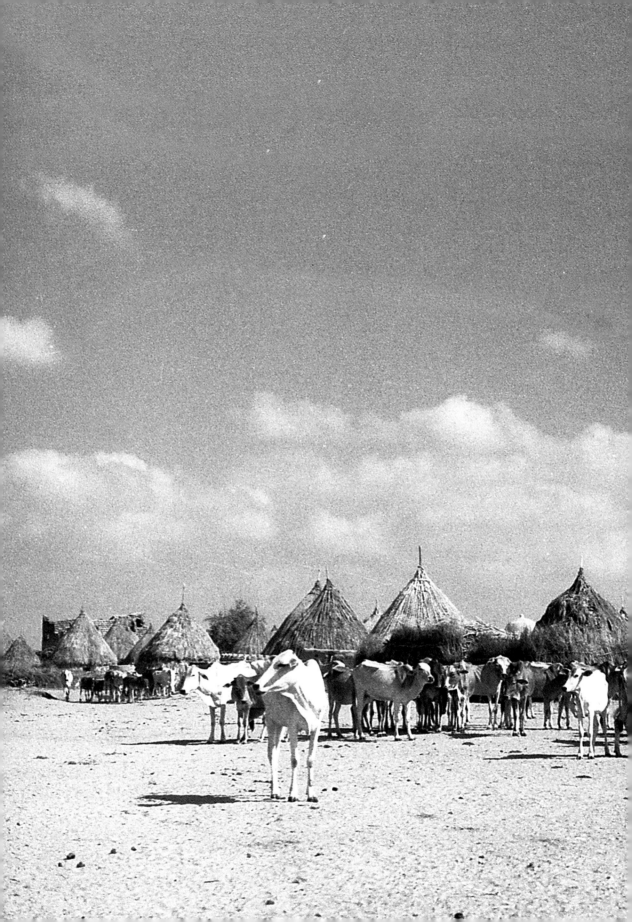

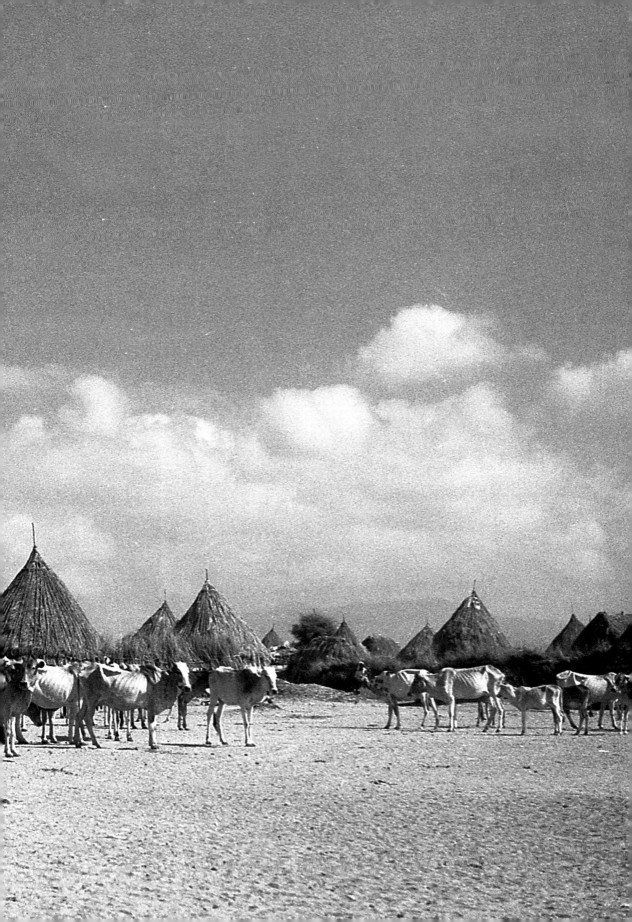

NEAR AL-MU'ARRAS, northern Tihāmah. A lone boy with a stick across his shoulders stands in front of an *'ushshah* hut settlement, wearing a broad-rimmed *zullah* hat. These broad-brimmed hats tend to be "unisex", though the women's ones sometimes have a smaller conic section. Similar to the small *khayzarān* (cane) fez-shaped hats, these closely woven *zullah*s can hold water temporarily. Loosely woven ones might provide better ventilation, but would not be so multi-purpose.

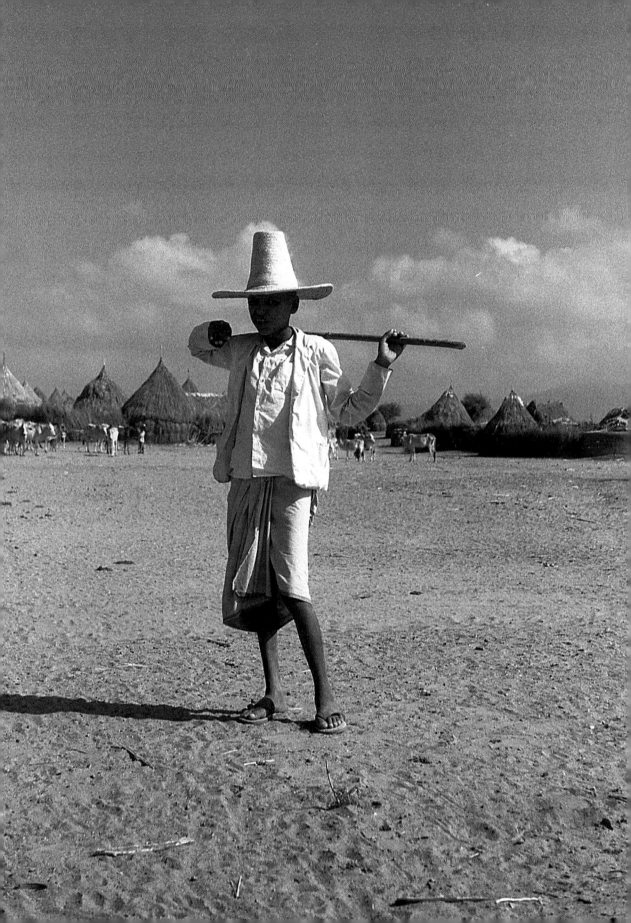

Above NORTH OF AL-MU'ARRAS. A Tihāmah boy leading a camel laden with brushwood crosses a somewhat desolate landscape.

Below NEAR AL-MU'ARRAS, northern Tihāmah. A solitary man in lone country walks with seeming intent to nowhere!

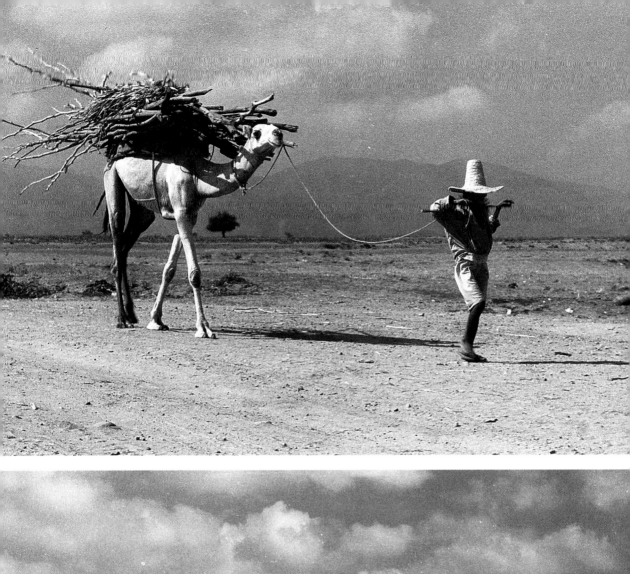

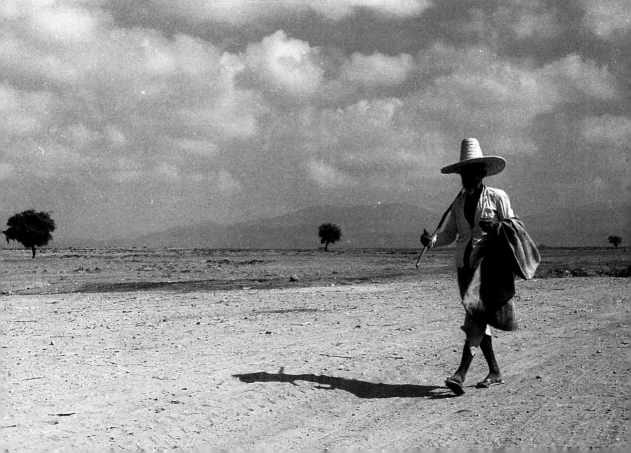

NEAR AL-ZUHRAH, east of Al-Luhayyah. Freya Stark with her beloved Leica, talking to a group of women by a crude *'ushshah* hut shelter. All of those to whom she spoke were both surprised to see a European lady and impressed by her fluent Arabic.

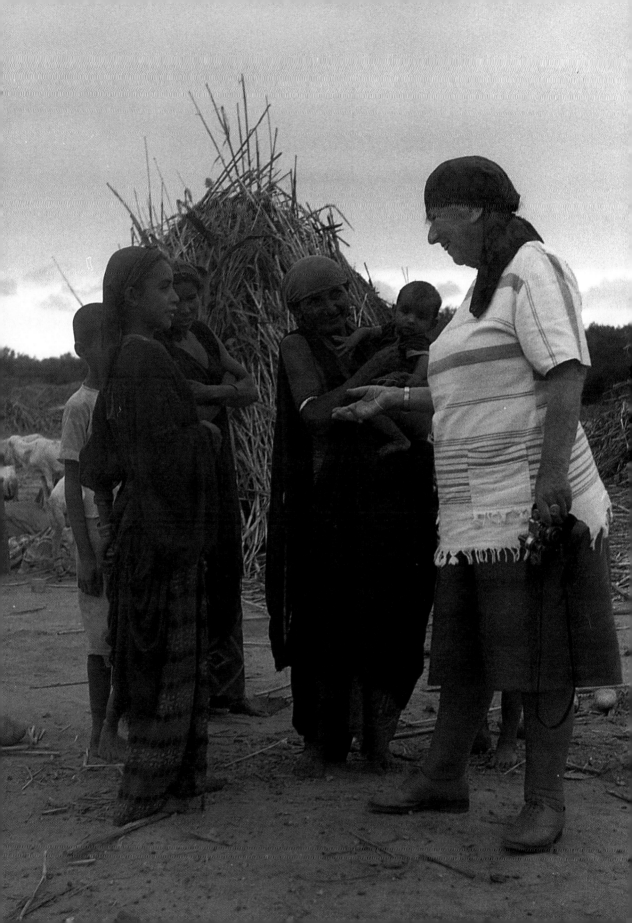

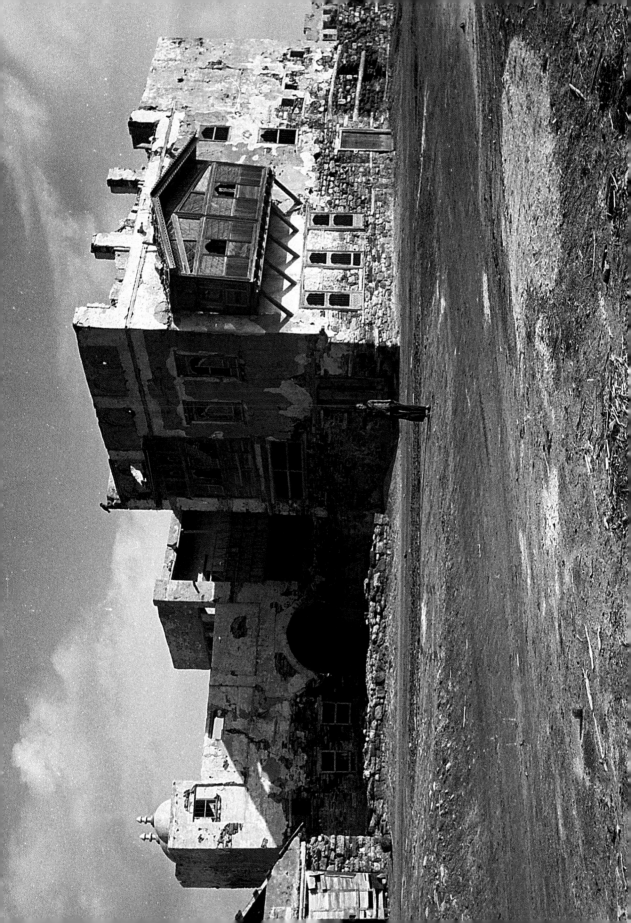

AL-LUHAYYAH. Old Ottoman house near the waterfront. Al-Luhayyah, founded in the 15th century, has an interesting history, not least as a convenient landing point for foreign invaders. It was founded by a Muslim saint, Shaikh Sālih, who built a house on the shore and spent the rest of his life there. After his death a "house of prayer" was raised above his tomb, and subsequently embellished, by degrees, in a manner similar to all the *wali*s we have seen. It became a rival port to Mukha for the export of coffee, being closer to Jeddah, and a number of Egyptian merchants settled there. As a consequence its architecture is a mixture of Ottoman, Egyptian and indigenous influences. It also became a disembarkation point for pilgrims before their making the overland journey to Mecca.

It is perhaps most famous in the West as the place where the Danish six-man expedition under Carsten Niebuhr landed on 29 December 1762. He was given a friendly reception by the governor, and on his unescorted departure south wrote: "Travelling being as little exposed to danger in Yemen as in any country in the world." He had yet to visit the highlands! During the First World War it was attacked by the Idrīsi of 'Asīr and in 1915 bombarded by British naval vessels in their support. (See Hudaidah caption.) It was finally occupied by the Idrīsis in 1918, recovered by the Imām in 1925 and again from the Saudis after the war of 1934.

The town is built on a slight rise and can become an island when the sea exceeds in its advance. The old houses were built of stone and coral taken from the reefs. But the coral, although first dried, has not withstood subsequent years of moisture and the houses are crumbling fast. As this picture was taken some forty years ago, little of the building, and others similar, may now remain.

ROOM FOR ONE MORE. Near Harad, the Yemen frontier town with Saudi Arabia, Yemeni Hajjis return from their pilgrimage to Mecca, in January 1971. They have been on the road for five days and will need another two before they reach Sana'a and their homes. At this time there were no metalled roads south of Taif in the southern Hijāz, until Hudaidah was reached. (I was going the other way and had another five days before reaching Jeddah.)

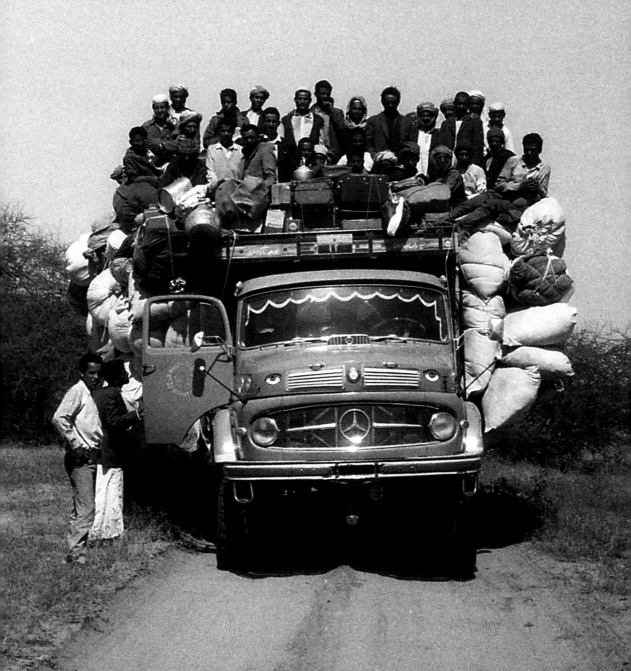

SA'DAH AND THE JEWS

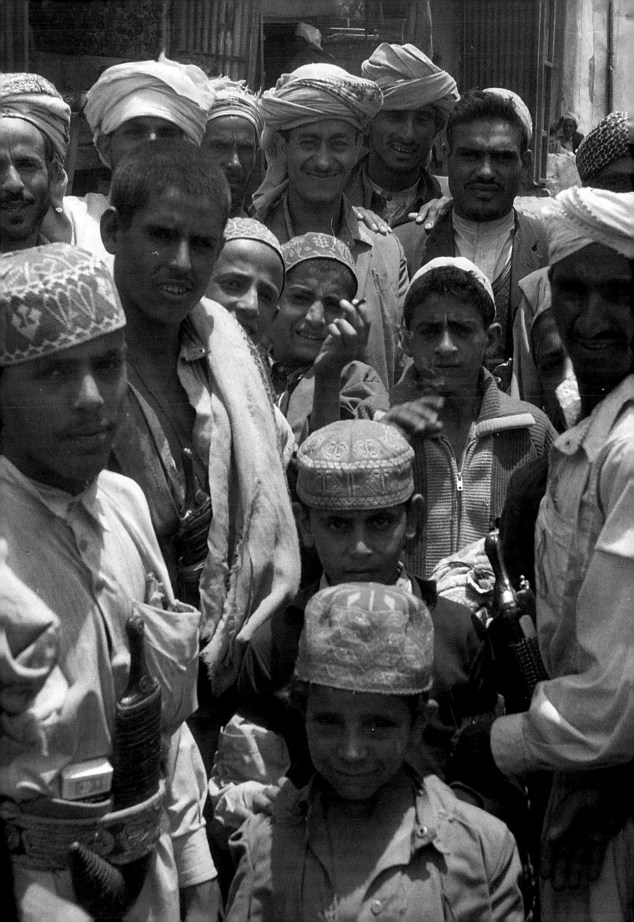

THE REDISCOVERY OF THE REMAINING
JEWISH COMMUNITY

MY AMBITION TO visit Sa'dah had a double motivation. First, its
description in the 1946 Naval Intelligence Division Geographical
Handbook, *Western Arabia and the Red Sea*, commences: "The town of
Sa'da, as yet unvisited by European travellers ..." Challenge enough,
though by 1970 there had been a few, such as a Swiss Red Cross mission
in the mid-1960s treating the civil war wounded, and visits by Eastern
Europeans employed by the United Nations. Also there had been one or
two foreign mercenaries working with the Royalist forces during the
civil war, camped outside the town itself, before they were forced to
leave. But I doubt whether any of these had much interest in the history
of the area. Second, while I was in Jeddah in the mid-1960s, I had learnt
from representatives of the exiled Royalist government that their forces
had had to flee from their traditional stronghold of Sa'dah on the arrival
of Egyptian troops. They were now secure in caves around Amlah further
north and were being looked after domestically both by the large number
of Jews already settled there and by the Jews who, fearing aggression, had
also fled from Sa'dah. I was amazed, disbelieving even, having, like others,
accepted that "Operation Magic Carpet" had resulted in the total exodus
of Yemen's Jews.

In May 1971, after the end of the civil war, and Britain's recognition
of the Republic, I made one of my periodic visits to Sana'a. Having a
few days to spare, on the spur of the moment and at my own initiative,
I sought permission from the then Prime Minister, Muhsin Al-'Aini, to

Opposite "My visit caused surprise, but no suspicion or hostility."
Curious but friendly faces greet my arrival in the city in May 1971. For
most I was perhaps the first Englishman they had seen.

visit Saʿdah. I explained this was one corner of *Arabia Felix* I had yet to visit. He saw no problem, commenting only that from the aspect of his job it was more *Arabia Infelix*.

I boarded an ancient DC3 Dakota, the crowd being held back so that I could obtain a seat. With Yemenis standing in the aisle, as on a London bus, we taxied off to the sound of banging on the door from those still trying to climb aboard. There were no seat straps, as these had been cut off to make dagger belts. We made three attempts to land on the desert airstrip outside Saʿdah. I subsequently discovered that a young Yemeni apprentice was "under instruction" from the Yugoslav pilot. On the ten-minute journey to the town itself I found myself sitting in the back of an open truck next to a Yemeni, who described graphically how he had personally killed a leading Zaidi prince, Abdullah bin Hassan, in July 1969. His boasting of this confirmed clearly that this was no longer a Royalist stronghold.

The town itself, housing within its main mosque the burial place of the first Zaidi Imām, Al-Hādi, was impressive. The clustered buildings, some rising to four or five storeys, were surrounded by a fifteen-foot-high wall with a wide inner rampart. I made the ritual two-mile walk along its length. The Egyptians had made a breach in the wall, the Bāb Hamdān, for their own use, but this had now been resealed. Some of the narrow streets were built with a gate at each end so that the quarter could be shut off at night. Baths, built by the Turks, were still in use.

My visit caused surprise, but no suspicion or hostility. I was accommodated in a shared *majlis* on the top story of a high building in the city, Bait Madaghah, overlooking the tallest, Bait al-Qarwāti. The house belonged to a wealthy merchant, Husain Madaghah, and was often used to accommodate government guests including, in the mid-1960s, the Egyptian Field Marshal ʿAbd al-Hakīm Amer. Husain's many sons soon became my companions. Early next morning, I went on to the roof

and sketched the 360-degree layout of the town, remembering those lines in that *Geographical Handbook*. Later, walking the streets, I caught sight of my first Jew. He was with a group near the bottom of a ladder at a building site. There was no doubt he was such, the shoulder-length side hair ringlets, *simnār*, giving him away. I later met him astride a donkey. We spoke and he, Yahūda, invited me and my Arab companion to his home at Ghurāz, a settlement about four miles outside the walls. We stayed there for several hours and chatted to his family. I was fascinated, and learned a lot, but wanted to know more.

The next day, at Yahūda's suggestion, my previous day's companion and some of his friends bumped across the desert in the back of a truck for some thirty minutes to Dimmāj. This was another settlement where most of the Jews of this area were now living. Scarcely had we entered a house but a sheep was slaughtered in our honour. We had no option but to stay the night. My Arab companions were hesitant. Whilst they mixed freely during the day, none had ever stayed overnight in a Jewish home. It was well known that the Jews made a potent wine; the grapes of Sa'dah are famous for this. They feared they might be accused of a night of loose living. In the event most left at dawn; like naughty children, they were anxious to regain the town without being spotted.

It was an evening to remember. The striking features of the dozen Jews in the room were accentuated by lantern light. Some of the men worked with silver filigree as they spoke. Our host's wife, Walla, breastfed her child. It was a biblical setting, literally. It was self-evident that these people have indeed kept culture, religion and language pure for over two thousand years. We talked into the early hours before I was given a comfortable bed on the roof. The stars were so luminous that I was able to write my diary notes by their light. Freya, as indicated from her letters we have quoted, would have loved it.

Next morning I discussed the localities and numbers of the

remaining Jews. My hosts identified for me some twenty-one separate *baits* (settlements) each named after the leading families who first settled there. They were divided between the *Yahūd al-maghrib,* the western *baits,* and the *Yahūd al-mashriq,* the eastern ones, which contained the majority of the population. The western *baits* were at Sa'dah, Khawlān Ibn 'Āmir in the extreme north-west, Sāqayn, Haidān (we recall from the introduction that the northern Jews were often known collectively as "Haidāns"), Raydah, Arhab and Al-Shaghādirah (west of Hajjah).

Of the eastern *baits,* two were at Amlah, where those Royalists had taken refuge after being driven from Sa'dah. One, the Bait Sabāri, called thus after an *'aylūm* (a respected elder) of that name, is the largest settlement still in Yemen and was thought to have its own synagogue. Others were at Gharīr, Wadi Āl Abū Jubārah near Kitāf, and at Kitāf itself. Evidence of the kinship amongst these scattered communities is that my hosts were able to divulge all this detail spontaneously. From a total of the number of adult males given for each *bait,* I was able to assess that some four hundred heads of families remained. Assuming that each family had additionally a total of four or five other adults and children, I estimated that the total number of Jews remaining was about 1,700. But that was probably well on the conservative side.

Apart from that estimate of numbers, I also gained insights into their way of living and recent history. They were emphatic that the Jews had fared better under the Zaidis in the north than among the Shāfi'is in the south. They regarded themselves first and foremost as Yemenis. After all, according to their own account, they had been in the country since the invasion of Judaea by Nebuchadnezzar and might even pre-date the Arabs in Yemen! Amongst themselves they spoke only Hebrew and observed the Jewish calendar, feast days and prescribed periods of fasting. Few were seen outside their houses on a Saturday. Literacy among males was total. Children were taught at home, not at the local schools. Both

religion and language had been passed down through the generations with no outside influences. Religious services were held at home. With the exception of Amlah, and possibly Sāqayn, there were no longer any synagogues. The population was too fragmented and dispersed to warrant them. The women remained unveiled and mixed freely with the men, sitting only on different sides of the room. Polygamy appeared to be practised. Boys were circumcised on the eighth day after birth, similar to the custom of the Arabs in the area.

In appearance and dress the Jews might, at first sight, appear similar to the Arabs, but they tended to be taller, fuller fleshed, have higher cheekbones and clearer complexions. The women maintained a more youthful appearance after childbirth than their Arab sisters. This may be due to less physical exertion in the fields and elsewhere. All Jewish males affected the shoulder-length plaited side locks, *zinnār*, often shaving the rest of the head. Their headgear was the customary Arab *kūfiyyah*, but worn loose. I saw none wearing the traditional Jewish black skullcap. They used names in common with the Arabs such as Yahyā and Yūsuf, but they also used Jewish ones such as Dā'ūd and Yahūda. The name Ezra is never used because of that curse he laid on them in the 5th century BC for their refusal to return to Jerusalem. Senior male leaders are given the honorific *'Aylūm*. The most common names for women are Walla, Ghusna, Zahra, Suhra and Sāra. Whilst amongst themselves, as mentioned, they spoke only in Hebrew, they were bilingual in Arabic. Sometimes, where it was more convenient, they wrote brief passages of Arabic in the Hebrew script, as we might write Arabic phonetically. The Jews were employed variously as shoemakers, silversmiths, alabaster dressers, stonemasons, carpenters, builders and armourers. Previously, they had worked in the local iron mines.

There were now no Jews living inside the walls of Sa'dah. They had moved out during the civil war between the Royalists and Republicans,

fearing the effects of Egyptian bombing and deliberate targeting by them. But they still owned property in the town, especially in the Hārat al-Dawār quarter, where they are landlords to the Arabs who rent their houses. During their temporary exodus, none of their property was touched or looted by the Arabs. From my observations there appeared to be complete harmony and social intercourse between Jew and Arab, both fraternizing in the traditional *qāt* sessions. The Arabs acknowledged to me that the Jews were the more hospitable.

The Jews were able to practise their religion with complete freedom, each family having its Jewish bible, the Torah (Pentateuch), in Hebrew. One I saw was inscribed "Printed in Poland, 1930". But the scarcity of these was a concern. An example of the tolerance shown by the Arabs was demonstrated by an *aiylum* reading a passage in Hebrew and then translating it into Arabic. The Arabs present nodded in unison in acknowledgement of its sagacity. When I eventually left Sa'dah, one of my Arab companions gave me a list of things he wanted me to send him: a copy of *Playboy Magazine* or similar, a cassette tape of the song *Never on a Sunday*, and five new copies of the Torah for his Jewish friends.

The Jews maintained close contact with their scattered communities throughout the North and gathered together for weddings and circumcision ceremonies. They had virtually no contact with those who had emigrated to Israel in the 1948–50 exodus, even though some five thousand had had to leave from the Sa'dah area alone. Those who remained were able to do so only by bribing the Imām's officials. One told me that his father had had to give a bribe of 2,000 Maria Theresa thalers in order to stay.* As for the Arabs, most wanted the Jews to

* It is difficult to equate that into current cash equivalents as a thaler's value is based on its silver content, which can vary. When I first went to Arabia more than fifty years ago it was common currency and tribesmen would bite the coin. The softer the bite the higher its silver element was believed to be, and thus its value. Only in the last forty years or so has it ceased to be quoted in the financial presses. Today in Britain one could expect to pay about £10–13 for a thaler.

remain, fearing a loss of irreplaceable skills. They regarded the community as something special, not to be surrendered. Despite this, the Jews confirmed that some of the restrictions placed on them from earlier centuries, which we listed previously, remained. These included an interdict on occupying any government position, including service in the armed forces, acting as a guarantor or carrying arms. Some, strangely, wore an empty dagger sheath, while others secretly carried a pistol for personal protection. But the Jews maintained that their lot was considerably better under the Republic than it had been under the Imāmate and that the harsh restrictions decreed by the Imām Yahyā in 1906 had fallen into abeyance. They included such privations as being forbidden to live in houses higher than those of their neighbours (the roof on which I slept overlooked all others in the mixed settlement); to discuss religion with Muslims (we have seen that this is no longer so); and being obliged to have a child adopted by a Muslim on the death of the father. However, it remained that no Jew could marry a Muslim girl unless he converted. Only one such case was on record in the previous ten years, while there have been seven cases of Jewish girls having to convert on marrying Muslims.

As I left Dimmāj with my remaining Arab companions, all the Jews of the house in which we had been staying lined up and kissed our hands, and then burst into tears. It was so moving I had to choke back my own. During my last night back in Bait Madaghah I reflected on how those remaining Jews lived in such surprising harmony with their Arab neighbours. There was nothing to suggest that picture of "gloom and depression" those early explorers in the 18th and 19th centuries had found.

My four-day visit to Sa'dah ended all too soon; it had been a voyage of discovery. I had missed my flight and had to return to Sana'a in the Governor's Toyota. There were no made roads and it was a twenty-four-

hour journey. We were not, as I had been warned, held to ransom by marauding pro-Royalist tribesmen, though I noticed money changed hands occasionally. Indeed, I found no residual pro-Royalist sentiment during my entire visit. We stopped only for a brief tea break at Raydah, the most southerly point where Jews were still found. An Arab approached me with a revolver in pieces which he had given to a Jew to repair but who had been unable to reassemble it. After some minutes of examination, I told him a vital pin was missing. When I got back to Sana'a and was preparing for bed, it fell out of my trouser turn-ups. I sent it back with an apologetic note, just catching the Governor's driver before he left.

The following day I again called on the Prime Minister, thinking it expedient to relay my activities. On telling him about the remaining Jews, he looked genuinely astonished: "But it is not possible; there are no Jews left in Yemen." He took some convincing.

As mentioned at the start, my visit to Sa'dah was entirely on my own initiative. No official sanction was sought and, whilst interest was shown, no publicity was given to my discovery, the feeling being that it was best to leave things as they were.* But subsequent to my visit, when some years later Sa'dah and the North became open to the more intrepid tourist, knowledge of these remaining Jewish settlements filtered out. As a result there were renewed efforts by the Israeli government to persuade them to emigrate to "the homeland". Some did, but further disasters befell those who stayed, especially in 2008–09 with the advent of Islamist extremism in the north. At the time of writing, March 2010, it is reported that the remaining Jews of Sa'dah and the surrounding areas have been driven out by rebel Hūthi tribal extremists, several being killed in the process. Some two hundred Jews remain in the area of Raydah further

* My original record of these findings is now available at the British National Archives at Kew, and a synopsis was carried in the *Jewish Chronicle* of 26 April 2002.

south and around seventy-five are under the protection of the government in the capital, Sanaʻa. Of those who have left Yemen in the recent exodus a few have sought asylum in Britain, settling with the ultra-orthodox Jews in the London borough of Hackney. How sad it would be if this presages the actual final exodus of this ancient community from their Yemeni home.

SA'DAH. "I was accommodated in a shared *majlis* on the top storey of a high building, Bait Madaghah, overlooking the tallest, Bait al-Qarwāti."

Bait al-Qarwāti viewed from the balcony of Bait Madaghah. The picture shows clearly the separate structural layers of a typical Sa'dah house. The top layer is built from kiln-dried mud brick, *ājur*; the middle section from a deep sun-dried mix of mud and straw, *midmāk*; and the base layer from stone, *hajar*, with a mud plaster covering, *milāj*. This latter has to be renewed every ten years or so. Note the use of ibex horns to decorate the top corners of the house, perhaps an echo of pre-Islamic custom.

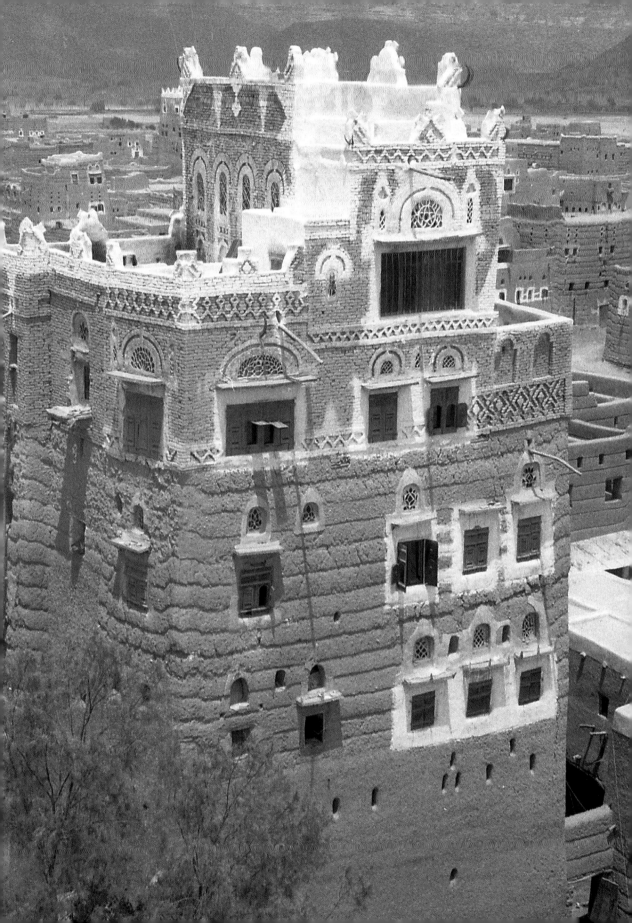

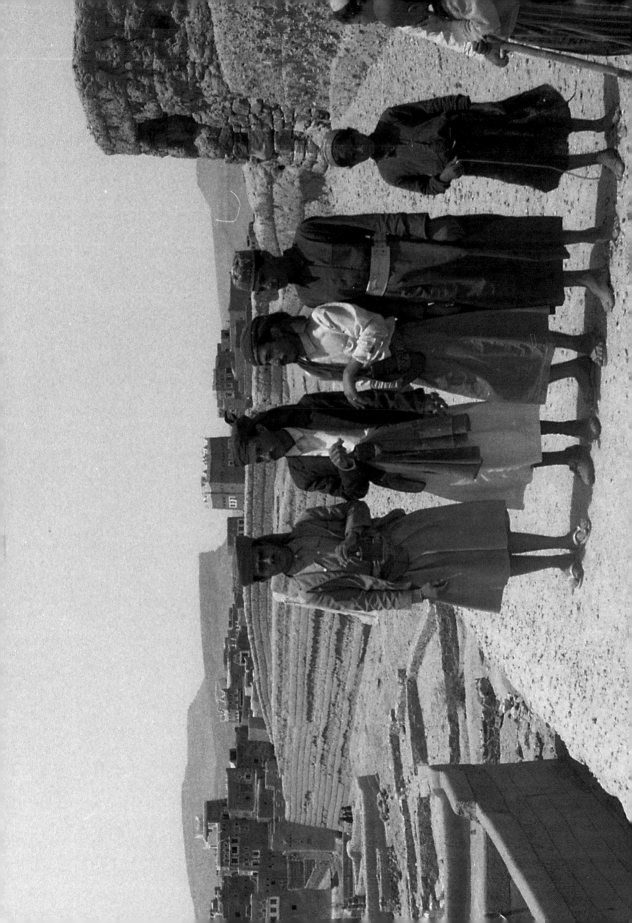

SA'DAH. "The clustered buildings, some rising to four or five storeys, were surrounded by a fifteen-foot-high wall with a wide inner rampart. I made the ritual two-mile walk along its length."

A group of local people standing on the twelve-foot-wide inner rampart of the walls that surround the city. One can gain some idea of the height of the wall and the staged layers, *zabūr*, required in building such, from this view of its inside as it bends to the left.

Within these massive thick walls are three gates, Bāb al-Yaman, Bāb Najrān and Bāb Mansūrah.

SA'DAH. Walls surrounding the Hārat al-Maidān quarter of the city in which both Bait al-Qarwāti, the tall building to the rear (the ibex horns on the corners can be seen) and the lower Bait Madaghah to its right, are located.

The picture shows clearly the construction of a typical boundary wall. They are built in stages, *zabūr*, as can be seen from the lined layers. Each is built from a dense sun-dried mix of mud and straw, *midmāk*, and is allowed to dry for about two weeks, depending on the weather and time of year, before the next is commenced. The walls of the city itself, which are much higher and thicker, are built of the same *midmāk* construction.

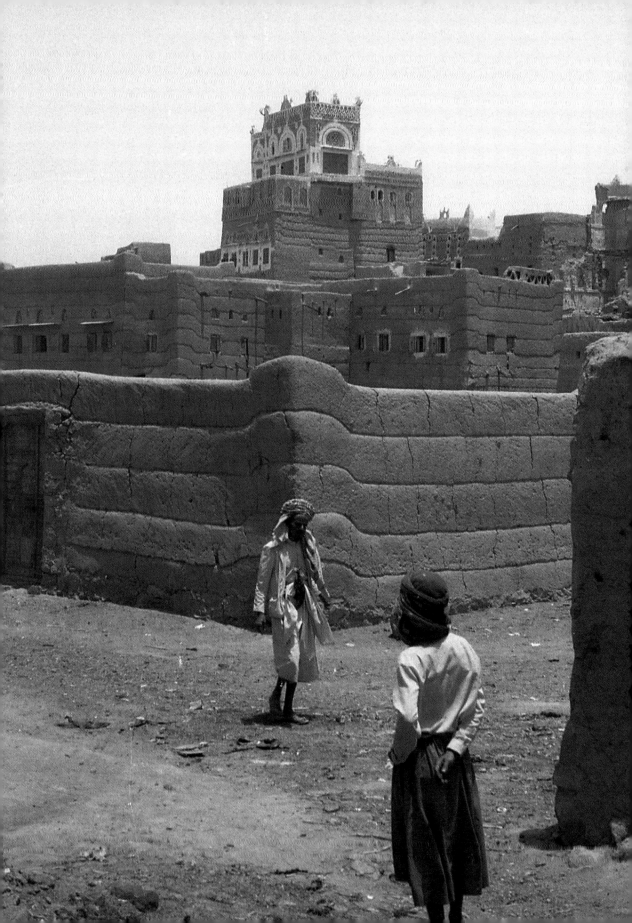

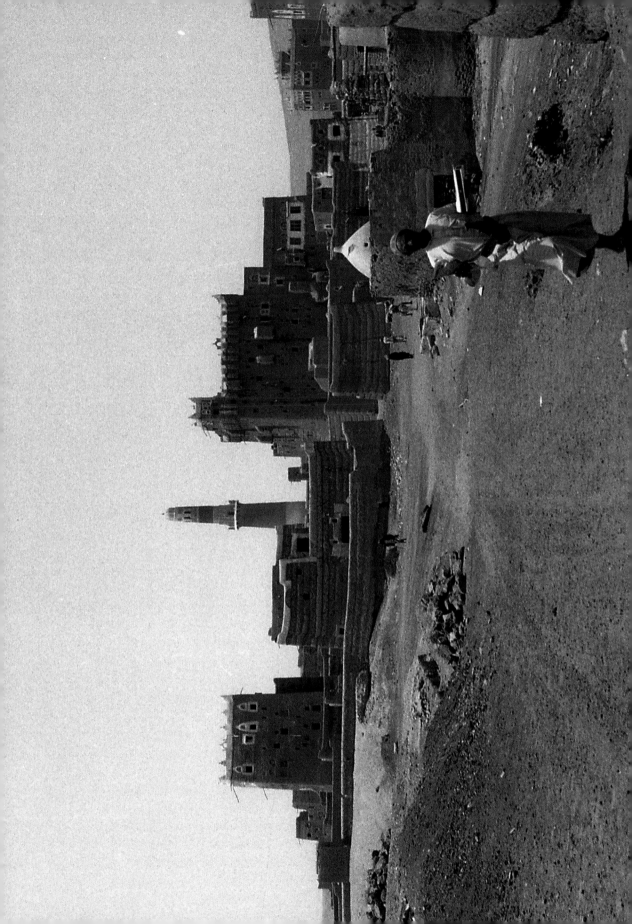

SA'DAH. A view of the city showing the minaret of the Imām Al-Hādi mosque, burial place of the first Zaidi Imām. Again one can see the typical *zabūr* sections of every wall.

SA'DAH. The Masjid Al-Hādi, mosque and burial place of the first Zaidi Imām, Yahyā Al-Hādi. Arriving from Basra he declared himself Imām in AD 897 and ruled until 911.

The smaller minaret to the left is that of the original mosque. The taller one to the right was built by the Imām Sharaf al-Dīn some three hundred years later when the mosque was extended. Today the joint mosques are known as Al-Jāmi' al-Saghīr and Al-Jāmi' al-Kabīr – the small and large mosques.

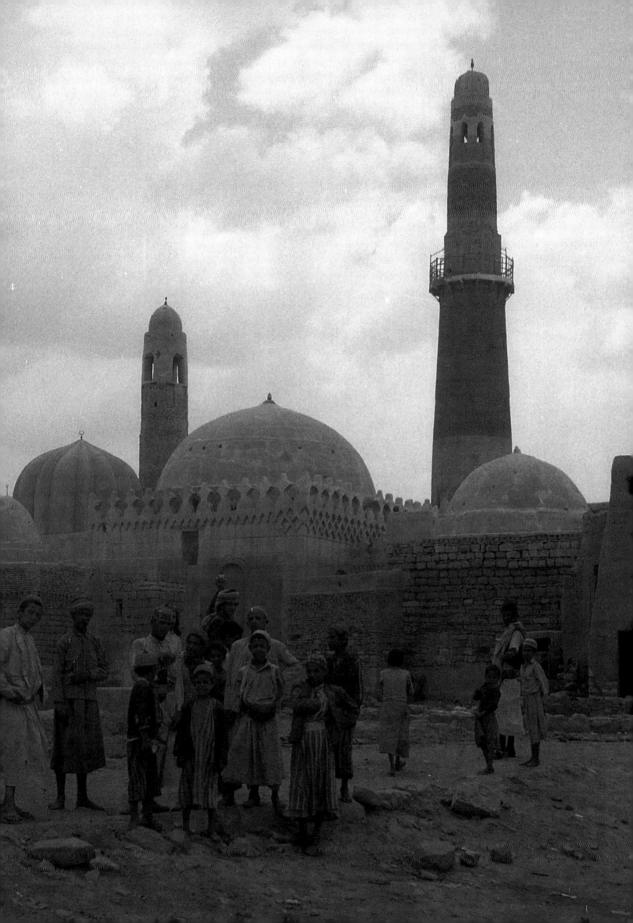

Opposite SA'DAH. Deepening a well in Shaikh Fayyid Al-Majli's garden at Rahbān, a small garden settlement about a mile west of the city.

The large number of people employed in lifting from this well is both because it is very deep and because they are not lifting water from it but clearing out accumulated sludge. Note the man to the left standing on the wall, emptying a bucket full of it.

Following page SA'DAH. The Hārat al-Darb quarter viewed from Bait Madaghah looking northwards. The larger white-washed windows give light into the *mafraj* or sitting room. The small apertures below are to allow for smoke emission from the kitchens and rooms where bread is baked.

As already noted the mud-plaster facing, *milāj*, on these houses has to be replaced every few years; it can be seen here beginning to crack and fall off in places. The house on the right again displays clearly the separate structural layers of kiln-baked bricks, *ājur*; sun-dried mix of mud and straw, *midmāk*, and the lower stone-based layer, *hajar*. The bricks were formerly set with a special salt-infused mud, but today normal cement is used. The shaped white crenellations, *sharānif*, on the tops of the buildings are made from a mixture of course-grained sand, *qadād*, and gypsum whitewash, *juss*.

The style of building differs from that of Sana'a but, as throughout Yemen, it depends to a large extent on the materials available locally.

274

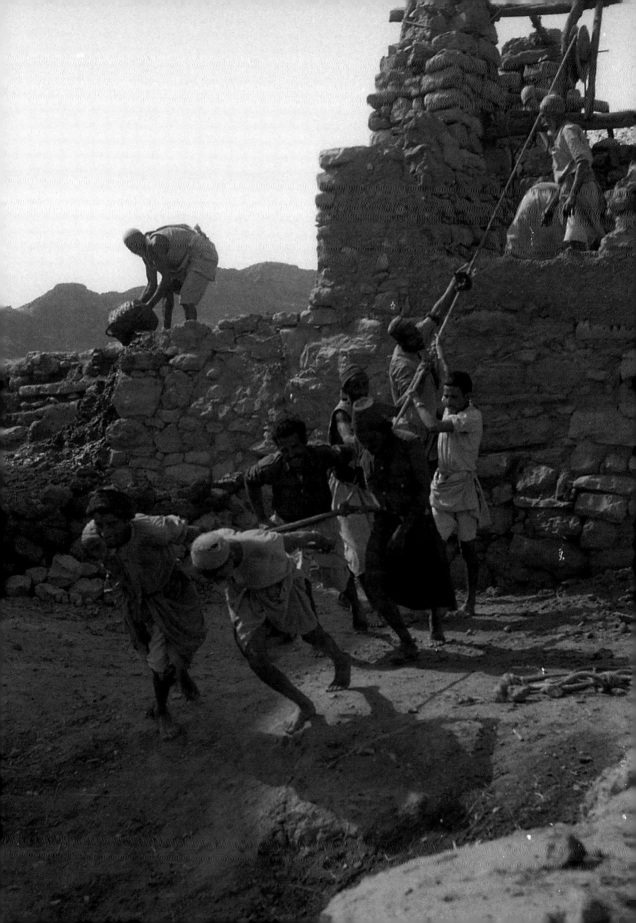

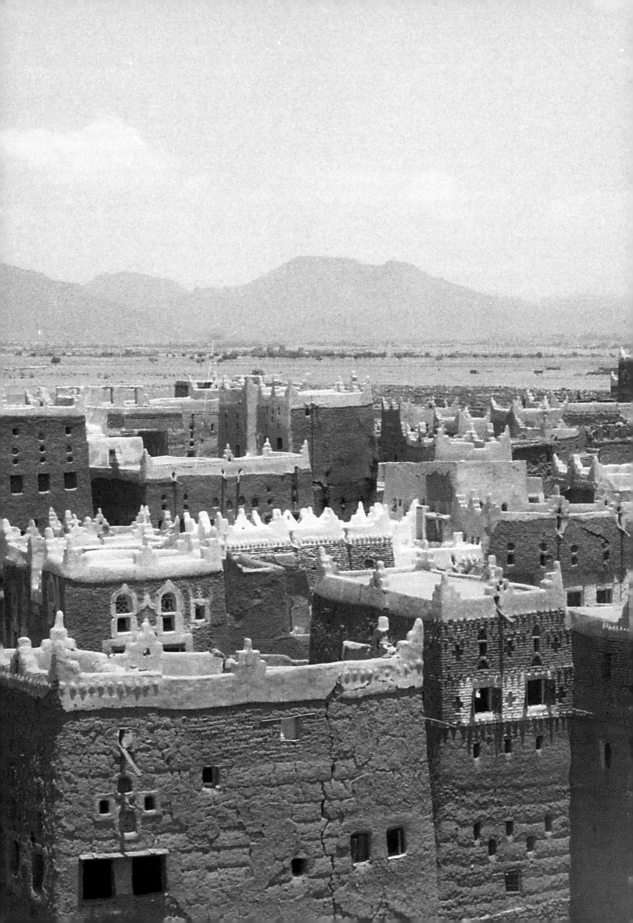

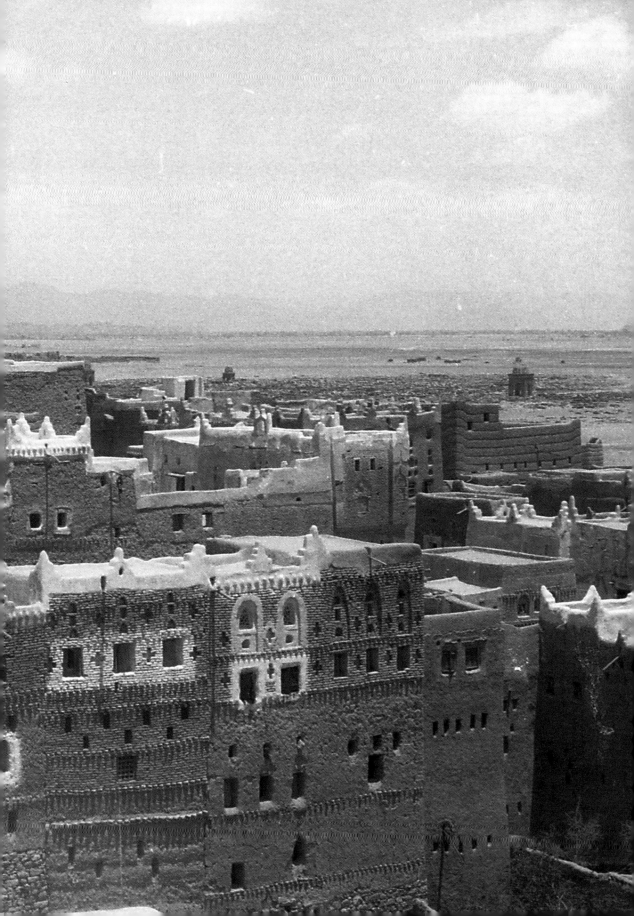

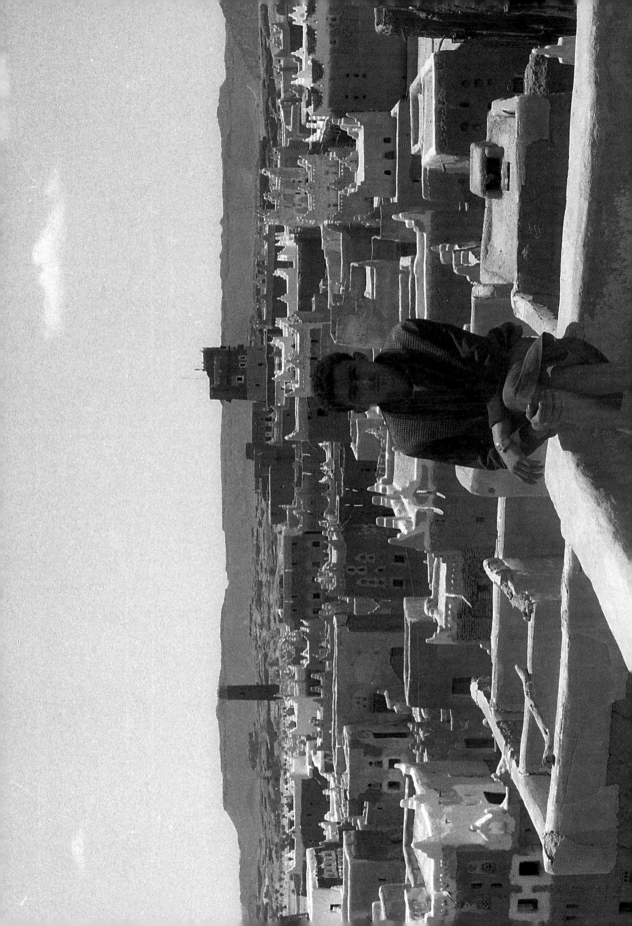

Opposite SA'DAH. Another view of the city from the rooftop of Bait Madaghah looking southwards, with one of Husain Madaghah's sons sitting in the centre. The tall building in the background immediately behind him is Al-Qishlah, the army barracks. The minaret to its left is that of the Masjid Al-Subaih, and next to it (not seen) is the city's main bakery. A tunnel links Al-Qishlah with the mosque and the bakery so that soldiers can reach both in case of siege and bombardment.

Following page SA'DAH. View looking east from the roof of Bait Madaghah, showing the Hārat al-Jarbah quarter. Clearly seen is the damage caused by Egyptian bombing before the Royalists were driven out of the city during the 1960s civil war. Some seventy houses were destroyed. The minaret of an old mosque, the Jāmi' Al-Dhawīd, is seen left centre, and on the extreme left a small section of the city wall, which bends and kinks in a very irregular manner.

279

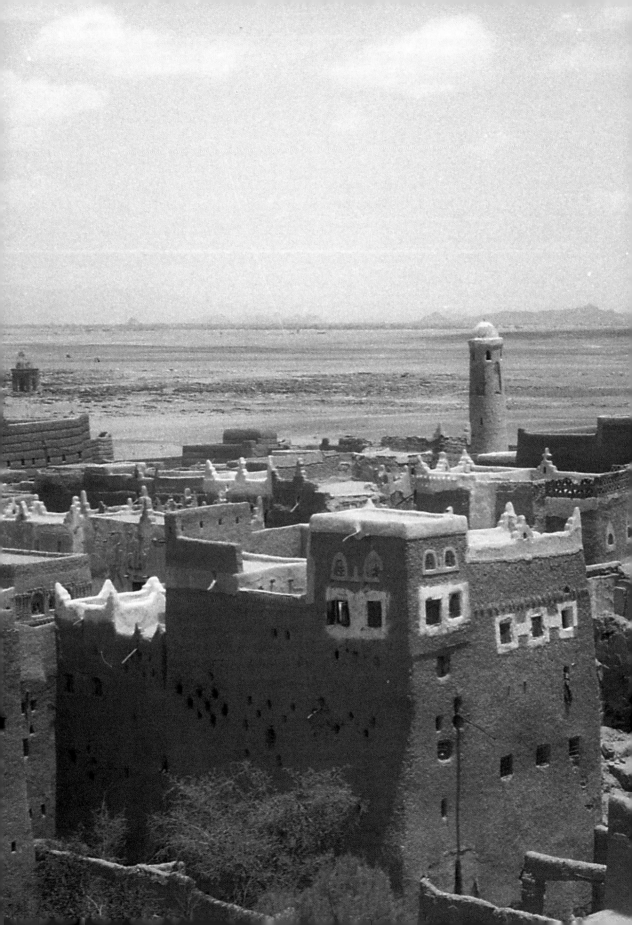

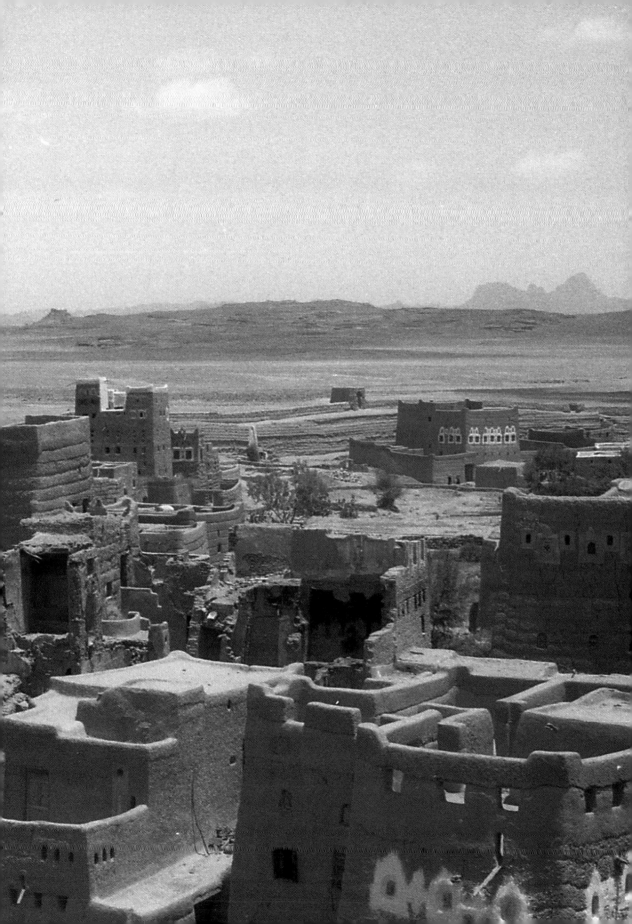

SA'DAH. "Later, walking the streets, I caught sight of my first Jew. He was with a group near the bottom of a ladder at a building site. There was no doubt he was such, the shoulder-length side hair ringlets, *zinnār*, giving him away."

Yahūda, as I subsequently discovered was his name, is in the centre with his face turned. The house behind is known as Bait Al-Sarīm. The owner, Muhammad Al-Sarīm, is sitting with his face turned on a top cornerstone of the adjacent building under construction. A wealthy merchant, he both makes, and sells, daggers (*janbiyyah*s).

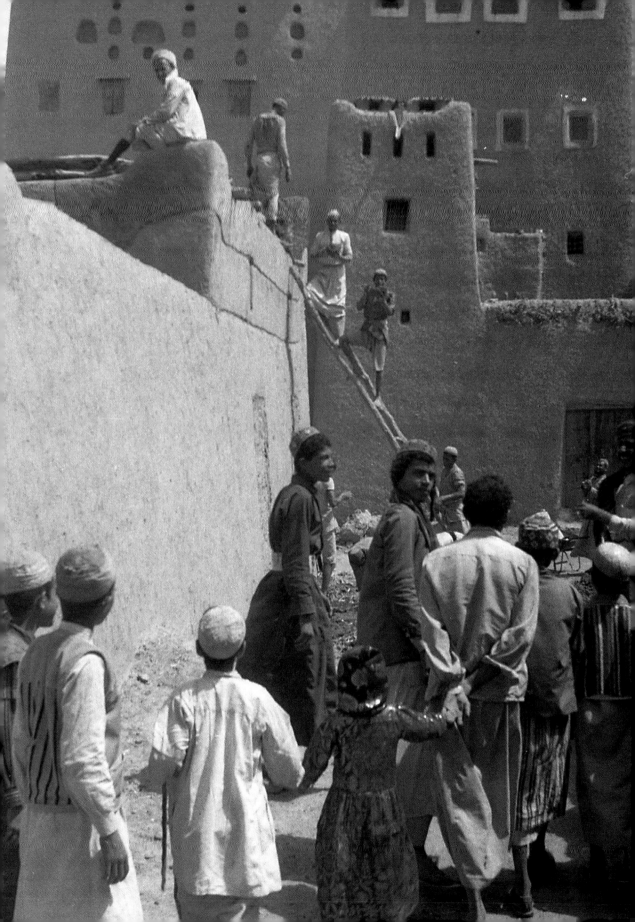

SA'DAH. "I later met him astride a donkey."

Yahūda, the first Jew I met, on his donkey. He subsequently accompanied me to Jewish families living in the Ghurāz and Dimmāj settlements outside the walled city.

At least the Jews can now ride donkeys astride. Some posit that if the Imām was touring in an area all Yemenis were expected to ride side-saddle to ensure a rapid descent in order to pay the necessary obeisance.

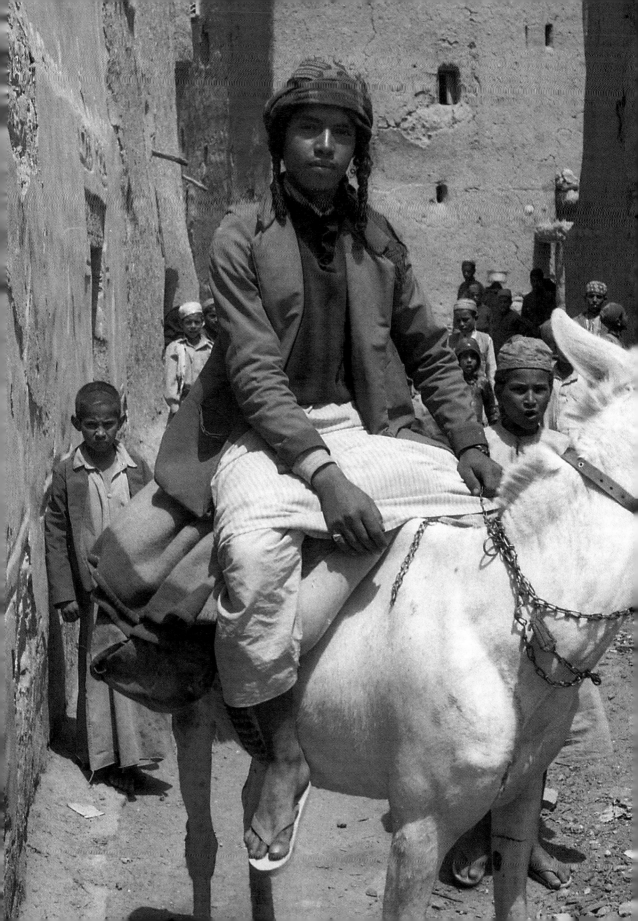

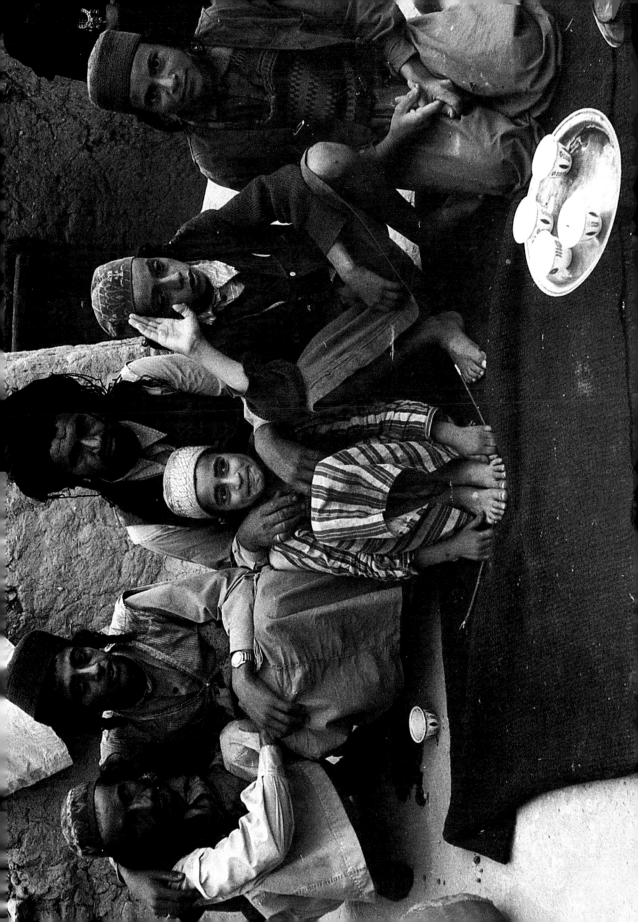

GHURĀZ, NEAR SAʿDAH. "…Yahūda and his companion invited me and my Arab companions to his home at Ghurāz …. We stayed there for several hours and chatted to his family."

A group of Jewish men and boys, seated outside their house at Ghurāz. Whilst there were no Jews still living within the walls of Saʿdah, many still owned property there. The Jew in the centre owned a shop in the main *sūq* and sold leather goods that he made himself, specializing in hammock-like cradles for babies.

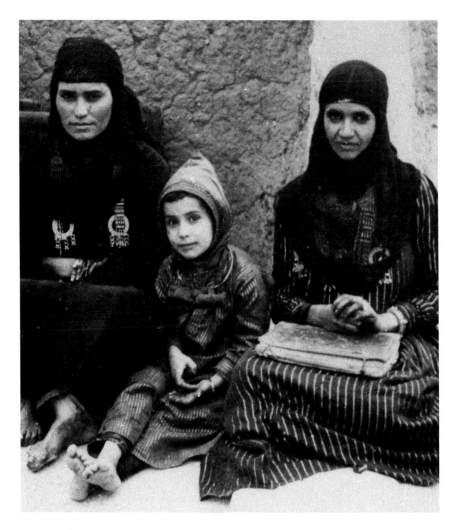

GHURĀZ, NEAR SAʻDAH. "… each family having its Jewish bible …
in Hebrew. One I saw was inscribed 'Printed in Poland 1930'. But the
scarcity of these was a concern."

Two Jewish women and a young girl at Ghurāz pose for the camera
with their well-used leather-bound Hebrew bible, the Torah.

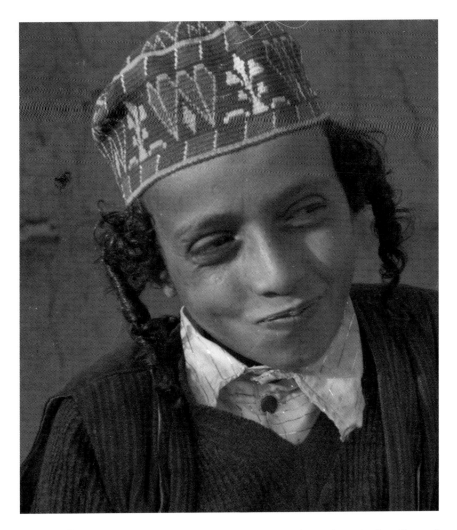

GHURĀZ, NEAR SA'DAH. A Jewish boy with a whimsical smile and side hair ringlets, *zinnār*. I noticed that during their early morning ablutions, especial attention was given to the washing of these side locks.

Although none of the Jews wore small black skull-caps, such as worn by the ultra-orthodox, the woven colour-patterned caps as seen here were common, especially among youths, as they were with Arabs.

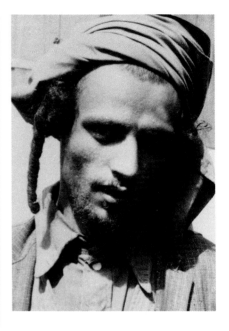
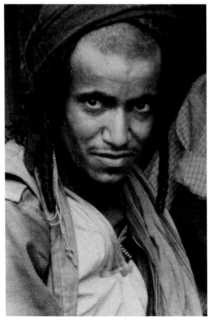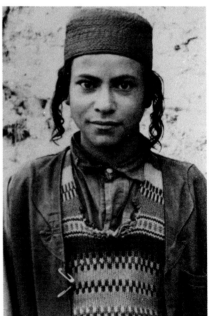

290

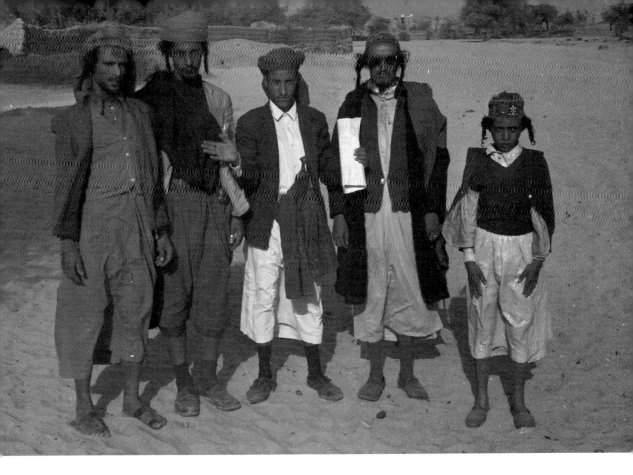

Above SA'DAH. "In appearance and dress the Jews might, at first sight, appear similar to the Arabs, but they tended to be taller ..."

Three Jewish men and a boy, with an Arab in the centre, outside Sa'dah. The Arab has an arm around a Jew and appears to be of harmonious disposition towards them.

Opposite SA'DAH. Studies of four Jews encountered during my visit. The different styles of affecting the *zinnār*, side hair ringlets, can be seen. Some are worn loose, others rolled tight.

ENVOI

And now, sadly, we must leave Yemen where we began with the frontispiece image of Freya in the Al-Haimat al-Dākhiliyyah. Here, back in the same area, she speaks with a lone woman standing on a rock, thanking her for all those wonderful days spent in her country. And for allowing us to capture so many magical images throughout Yemen, some of which may already have disappeared by the time you, dear reader, have feasted on them.

Following page The author …

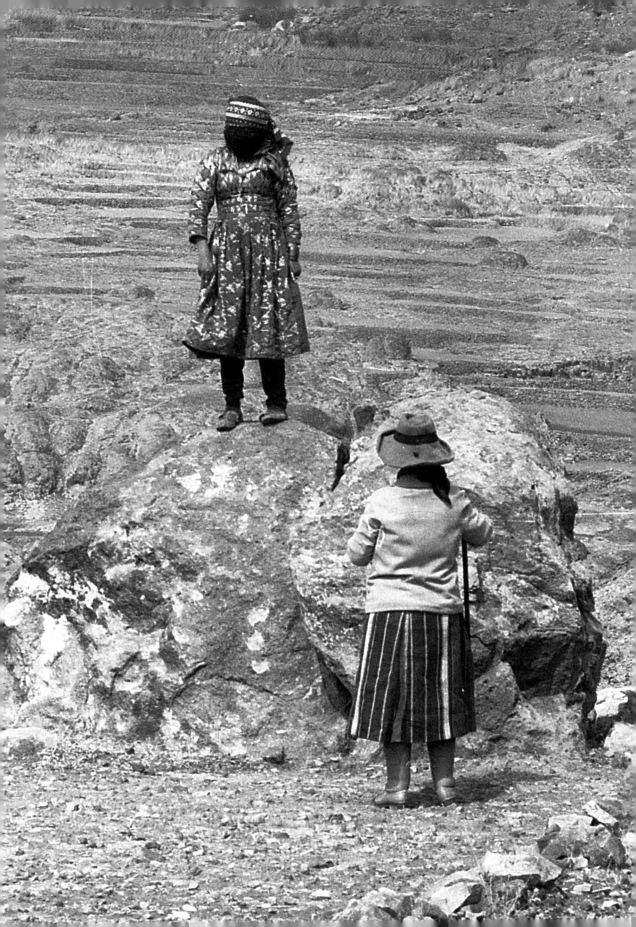

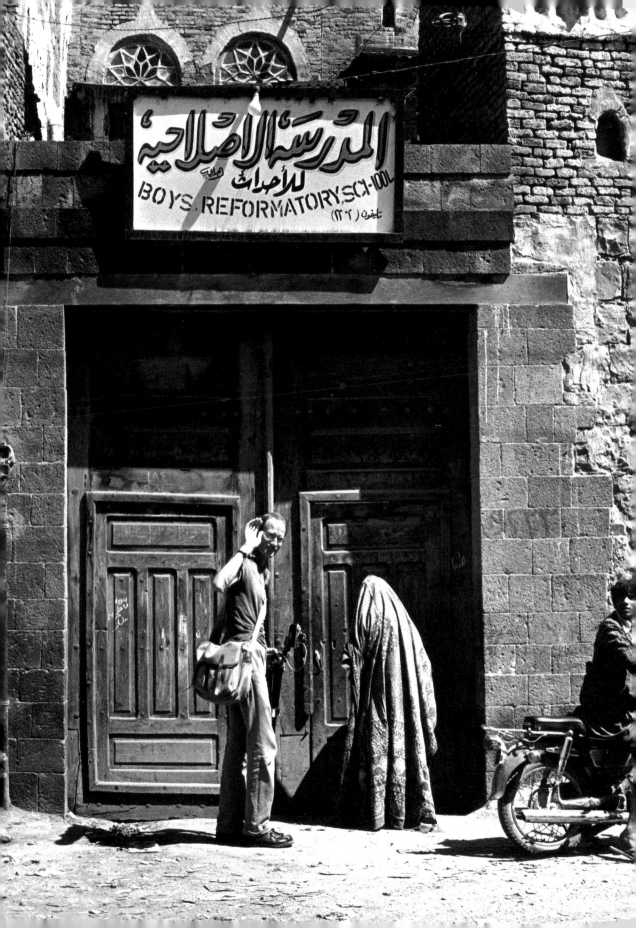

GLOSSARY

'arīsh Conical straw thatched hut

Ahl al-Kitāb People of the Book, i.e. Jews, Christians and Sabians [Mandaeans] whom the Qur'ān recognizes as having revealed scriptures

ājur or *yājūr* Kiln-dried mud brick

aylūm Respected Jewish elder

bāb Door, doorway, gate

bait Lit. house, also settlement

barqa' Woman's face veil

burj Tower

dā'ī Earthly representative of a religious leader gone into occultation (*ghaybah*). Also, missionary

damān Dung

dann, pl. *dinān* Earthenware water jar

dhurah Sorghum, millet

dimmaini pl. *dimmainah* A dung remover

'Eid al-Aḍḥā Lit. "Festival of Sacrifice", commemorating Ismail's offering to sacrifice his son

'Eid al-Fiṭr Festival marking the end of Ramaḍān, the month of fasting

fidāmah – straw-woven muzzle for cattle

fūṭah Cloth, often wrapped sarong-like around the waist; apron

ghāf Prosopis cineraria, a tree common in Arabia, with a very deep taproot, giving good shade

ghaybah Occultation, a state of abeyance

ḥabl Rope

ḥajar Stone

ḥawi Open secluded area built onto side of building

ḥawsh Courtyard, secluded area for women

hijrah Place under religious protection where violence is forbidden

huqqah Water tobacco pipe, also known as a *shīshah*, *narghīlah* or *madā'ah*.

idhān The Muslim call to prayer

janbiyyah, sometimes *jambiyyah* Dagger

jabal Mountain

jaḥal or *jaḥlah*, pl. *jiḥāl* Water jug or water skin, clay waterpipe jar

jizya Poll tax imposed on non-Muslims

juṣṣ Gypsum, gypsum plaster, whitewash

khayzarān Fine cane or bamboo

kūfiyyah Fez-shaped hat made from *khayzaran*

madā'ah Hookah or water pipe

madāḥ Panegyrist

madhhab School of Muslim law

mafraj Sitting room

majlis Semi-formal social gathering; reception or conference room

manṣab Representative

maqramah Face scarf

mashrabiyyah Wooden screened window balconies, often notable for elaborate carved decoration. They maximized ventilation while maintaining shade and privacy, and are a feature of Red Sea coastal architecture.

mīḍā'ah Mosque water basin

midmāk, pl. *madāmīk* Sun-dried mix of mud and straw used in building

miḥrāb Niche in wall of mosque to indicate direction of Mecca

milāj Mud plaster covering

minārah Minaret, or lighthouse

minbar Mosque pulpit

mukarrib Priest king

malik, pl. *mulūk* King

Mu'tazilites A rationalist school of Islamic interpretation

muzallah see *ẓullah*

naqsh Engraving, sculpture; carved plaster decoration

narghīlah Tobacco pipe

nabī Prophet

nūbah Type of fortified tower, usually built into a wall

nūr Light

qaḍāḍ Coarse-grained lime-based plaster like Roman cement, mixed from slaked lime with an aggregate of cinders or sand, which is then sealed and burnished with mutton fat to create a waterproof render for use on roofs and in cisterns.

qarqūsh Pointed bonnet made from a square piece of cloth

qārūrah, pl. *qurārir* Earthenware water jar

qāt Mild narcotic obtained from chewing the leaves of a bush, *Catha edulis*

qubr, pl. *qubūr* Shrine, tomb of a *wali*

qullah, pl. *qulāl* Earthenware water jar

qunza'ah Tuft of hair on a tonsured boy's head, cock's comb

Qur'ān The Muslim Holy Book often spelt, incorrectly in English, Koran

sharānīf Crenellations on the top of buildings

shīshah Tobacco pipe

sitārah Outer cloak

sūq Marketplace

tais Male kid goat

ṭār Drum

ṭabaqah Circular eating mat made of straw

tibn Straw

ṭīn Clay

ṭūb Brick

ṭūl Length of rope

ṭalli Male lamb

'ushshah, pl. *'ushāsh* Conical straw thatched hut

wādī Valley or river bed, usually dry

wali Saint

wālī Regional governor

wuḍū' Ritual ablution before prayer

yaman Happiness; right hand side; Yemen

zabūr Horizontal layers in mud-wall building

zanbīl Basket

zarībah Animal stockade made of brushwood, on the Tihāmah

zinnār Side hair ringlets worn by certain Jews

ziyārah Visitation

ẓull Shade

ẓullah Umbrella; broad-brimmed straw hat. Colloquially often *muẓallah*, a place of shade

CHIEF WORKS CONSULTED

Aithie, Charles and Patricia (2001), *Yemen: Jewel of Arabia*, London: Stacey International

Barer, Shlomo (1952), *The Magic Carpet*. London: Secker & Warburg

Belhaven, Lord (1951), *The Eagle and the Sun*. London: John Murray

Bethmann, Erich (1960), *Yemen on the Threshold*. Washington DC: American Friends of the Middle East

Costa, Paolo and Ennio Vicario (1977), *Yemen: Land of Builders*. London: Academy Editions

Cross, F. L., ed. (1958), *The Oxford Dictionary of the Christian Church*. Oxford: Oxford University Press

Daftary, Farhad (1990), *The Ismailis: Their History and Doctrines*. Cambridge: Cambridge University Press

Eraqi Klorman, B. Z. (1993), *The Jews of Yemen in the Nineteenth Century: A Portrait of a Messianic Community*. Leiden: E. J. Brill

Glassé, Cyril (1989), *The Concise Encyclopaedia of Islam*. London: Stacey International

Goitein, S. D. (1947), *From the Land of Sheba: Tales of the Jews of Yemen*. New York: Schocken Books

Groom, Nigel (1981), *Frankincense and Myrrh: A Study of the Arabian Incense Trade*. Harlow, UK/Beirut: Longman Group and Librairie du Liban

Hastings, James, ed. (1909), *A Dictionary of the Bible*. Edinburgh: T. & T. Clark

Naval Intelligence Division (1946), *Western Arabia and the Red Sea*. London: Admiralty Geographical Handbook Series

Newby, Gordon Darnell (1988), *A History of the Jews of Arabia: From Ancient Times to Their Eclipse under Islam*. Columbia: University of South Carolina Press

O'Collins, Gerald, and Edward G. Farrugia (2000), *A Concise Dictionary of Theology*. London: T. & T. Clark

Playfair, Robert L. (1970), *A History of Arabia Felix or Yemen: From the Commencement of the Christian Era to the Present Time, including an Account of the British Settlement of Aden*. First published 1859. London and Amsterdam: Ad Orientem with Philo Press

Reilly, Sir Bernard (1960), *Aden and the Yemen*. London: HM Stationery Office

Sayyid, Ayman Fuad (2002), *The Fatimids and Their Successors in Yemen: The History of an Islamic Community*. London: I. B. Tauris

Searight, Sarah (2002), *Yemen: Land and People*. Photography by Jane Taylor. With an introduction by Tim Mackintosh-Smith. London: Pallas Athene

Serjeant, Robert B., and Ronald R. Lewcock (1983), *Sana: An Arabian Islamic City*. London: World of Islam Festival Trust

Sharafaddin, Ahmed Hossin (1961), *Yemen: "Arabia Felix"*. Ta'izz: no publisher given

Simpson, St John, ed. (2002), *Queen of Sheba: Treasures from Ancient Yemen*. London: The British Museum Press

Stark, Freya, *The Southern Gates of Arabia: A Journey in the Hadhramaut*. London: John Murray, 1936

— *Seen in the Hadhramaut*. London: John Murray, 1938

— *A Winter in Arabia*. London: John Murray, 1940

— *Traveller's Prelude*. London: John Murray, 1950

— *Beyond Euphrates: Autobiography 1928–1933*. London: John Murray, 1951

— *The Coast of Incense: Autobiography 1933–1939*. London: John Murray, 1953

— *Dust in the Lion's Paw: Autobiography 1939–1946*. London: John Murray, 1961

Stone, Francine, ed. (1985), *Studies on the Tihāmah: The Report of the Tihāmah Expedition, 1982, and Related Papers*. Harlow: Longman

Tarcici, Adrian (n.d.), *The Queen of Sheba's Land: Yemen (Arabia Felix)*. Beirut: Nowfel Publishers

Wald, Peter (1996), *Yemen*. London: Pallas Athene

Yusuf 'Ali, Abdullah (1989), *The Holy Qur'ān: Text, Translation and Commentary*. New revised edition. Brentwood, Maryland: Amana Corporation

Leica books

Matheson, Andrew (1953), *The Leica Way: The Leica Photographer's Companion*. London: Focal Press

Rogliatti, G. (1975), *Leica: The First Fifty Years*. Hove, UK: Hove Camera Foto Books

Wright, A. Neill, and Glanfield, Colin (1986), *The Collector's Checklist of Leica Cameras, Lenses and Accessories*. Camera Collector Books

INDEX

NOTE: In alphabetizing, Āl, Al-, b. and Ibn are ignored.

305

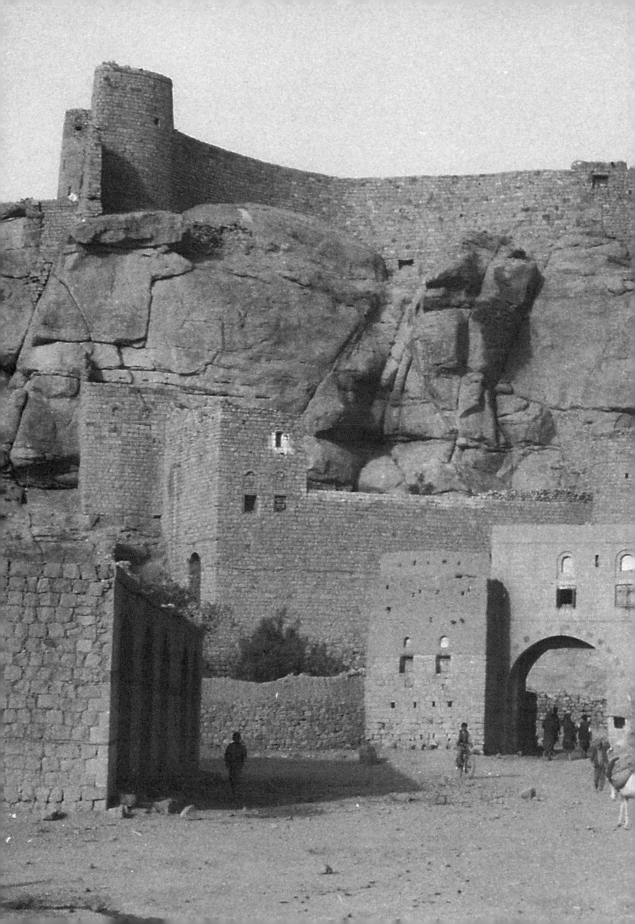